THE
ENCYCLOPEDIA
OF
CALLIGRAPHY
TECHNIQUES

Piece by Ieuan Rees

THE ENCYCLOPEDIA OF CALLIGRAPHY TECHNIQUES

DIANA HARDY WILSON

SEARCH PRESS

A QUARTO BOOK

Published in paperback 2002 by
Search Press Ltd
Wellwood
North Farm Road
Tunbridge Wells
Kent TN2 3DR

Reprinted 2003

ISBN 0 85532 998 X

This book was designed and produced by

Quarto Publishing plc
The Old Brewery
6, Blundell Street
London N7 9BH

Senior editor Kate Kirby
Editors Judy Martin, Angie Gair
Designers George Ajayi, John Grain, Penny Dawes, Karin Skånberg
Photographers Ian Howes, Martin Norris
Illustrator David Kemp
Picture research Kate Russell-Cobb
Art director Moira Clinch
Assistant art director Chloë Alexander

Special thanks to the Canonbury Art Shop, London, N1, and
Falkiner Fine Papers Ltd, London, WC1 for the loan of materials
shown on pages 186-187

Typeset by Ampersand Typesetters, Bournemouth
Manufactured in Hong Kong by Regent Publishing Services Ltd.
Printed in China by Leefung-Asco Printers Ltd, China

CONTENTS

PART ONE

TECHNIQUES • 8

BASIC PENMANSHIP • BORDERS • BRUSH LETTERING • CALLIGRAM • CAROLINGIAN
COLOUR • COMPOSITION • COPPERPLATE • DECORATED LETTERS • DOUBLE POINT
DROPPED CAPITAL • FLOURISHING • FOUNDATIONAL HAND • GILDING • GOTHIC
HEADINGS • HUMANISTIC • ILLUMINATION • ITALIC • LAYOUT • LOMBARDIC
MANUSCRIPT BOOK • MARKS ON PAPER • NUMERALS • ORNAMENT • QUILL PEN
RAISED GOLD • REED PEN • ROMAN CAPITALS • RULES • RUSTICA • SPLIT NIB
SWASH LETTER • TEXTURE • UNCIAL AND HALF-UNCIAL • VERSALS

PART TWO

THEMES • 92

LETTERFORMS • 94
FORMAL CALLIGRAPHY • 108
WORDS • 118
APPLIED CALLIGRAPHY • 146
THE THIRD DIMENSION • 168
EXPERIMENTAL CALLIGRAPHY • 176
TOOLS AND EQUIPMENT • 186
INDEX • 188

INTRODUCTION

The art of calligraphy has survived and is flourishing despite significant changes in its status. During and after the days of the Roman Empire, the developments in communication were mainly alterations in style and methods of writing to facilitate speed of production and economy of materials. In Europe, the fifteenth century heralded the invention of printing and mechanical reproduction methods, which have continued into the twentieth century, to the evolution of the computer and desk top publishing. These major developments and their attendant technologies have contributed valuable additions to methods of communication, and some are admirably explored by contemporary calligraphers.

In discovering the visual delights of calligraphy the perceived barrier of having no "artistic talent" disappears. This may occur through working with the raw materials of language (letterforms). The familiarity engendered through handwriting and the printed page presents a less daunting prospect than picking up a pencil to draw. There is no less attention to detail required in crafting beautiful letterforms than in drawing: both insist on precise observation and industry. Studying the individual letters of a style or hand

and their relationship to each other, will reveal repeated shapes and lines. These specific features form the basis of a transcribing language.

Learning calligraphy encompasses more than the production of beautiful letters. The manipulation of the tools is only one part: manipulation of the marks they make is an integral component. Splendid presentations depend on more than technical expertise, the letters demand good layout and design. These are further enriched by the breadth of an individual's experience. The calligrapher as artist makes statements and shares perceptions, celebrating the opportunity to use both words and images.

The creation of a reference collection of ephemera, photographs and notes will broaden understanding and personal awareness of the art.

To explore and experiment with new ideas and applications will bring its own rewards and the joy of creating calligraphic artforms... Do not be frightened by conformity and do not be limited by convention!

PART ONE

TECHNIQUES

Beautiful pieces of calligraphy and richly decorated manuscripts can be daunting to the aspiring calligrapher, but learning to use these as sources of inspiration and reference is not difficult. Breaking down the overall picture of an image, or series of images, helps to identify the constituents that make up a work of art.

Developing this skill in the novice calligrapher is precisely the aim of this book. The first half of the book contributes to removing some of the art's mystery, showing how what seems impossible can in fact be achieved. The techniques explored each explain different aspects of the subject.

Any calligraphic letter is built up stroke by stroke, and in the following section the alphabet of each hand or style is accompanied by a diagram showing the sequence and direction of the strokes. (The pen is always lifted off the page between strokes, except in some cursive styles, such as Copperplate.) Each letter is also composed of thin and thick strokes, created by manipulating the pen at specific angles to

the page. The correct proportions for different letters (that is, the letter height) are calculated in relation to the thickness of the nib. These step-by-step illustrations, finished examples and a cross-referencing system show the range of techniques which can be explored. When creating your own calligraphy they can be employed individually or in combinations.

Understanding the symbol

Where appropriate a symbol indicating the suggested nib width, letter height and pen angle accompanies each alphabet: use this as a guide only. Whatever size nib is used, the height of the letter is always determined using a "ladder" of nib widths.

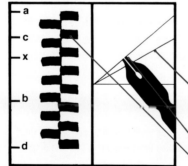

a refers to the ascender height
c refers to the height of the capital letter
x refers to the x-height, that is the height of the body of the letter
b refers to the baseline, where the body of the lower case letter sits or the base of the cap sits
d refers to where the descender finishes
pen angle hold your pen over the nib to ensure that it is at the right angle before you start; when more than one angle line is shown, this indicates there is a range of angles for that hand
nib width the correct width of the pen is shown
ladder to determine letter height

BASIC PENMANSHIP

It is important for all calligraphers to establish the ideal working conditions for producing their best work. A comfortable working position will achieve a good overview of the work, a relaxed posture, and a steady flow of ink. Good posture and a relaxed position are very important. Try and keep all body weight directed through the spine, the legs relaxed, and both feet planted firmly on the floor. This position should discourage the temptation to lean forward putting weight on the arms, which would hinder movement. Learning calligraphy requires much practice and concentration, but it should be a pleasurable experience, not a chore. Take regular breaks, and do some stretching and relaxing exercises between sessions.

It is not essential to have a floor-standing drawing board. A drawing board that is hinged to a table top, or one that can be secured at the edge of a table and rested on wooden blocks or books, are both good. These boards have the added advantage of being able to be raised and lowered to good working inclinations. If none of these possibilities exist, a clean board resting on the lap and leaning against a table will suffice, although it is not ideal as movement becomes

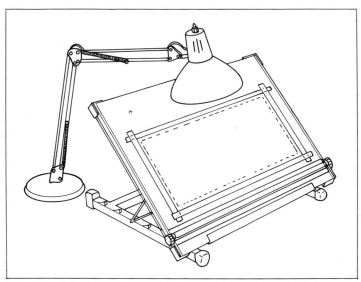

restricted. Alternatively, use the flat top of the table, resting your weight on the left elbow (if right handed) so the writing arm can move freely.

Whichever working arrangement is used, there must be some padding beneath the paper. This will add to the flexibility of the metal nib. Several sheets of blotting paper or newspaper ironed flat can be used for the padding, which must be bigger than the working paper size. Cover the padding completely with a clean sheet of paper, and fix it to the board or table top with masking tape.

A clear and evenly distributed light needs to fall on the working area, and so all shadows from the hand falling on the working surface must be eliminated. To do this, the light source needs to be to the left of the working area (for right-handed calligraphers).

When beginning to work, place a clean cover sheet under the writing hand. This will prevent grease or oil from marring the writing surface. Direct your attention to the letter shapes, being aware of counter-stroke shapes, spaces between letters, and thickness of strokes. Take care to maintain a constant pen angle of the writing hand, and check it regularly. Try to establish a rhythm to your lettering;

A drawing board is useful for doing calligraphy, good light is essential. The board must be large enough to accommodate the paper size with generous margins all round.

hesitancy will produce fractured letterforms.

As confidence is gained, and a certain comfortableness is felt with the basic letter shapes, start to write individual words, then sentences from songs and poems. Do not worry about misspelling words; carry on so that your rhythm is not broken.

Pens and pen angles

A square end or chisel-shaped nib, pen or brush is the essential instrument for calligraphy. When the pen is held in the hand, it should point over the right shoulder for a right-handed person.

The squared writing edge of the pen forms an angle to the horizontal writing line, and this is known as the pen angle. Each hand has its own specified pen angle which ensures that the correct proportions and balance of thin and thick strokes are maintained.

Letterforms

The style, or "hand", which

These simple strokes form the basis of letter construction.

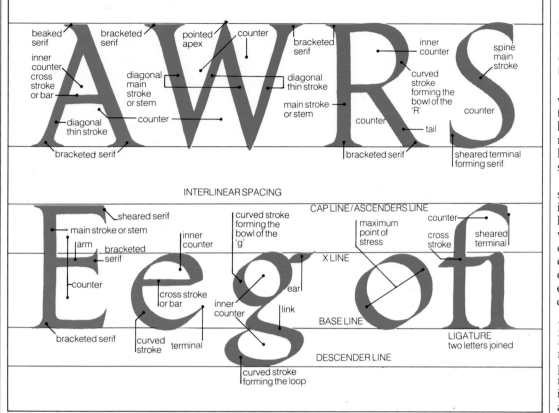

Letter construction
A special terminology is used to describe the constituent parts of a letter. Shown here Roman capitals (majuscules) and Roman lowercase letters (minuscules).

width marks, the nib is turned to 90° to the horizontal writing line. A new ladder must be made to calculate the letter height for a change in lettering style or nib width.

To add a word in another style to, for example, a line of italic writing with lower case letters of five nib widths, you will have to experiment with different nib sizes to find the one that gives the depth of the existing x-height. This will ensure the proportions are correct.

Left-handed calligraphers
For left-handers, oblique-cut nibs are helpful. The correct pen angle for each hand must remain the same, however, so it may be necessary to alter the angle of the paper. Tilt and move the paper to the left, so the head has to turn slightly and writing across the body is avoided. Tuck the left elbow in towards the waist.

With the paper moved slightly away, the writing hand is further from the body; this allows greater freedom of movement. The intention should be to achieve a comfortable writing position; if using a drawing board, it may help to steepen the angle.

you write in is composed of letterforms. These are divided into capital, or upper case, letters and small, or lower case, letters (older terms for these were majuscule and minuscule respectively). All calligraphers need to aim for good legibility, and lower case letters are the best choice for an interpretation involving long texts or copy. The arrangement of the letters, with their ascenders and descenders creating variation and texture, are easier to read than a solid block of capital letters.

Proportions
Good proportions for the letters are essential, and these can vary between those which are slightly narrow, called condensed, and those which are wide in relation to their height, or "expanded". The internal proportions of a piece of calligraphy are dependent on the ratio of the pen width to the letter height. Thus an italic hand written six nib widths in height produces a more slender, finer stroke than the same letter written at five nib widths. Likewise, if the same letter is written less than five nib widths in height, it would be bolder and squat, with internal proportions to match.

Our eyes distort visual proportions when looking at written letters, and in some cases this must be compensated for. Letters with larger, round counter shapes – c, o, q and s, for example – will appear proportionally smaller in a line of writing, and so the curved strokes are taken slightly above the x-height or guideline. Some angular letterforms require the same treatment.

Ladders and letter height
Initially, each style of letterform is written at a specific height. The height of the letters is determined by a specified number of nib widths, which ensures that the hand's proportions are correct.

To make a ladder of nib

BORDERS

Borders can be incorporated very successfully in many designs. Surrounded totally or in part by a border, a block of text or lines of information on a card can be greatly enhanced. Verses of a poem can be separated by a single line of patterning. Borders should complement the calligraphy; they should not overpower the text, or look too timid. Too much elaboration can easily detract from the overall appeal of the work.

Borders define a space and can "tidy up" a piece of visual work, but cannot save it if the letterforms and spacing are not well planned in the first place. To demonstrate the power of the border, take a freely drawn piece of lettering or ornament and simply surround it with straight lines. The difference in visual impact is immediate, the effect is the same as framing a picture.

There are four basic components of border design: repeat horizontal marks, or filling-in worked as a continuous running pattern; a series of vertical marks; a fusion of horizontal and vertical elements; an arrangement of panels. Put more succinctly, the simplest options are spot, horizontal, vertical and oblique marks.

Borders should be related to the nature of the work. This is more obvious in other craft areas, but should not be ignored in calligraphy. You can render the writing without embellishment and, without loss of meaning or intent, surround it with a highly decorative and well constructed border that provides great visual and aesthetic impact.

It takes careful consideration and artistic judgement to achieve the correct proportions of a border and its overall value in the work. There is no reason for a border to be straight or for the boundaries to be parallel. It can surround an irregular space and have straight lines on the outer perimeter.

The corners of borders need careful planning. When you have made a clear decision as to the nature of the join, whether it is to be oblique, square, or joggled mitre, the object is then to design with the join, not to accentuate or necessarily conceal it.

Sources of ideas for borders abound. You will find it useful to start building a border repertoire. For example, you might make a study of brick bonds, embroidery, or wrought and cast iron objects. Such items provide a wealth of line qualities, shapes and patterns that can all be incorporated into border design. Make sketches with a pencil, then put tracing paper over your sketch and, using a nib, go over the drawing in ink, selecting simple repeated components. Use these to create an original border.

Tools and techniques

Mix and match techniques in your designs: for example, use broken rules interspersed with dots made with a broad nib. Almost any tool is suitable for building up a border – brush, pen, fibre-tip pen or pencil. Introducing colour to a border requires some planning but used well, colour is very effective.

Working on squared paper will help to build your confidence, giving a framework to the design as you twist and turn the broad nib to invent new arrangements. This exploration also makes a good practice exercise or "warm-up". Spend some time roughing out the design of the border, especially on the critical decision as to whether it will form a full or partial enclosure for the text. A semi-enclosure is most likely if a decorative heading is part of the piece.

If confident line drawing is one of your strengths, the border might include small concealed images relating to the text.

Cartouche

Although not strictly calligraphic, the cartouche is a device worthy of consideration. Cartouches evolved from an ancient art applied to paper and parchment labels used to hold inscriptions or badges. The edges were cut in an intricate manner that resulted in ornamental curling of the labels, usually into scroll forms. The shapes evolved further in the forms of shields, and eventually panels were cast or carved to enclose an inscription, although they were sometimes left blank. In either state, they constituted an important element in design, especially to offset or draw attention to a more engaging ornament.

Calligraphers can refer to old cartouche designs as a rich source of ideas applicable to name cards, heraldic work, quotations, and many other calligraphic works.

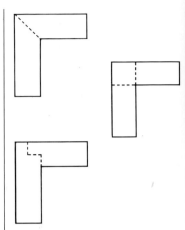

Joints for borders
The structure of a border framing a work needs consideration. Frames are formed in several ways, including oblique, square and joggled mitre. The corner is the best place to start when designing a border to form a full or semi-enclosure.

Pointed brush border
1 When designing borders, experiment with different tools and media to add further variety to the strokes and marks. For example, manipulating a pointed brush, with designer's gouache, can produce varying weights of mark. Pulling the brush lightly, with no noticeable pressure, results in fine lines.

2 Applying a little pressure and pulling down quickly through the stroke produces a contrasting bold line.

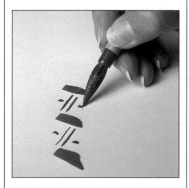

3 Delicate dots can be added using the tip of the brush. Control of tho dot size is dictated by the pressure placed on the brush as it rests on the paper.

4 The dots in this completed simple border pattern were made by placing the point of the brush on the paper, then pulling it slightly downwards as it was lifted off the paper.

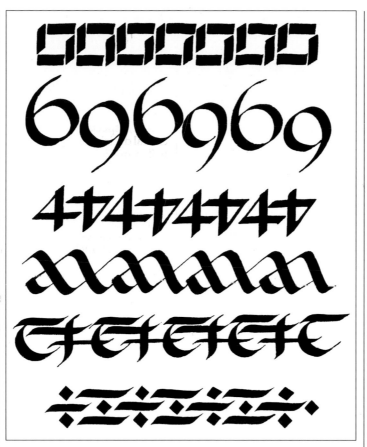

Borders: basic strokes

The broad pen can be used to produce simple and pleasing marks which, either alone or in combination, can be repeated to create a decorative border. Changing the pen angle will increase the variety and interest even within the same border.

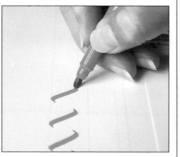

Fibre-tip border

1 Fibre-tip pens with chiselled nibs are useful for working out border patterns, being instant in use and available in a variety of colours. Employing basic broad pen strokes, a line is worked through to the end.

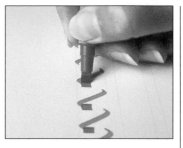

2 Turning a thick pen to an angle of 90° to the horizontal writing line, square dots are placed at the top of the slanted line.

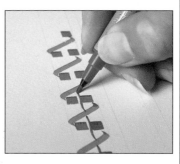

3 Dots are placed at the base of the slanted line. Then the same pen, held at about 10° to the horizontal, is used to produce a thin, graceful stroke.

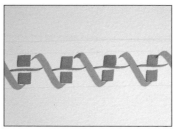

4 This red and green border could have more lines and shapes added, or, as here, be regarded as complete.

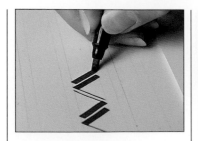

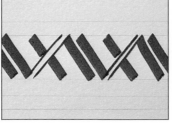

Black and white border
1 The width of stroke varies according to the direction in which the pen is moved while retaining a fixed nib angle. Here a black fibre-tip pen, held at an angle of 45° to the writing line, produces thick downward strokes.

4 The thin and thick strokes form a simple and basic pattern. The application of additional shorter strokes to break up the white space produces a more interesting and pleasing result.

2 Repeating the letters, with their elegant proportions and thick and thin strokes, leads to a perception of an arrangement of shapes rather than actual letters.

Broad brush border
1 A brush with a square-cut end can be used to create a border composed of simple repeated shapes.

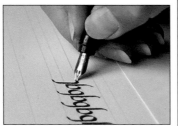

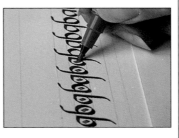

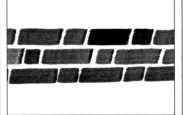

2 Holding the pen at the same angle and moving in an upward direction produces thin strokes.

Letter border
1 Borders constructed from letter shapes can be used successfully, especially if the letters are chosen to represent or allude to something referred to in the piece they surround. If no obvious links present themselves, letters that contrast with or balance each other can be selected.

3 The inclusion of a spot colour, as a simple device, can add a surprise element and further disguise the actual letter shapes.

2 This example is based on a brick bonding design. The same arrangement can be made using a broad nib.

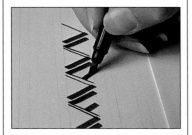

3 A short, thick stroke is inserted between the major lines of the pattern to break up the white space. The lines are first applied along the bottom of the design, before working through the top row.

4 The final picture perfectly illustrates how the letters have become mere vehicles in the creation of this border. The work has a balance of black and white and reads as a row of shapes and lines, rather than letters.

BRUSH LETTERING

Brushes are included in a calligrapher's toolkit to acknowledge an excellent method of practice and experimentation. The ability to use different brushes and a variety of inks and paints can be a great asset, providing a range of instant visualizations.

The best way to learn the possibilities of brush lettering is to work on quite a large scale and freely, in an informal style. Something of a hidden agenda exists when you work with brushes. This is particularly in evidence when the amount of ink or paint on the brush diminishes, providing the potential for interesting textural contrasts. For example, if the ink runs dry in mid-letter, you can make a positive feature of the change of emphasis, rather than dispensing with the work as "no good".

You can experiment further by laying patches of wet colour side by side and letting the different colours merge. A pre-planned colour selection can produce some exciting and extremely interesting results.

Broad, flat or square-tipped brushes produce bold lettering. Manipulation of the brush angle, particularly when doing a horizontal stroke, creates further interest.

When working with brushes, you will soon realize that, having worked a successful solution in rough form, recreating the exact same image in the finished work is not so easy. This must be regarded as an exciting advantage of brush lettering, not as a deterrent. Because of the free movement of the brush, a good understanding of letter shapes is essential if you

are to achieve convincing brush lettering.

Discovering which brush to use, in order to achieve the required impact, is truly a matter of trial and error. Favourite solutions will reveal themselves over a period of time. Get to know the marks of as many brushes as possible. The traditions of eastern calligraphy are founded in the use of brushes, so include Chinese bamboo brushes in your selection. The hairs of these brushes come to a fine point and make marks quite different from those of square-cut watercolour brushes. Your attempts at lettering with pointed brushes may result in images related to oriental brush-writing styles. Study of eastern brush techniques can only make an enriching addition to the repertoire of the western calligrapher.

Brush lettering can be incorporated in a wide range of designs, creating strong visual effects with an enticing air of informality. The image of brush lettering, for example, as a headline above the more formal writing of the broad nib can be highly effective. In this role, brush lettering played a major part in advertising design of the 1930s and 1940s, particularly in the United States of America. If you look at examples from that period, you will see the potential of using freely written brush script with formal typeset copy.

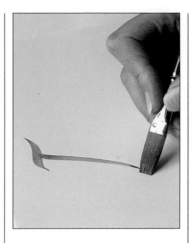

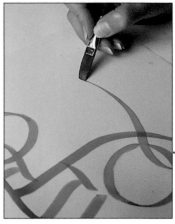

Arranging letters
1 Working with a large square-cut brush permits much freedom of individual expression. The first letter provides an anchor from which the remaining letters can hang or around which they can be grouped.

3 Pleasing arrangements can be arrived at, often unintentionally, when practising lettering with a brush. An extended stroke to create a swashed letter is easily accomplished with a brush.

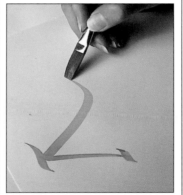

2 The letters are constructed in the traditional manner of following a stroke sequence. The brush is held at an angle either suitable to the style of lettering being effected or to produce the intended weight of stroke for a particular piece.

4 Place a sheet of clean paper under your writing hand to keep the writing surface clean and free of grease.

Allowing the design to grow, without adhering to any preconceived ideas, often produces pleasing results.

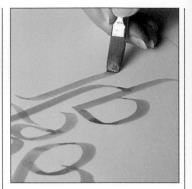

5 The introduction of a second colour and a different weight of letter provides two immediate contrasts. Delicate strokes made with a fine-pointed brush further contrast with the weight of broad strokes made with a flat brush.

Exploring single letter shapes
1 Practising single letter shapes with a large square-cut brush provides an excellent method for learning about letter construction.

3 Using a brush provides a flexibility of physical approach not available with other instruments. The springiness and lightness of touch of the brush hairs on the page, compared with the rigidity of a steel nib, allow much freedom of movement across the page.

5 The head of the brush is kept at a consistent angle to enable thin and thick strokes to be formed.

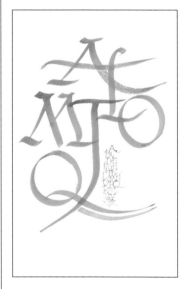

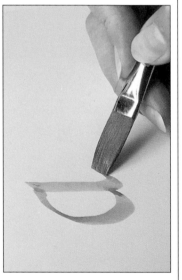

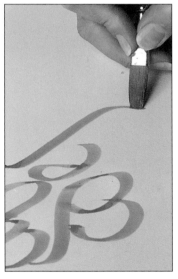

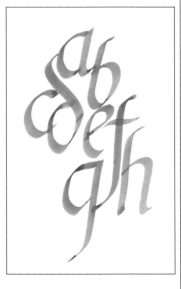

6 The completed piece illustrates contrasts of colour, letter size and style. Consideration has been made of the space occupied by the freely written individual letters, and of their collective arrangement.

2 The sequence of strokes which make up the letters is the same as that used with a pen.

4 The opportunity to dispense with the confines of guidelines is a chance to experiment with offsetting letters on the page.

6 Even if some of the letters do not "feel" right, do not abandon the piece: the purpose here is simply to practise manipulating the brush. Exercises like this one should be approached in a relaxed manner.

Using a pointed brush

1 A pointed brush, of the kind used for Chinese calligraphy, is excellent for practising freely constructed letters. Chinese brushes are designed to hold much more paint or ink than a traditional Western watercolour brush.

2 Chinese brushes are also versatile: fine strokes can be produced with the tip, and broad strokes with the body.

► SUZANNE GUEST
Working with a square-cut brush enables a perfect reproduction of the strokes made with a square-ended nib. The brush affords a greater freedom of movement and an opportunity to experiment with colour. Watercolour can be overlaid, as in this work, to exploit its transparent nature. Colour washes have been applied to the base ground and coloured pencils used to embellish some letterforms.

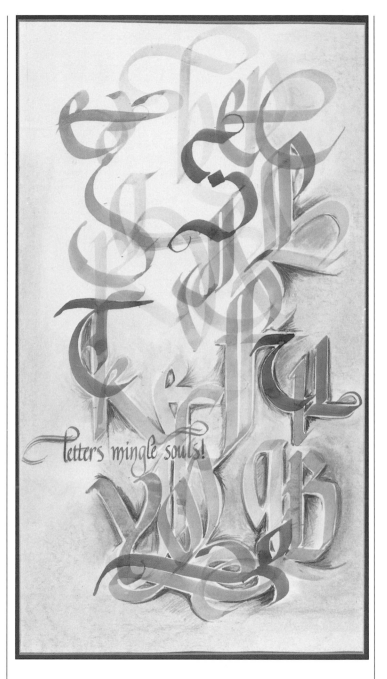

CALLIGRAM

Curiously, this word does not appear in some of the major dictionaries, nor are there references to this wonderful device in many books on calligraphy. A calligram is a picture or design that is entirely created by arranging words or lines of words to form the image. Usually, the words relate directly to the image.

At its most basic, a calligram is a single object filled in with written texture. The principle is readily recognizable from examples of Christmas card designs, in which a calligrapher has arranged words on the theme of Christmas into a familiar and easily perceived shape – a traditional Christmas tree, a plum pudding or a cracker.

There are no hard and fast rules for creating calligrams although, like most visual design problems, they require good planning if you are to achieve successful results. A calligram should be seen as a device to create a little divertissement. As a calligrapher's contrivance, it can be well employed in any number of items, ranging from business cards and personal stationery to leaflet and poster design.

A good calligram is only achieved by patient trial and error, with considerable time spent on roughing out ideas and images, and simply experimenting. When you have chosen a subject, draw up a recognizable representation of the shape in outline. Use good reference to get the shape right. Even if part of the design will include distortion of the original shape, always begin with the correct form. Beautifully textured writing will not save a calligram if the shape is unrecognizable.

With a strong and easily identifiable shape, a very loose style of lettering can be used. For example, a leaf shape could be quite simply formed by repeating the word "leaf" over and over again in a freely written script.

If the words are to be read, then you need to spend more time considering the design. Fitting a selected text or specific information into a defined shape can prove extremely difficult. Some possible solutions include using different styles of lettering and different weights. Variations of texture add interest and can be obtained by changing the nib and lettering size.

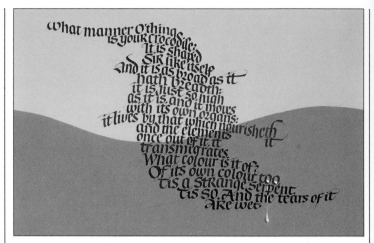

▲ KENNEDY SMITH
Constructed with words from Shakespeare's *Antony and Cleopatra*, the crocodile slips quietly into the water.

▼ HARRY MEADOWS
This picture was produced with watercolour on vellum, with a sparkling embellishment of burnished gold.

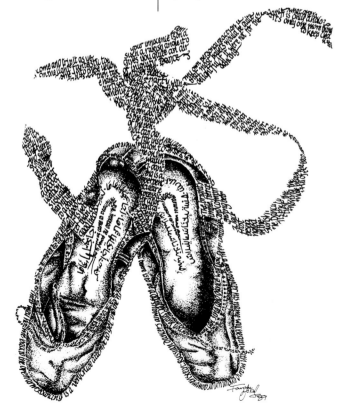

◄ FARAH GOKAL
This work by a young student shows great imagination. The calligram technique is combined with simple drawing methods to produce textural quality. Letters change in size and have extensions to create effect. The Arabic script on the inner sole blends in beautifully.

CAROLINGIAN

This minuscule, sometimes referred to as Carlovingian, was the result of an organized attempt to unify the hands in use in western Europe in the eighth century, including the classical Roman alphabet and cursive scripts. In AD 789, at the behest of Charlemagne (c.742-814), king of the Franks, a decree was issued requiring this standardized hand to be applied to all existing literary works, legal and official documents and ecclesiastical services.

Carolingian flourished as a bookhand with few modifications in the relentless quest for speed and economy. In work of the ninth century, some variation in pen angles can be seen. This resulted in some inconsistencies in the letterforms, not just in the formation of thick and thin strokes. The lettering became more condensed by the tenth century, which suggests it was a precursor of the GOTHIC styles to come.

Carolingian is widely acknowledged as the first true lower case alphabet. The letters of this hand are readily identified by the long ascenders and descenders that accentuate the smallness and roundness of the letter bodies.

To write this well-composed script, use a medium-sized nib and a pen angle of 35°-40°. The body of the letter is only three nib widths in height, whereas the ascenders and descenders can be as much as six nib widths. This provides the correct proportions for the letters.

The slightly clubbed serifs of the ascenders are made in two strokes. The first is a hooked downward stroke that becomes the "length" of the serif. The second is the beginning of the main vertical stroke. The lines of work will benefit from good interlinear spacing, with six nib widths being the minimum depth, so that ascenders and descenders from succeeding lines do not become entangled.

There were no specific capital forms to accompany these letters, so initially Roman square capitals were used. Now, there is a variety of majuscules that combine very successfully with the Carolingian forms, such as ROMAN capitals, UNCIALS or VERSALS.

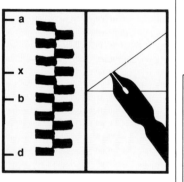

▶ This is a contemporary rendering of a modified tenth-century hand and Carolingian minuscules. There were no majuscules to accompany this lower case hand, so Roman, Versal and Uncial letters were used instead.

1 Using a square-cut steel nib, held at an angle of 35°, the club-shaped serif is made. The serif is a single stroke made by pulling the pen in a small elongated arc to the left. The pen is then placed back at the starting point (which is the top of the letter) and the main vertical stroke is formed.

2 The letter is completed with a single stroke pulled sharply round to the right.

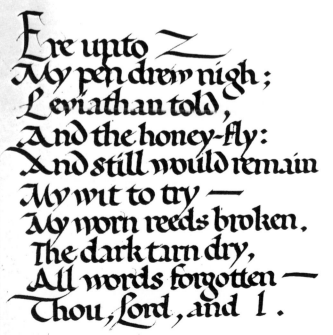

Ere unto Z
My pen drew nigh;
Leviathan told,
And the honey-fly:
And still would remain
My wit to try —
My worn reeds broken,
The dark tarn dry,
All words forgotten —
Thou, Lord, and I.

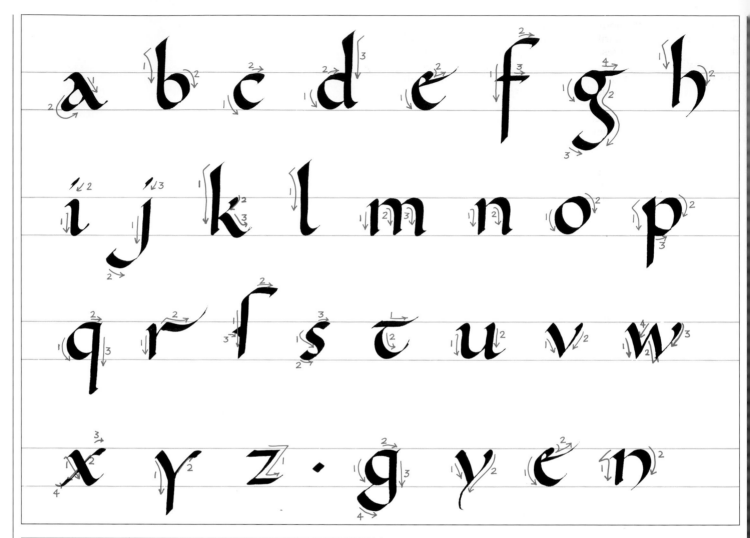

Carolingian alphabet

The Carolingian is a minuscule face, with no accompanying majuscule form. Close attention must be given to the letter shapes, with their distinctive small rounded bodies and proportionately long ascenders. This hand demands good interlinear spacing, so that the ascenders, with their characteristic clubbed serif, do not intrude on the descenders of the previous line of writing.

Practise the two strokes which make up the serif, as it is easy to misplace the hooked first stroke so that it projects beyond the right-hand side of the vertical second stroke.

The original s form is included in this alphabet. Although this shape is now seen as unusual, it works better in some letter combinations (such as ST) than the more readily identifiable modern form of the s.

The first stroke of the characteristic clubbed serif is a downward hook. Next, the vertical stroke descends, gathering the end of the hook on its descent. Construct the bowl of the lower case d first, in two separate strokes.

COLOUR

The introduction of colour into a calligraphic work instantly adds substance and gives another dimension to the piece. In past centuries, as now, the use of colour was dictated firstly by the availability of materials and secondly by the requirements of the work. Pellucid, uncomplicated colour decoration was applied initially to draw attention to specific information and to contrast with the dense blackness of the text.

Colour made from rubrica, a red earth, was commonly applied to manuscripts not by the scribes themselves, but by rubricators, experts at employing the pigment. The "rubric" which they applied might be the title, a heading or an initial letter in the manuscript, notes of instruction in the margin of a text, or an entire paragraph.

The opportunities for including colour to some degree paralleled the development of the scripts that they both accompanied and utilized. The VERSAL letter, for example, heavily ornamented, blossomed on the pages of broad-pen scripts, creating immediate interest and contrast.

The range of colour applications remains largely unchanged since the time of considered and glorious ornamentation of illuminated manuscripts. Colour can be included as an entire pictorial piece, as a single capital letter at the beginning of the text, or as individual letters throughout the work.

There is an extensive range of materials supplying colour for the calligrapher. The two most useful sources of colour to be laid down for finished work are coloured inks and paints. Some consideration needs to be given to selecting the right medium for the work. The medium must be suitable for application with the intended writing instrument, giving sharp edges and hairline serifs or decoration as required. You must also consider the permanence of the work. Inks with an inherent transparency will have a tendency to fade, unlike opaque designer's colours or gouache.

The paper must also be chosen carefully. If you are using watercolours, a paper that can absorb the added moisture will be necessary.

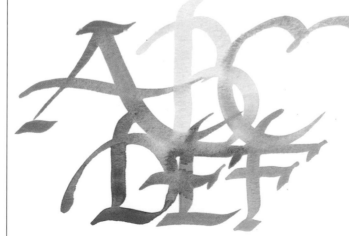

Using a large brush

1 Working with colour and a large brush is an adventure, and one from which much can be learned. The freedom of movement afforded by the brush, combined with the search for an interesting layout and arrangement of colour, is also good for developing personal concepts for use in later works.

2 Placing a second colour over a first, while the latter is still wet, can produce exciting results.

3 Occasionally this wet-into-wet technique results in a muddy mess; but the enjoyment experienced and the discoveries made through your experiments are, initially, more important than achieving a perfect result every time.

4 Experience will tell you how much time to allow between applications of colour to achieve a more controlled result.

Inks

For single-colour work, a good quality calligraphy ink can be used. These inks are specially formulated, are waterproof, and have good permanence. They provide a substantial finish to the calligraphic stroke.

Drawing inks, available in many brilliant, transparent colours, require no mixing, although they can be mixed with each other. Being ready to use, they are a good choice for practice strokes and roughing out colour areas, either in text or decoration, even though the final work may be executed in another medium. The fluidity of the inks makes them ideal for this purpose, and they can be used directly with nib, brush or ruling pens (see RULES).

Concentrated watercolours or dyes are mediums that give a very bold finish and can be used direct from the container or diluted with water.

Paints

Watercolour is the medium most frequently employed by calligraphers. Individual preference dictates whether to use paint from a pan, cake or tube. These colours, which need to be mixed with water to create a workable consistency, readily mix with each other to furnish an extensive palette.

Watercolours provide a luminous effect. The principle of watercolour work is that the light comes from the substrate – usually white paper. Layers of colour can be applied separately, overlapped or built up one on another. This must be done carefully with fresh colour to benefit fully from the effect of these pigments.

Designer's gouache

provides a superior source of solid colour, not obtainable with translucent watercolours. The opaque colour sits on the substrate and light is reflected from the painted surface, so white or coloured paper can be used without fear of losing the vibrancy of the paint hues. Water is used to thin and mix gouache and does little to diminish the brilliance of the colours. Colour can be laid thinly as a single layer or be strengthened by painting wet into wet, or colour mixes can be made in the palette.

Applying colour

When working with any colour system, always mix more than the job will require and keep a note of the colours you use and their proportions in the mixtures. You will need to practise mixing colours to a good working consistency so that the paint flows in a manner that will achieve the intended results.

Do plenty of rough workings and test the substrate for absorbency. Always have an offcut of your selected paper or board to hand on which you can test the colour, for both consistency and colour match. Mix the colours well, check that you have the required colour, and keep on checking and stirring so that the colours do not begin to separate out.

There are two agents that you can use to improve paint consistency. The first is gum arabic. Most designer's colours have this as an ingredient. It aids the handling or flow of the paint and slightly increases the gloss of its finish. The other agent is ox gall. Both agents improve the adhesive quality of the paint. When using gum

Preparing to use paint with a nib
The paint is prepared in a palette. Water is carefully added with a brush or eye-dropper so that the paint does not become too thin. It is always advisable to test for consistency and colour match on a scrap of paper. Use a brush to transfer a small amount of the paint onto the nib.

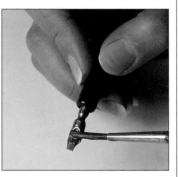

Using a nib
1 Hairline extensions to letters are often easier to form with paint than with ink. This is because paint takes longer to dry and so enough residue of liquid is available to pull down with the corner of the nib. Load the nib carefully with a brush, then check that it is not overloaded before starting to work.

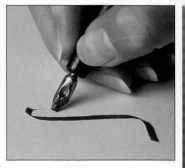

2 When executing fine lettering with paint, the nib will require frequent cleaning. This is best done between letters to prevent clogging and to maintain the crisp edge required of the lettering style.

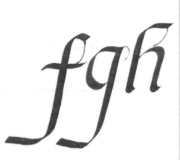

3 When working with colour, care must be taken to maintain an even distribution of colour tone, unless an irregularity is being exploited. The hairline extensions are made by lifting the nib, and dragging wet paint with one corner of it. This can be easier to achieve with paint than with other media because paint takes longer to dry. A pool of liquid, ready to be pulled into an extension, remains at the beginning or end of the stroke for longer.

arabic or ox gall, add them to the paint mix very carefully and only one drop at a time. Use a toothpick or matchstick to apply the drops, not a brush.

If you are using a pen, load the nib with a brush, then check that it is not overloaded either by flicking the pen (well away from the final piece) or by writing a small stroke on a scrap sheet.

Working with paint, in particular, necessitates cleaning the nib or brush frequently. This should become a habit and be done even if the tool does not seem to require cleaning. It is better to do so before a disaster mars the work.

When the medium is mixed with water, the liquid tends to collect at the bottom of the letter strokes. This may be the intention, and can be exploited to the advantage of the work. However, if this is not what is required, you need to lower the angle of your work surface towards the horizontal.

Understatement, deliberately limiting the amount of colour, can result in a superior finished work as compared to a piece where colour is overstated and the impact is lost. Colour intended to provide contrast and draw attention to the work must also supplement it; but if the lettering is not well executed, the colour cannot save the work.

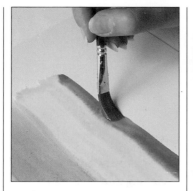

Preparing a coloured ground
1 Although most calligraphy is done on white or cream paper, a coloured ground can often add an extra dimension to a work. To create a delicate wash of colour, use thinly diluted watercolour paint applied to pre-dampened paper with a broad flat brush. Colour-washing works best on heavy or absorbent papers. Be sure to mix plenty of paint so you don't run out half way through, and apply the wash quickly to avoid streaks and runs.

2 Allowing different drying times between the application of adjacent colours will permit some of the colours to merge into each other. In well planned and more complicated works, this can add background interest and suggest visual ideas that can be exploited.

3 Make sure the paint is absolutely dry before attempting to write on the sheet.

▶ JOHN SMITH
The choice of a dark coloured paper adds an extra dimension and depth to this work. The gouache, with its excellent opacity, sits well on the coloured ground. The contrasting colours used for the words by P B Shelley work well together, especially in their arrangement of broken lines. The grouped lines, with colour overlapping, add movement to the work, designed to a circular format and transformed visually into a spiral.

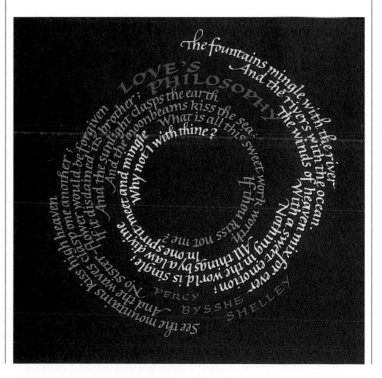

COMPOSITION

Calligraphic design is design of a very specific nature, either predominantly or wholly concerned with the visual arrangement of words. Numerous decisions contribute to the production of a harmoniously arranged work. Some solutions present themselves quite readily, while others are of a more quirky nature.

It is advisable to develop a personal checklist of design elements. This will be of enormous benefit, as there are so many considerations that have a serious effect on the final work as a whole. Some resolutions become automatic as your working knowledge develops. If the work is for a client, it is possible that many of the ingredients of the design have been specified already.

Give your attention first to the text or copy. You must establish a measure of familiarity and understanding while building a feeling for the words as you read them through. Ask questions as the reading proceeds: what is this about, who will read it, what is important, will it be held or read at a distance?

Some solutions come immediately into focus from the reading, including the purpose and conditions in which the text will be read. In the early stages, you may have ideas about embellishment – it becomes more obvious whether the text is suitable for FLOURISHING, or should have a BORDER, or bullet points for highlighting specific and important information. At this stage, such thoughts are merely conjecture and may change, but your first impressions are worth noting.

Next, pay attention to the lettering itself: the height, weight and style must be determined, and also whether some or all of the letters might be executed in colour. In answering your earlier questions, you will already have eliminated some letter styles. From the choices remaining, you can attempt to match the mood and inference of the words.

Deciding on the right style for the work is very important. It should be appropriate to the function of the piece: for example, a complicated Gothic hand or overtly flourished letters would be a disastrous choice for a public notice in which immediate legibility is essential.

Remember that you can introduce emphasis with a change to the weight, height and colour of the lettering. For example, a heading written in bold upper case letters in colour will contrast well with a text written in smaller upper and lower case letters of the same hand in black. This could make a better design than combining two distinct letter styles. Some changes of height and weight also create texture and introduce movement.

The size of the finished work may be predetermined. If it is not, you must focus on the format and dimensions of the piece. First, is it to be landscape or portrait or square? Perhaps it is to be reproduced for an item that will be sent through the post. What sizes of envelopes are available, and is the work to be folded?

The choice of a particular paper or board can often be resolved by the nature of the words to be written. If this is

not the case, follow basic rules for selection. Look for colour, weight and surface finish that will complement the calligraphy. All the materials you use are of great importance. The paper should enhance the work as a whole, but it must also be a sympathetic surface for the chosen medium.

Putting together all of the decisions made thus far, you can now proceed with rough workings. The arrangement of words on the page is further explained in LAYOUT. Do lots of roughs, nurture the ideas and learn to trust your intuition. Do not throw away any scribbles: ironically, the first working is often the best solution.

2 The landscape shape is also a rectangle. The long sides are on the horizontal. Work can be placed anywhere in the space. Try experimenting with different layouts, both symmetrical and asymmetrical.

3 The square is the third shape in this group. Work can be arranged to dramatic effect within this geometrically regular figure.

1 The final presentation of a calligraphic work can affect how well it is received. One of the first decisions you will need to make concerns the overall shape of the substrate on which the work is to be executed. There are three recognizable shapes to choose from. The first is referred to as portrait. This is a rectangle with the long sides running vertically. Work can be planned to occupy any space within this area; it does not have to be centred.

COPPERPLATE

In the sixteenth century, the quality of rolled copper sheeting supplied to engravers improved dramatically. Lettering engravers were finally able to work with their burins on a surface comparable to the paper or parchment used by scribes. Inspired by, or envious of, the new-found freedom expressed by the engravers, scribes abandoned their broad square-cut quills for flexible, pointed nibs. A fine cursive writing emerged; it could be rapidly written, dispensing with the need to lift the pen off the paper except for punctuation and word and line breaks. The result was elegant lettering that flowed across the page.

A pointed flexible nib responds to the pressure placed on it by the writer. A major feature of copperplate is the slight swelling of the downward strokes. This is acquired by applying a modicum of pressure to the pen as the stroke is made, thus forcing a little extra ink to flow through the now slightly separated point of the nib. Similarly, by releasing almost all the pressure on the upward stroke between letters, an extraordinarily fine line is achieved.

Other readily identifiable characteristics of this hand are the occasional looped ascenders and descenders and the graceful, flowing forms written at a slant of 54°. It is extremely awkward to write beautiful copperplate without the correct equipment – either a pen with an elbow-angled nib, or an angled nib holder. The angle of the nib or holder provides the slant.

The improvement in engraving techniques coincided with increased levels of literacy that had developed after the advent of printing from movable type. People wanted to write and in response to this interest, scribes prepared instructional copybooks. These were printed from metal plates, incised by engravers who executed exquisite, fine lines that flowed and flourished, with an amount of decorative ornamentation.

Copperplate lends itself to ornamentation, particularly energetic flourishing. If you look at old manuscripts written in any of the numerous cursive scripts, you will find grand pieces of penmanship rendered almost illegible. Here are beautifully executed letters disappearing in a subterfuge of ornament.

Copperplate became associated with more than handwritten lettering and printing. The lettering engravers exercised their art on items made of, for example, precious metal. Other craftspeople followed suit. Glass engravers, clockmakers and metalsmiths acquired the elegant hand for their own purposes.

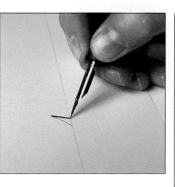

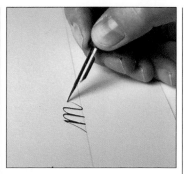

1 The letter shown here is being written with a fine straight nib. The letter begins with a hairline stroke, made with virtually no pressure on the nib so that it glides gracefully over the page. Gentle pressure is applied to the first vertical stroke, which finishes with a square end.

3 Unlike the first two vertical strokes, which finished with a square end, the final stroke curves round into a hairline. This hairline is usually extended and becomes the first stroke of the next letter.

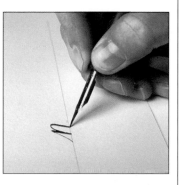

2 The second vertical stroke is preceded by another fine hairline stroke. Observe where the hairline leaves the first vertical stroke. Notice the shape of the white space formed by these two strokes.

Copperplate alphabet

This elegant script is composed of four basic strokes. The first is the hairline which begins most of the letters. There is a further hairline which serves as a ligature to join the letters. There are some strokes which have square ends. The final stroke to consider begins and ends with a hairline but swells in the middle as pressure is applied to force more ink through the nib.

The letters can be written with an elbow-angled holder or nib, or, with practice, a fine pointed nib. The slant of the writing is 54°, giving fine and flowing lines. The looped or flourished ascenders and descenders are generally of a greater length than those which finish straight.

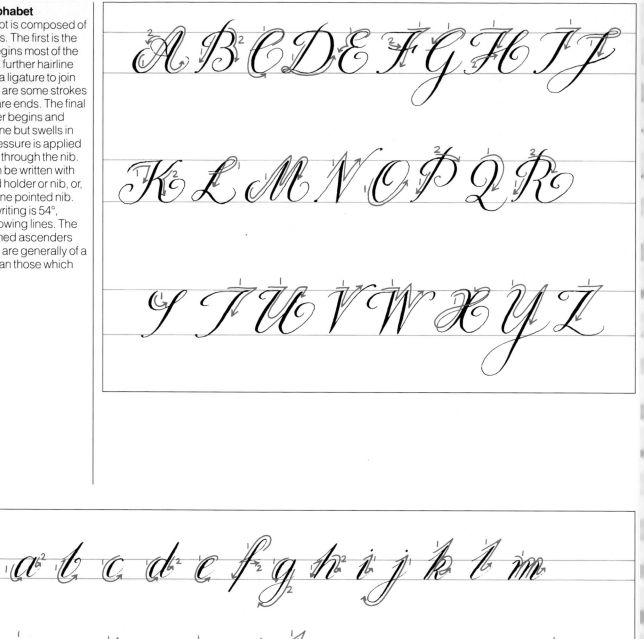

DECORATED LETTERS

In the early centuries AD, the papyrus roll was supplanted by the codex, a form of book made from folded sheets of, usually, animal skin. Initially, the purpose of the codex was to be read aloud and the scribes would insert simple marks to indicate text divisions. In time, the manuscripts acquired a more revered status and their appearance became important. Gradually coloured letters were included as a device to signify headings, new chapters and changes in the text.

The interest in appearance soon resulted in the initial letters being richly embellished and decoration being added. For a time the scribes were also the artists. Close study of their manuscripts reveals some individual characteristics in their work. But before long other craftspeople, including rubricators and illuminators, joined the scriptoria (writing rooms) and took responsibility for their own tasks.

This method of working, with individuals writing, illustrating and decorating by hand, continued unchanged until the advent of printing in the fifteenth century. Soon after, printers began to use wooden blocks for mechanically reproducing decoration and illustration in their books.

The calligrapher today pursues the art of the decorated letter in much the same manner as did the medieval monks. Studying examples of the early decorated letters is an immensely pleasurable experience that reveals a rich source of ornamentation. This is the best route to follow if you wish to understand the nature of calligraphic decoration and discover how to apply your own ideas.

Three main methods of decorating initial letters can be observed. Each involves one or more of the following elements of design: dot, line, shape and colour. The first method is simply to fill in the letterform; the second is to add decoration; in the third method, the decoration forms the actual letter. Many of the early decorated letters were so heavily ornamented that they became, through the distortion, unrecognizable. Other letterforms, in which decoration was applied both to the letter and the surrounding area, completely dominated the page.

When introducing a decorated letter to a work, you need to establish a relationship between the text and the initial letter. Sometimes this can be done by introducing a border, using an element in the same ornament style as that adorning the letter. In some extreme cases, the entire initial letter and accompanying decoration form a border on the left-hand margin. Occasionally, the motif continues across the top and base of the body of the text.

The decorative elements should reflect the nature of the text – the meaning and intent of the words. The most basic embellishment can be made from dots, simple patterns and coloured shapes. If no particular images occur to you, think of things that stretch and twist, can intertwine and suggest movement. Many plant and animal forms fall into these suggested categories. Use good reference material for

Letters can be constructed entirely of patterns or shapes. Develop your ideas on scrap paper – not on the final piece. For the finished work, lightly draw the letter shape in pencil. Depending on the nature of the design, continue to work in pencil before applying ink or paint so that changes can easily be erased.

the images, even if a measure of distortion occurs in the final form.

The letter shape itself will provide some clues to the nature of the decoration. The letter may lend itself to some distortion – for example, elongation of a vertical stroke or enlargement of a counter shape. An open counter provides a good area for filling in with decoration.

Do plenty of rough workings, as near as possible to the style and size intended for the finished piece. A time-saving method is to take an enlarged photocopy of the letter or letters for decoration, then to lay tracing paper over the copy, on which you work the rough. This saves repeated drawing of the letter and allows a relaxed approach during the exploration period.

Remember the original concept of the decorated letter: it is an indication of something, an indicator to the reader.

There are many situations in which a decorated capital letter is still used, and can be used very effectively. Charters, memorial literature, heraldry, ceremonial certificates, civic and royal documents all employ this device. There are many more personal applications on quotations, poems and special greetings.

ROMAN CAPITALS, RUSTICA, VERSALS, UNCIALS and simply flourished LOMBARDIC letters are all suitable for decorating.

▲ Letters can be decorated by solely concentrating the ornament in the background. Additional ornament to the letter can be in a contrasting style. Here, there are spirals and circular forms on the letter L against a squared background.

▶ A typical initial letter from the Lindisfarne Gospels. The Gospel According to St Matthew begins with letters filled with zoomorphism, interlacing and spirals. Red dots in two rows surround the enlarged letters, and form the basis of the pattern behind the second and third rows of letters.

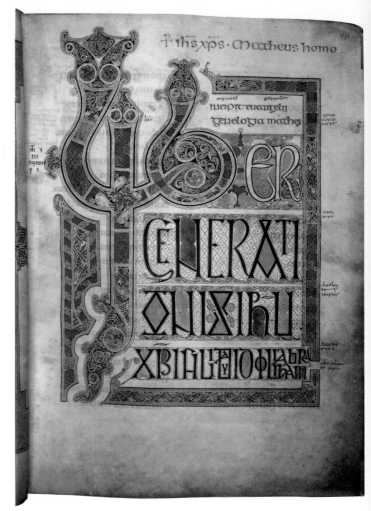

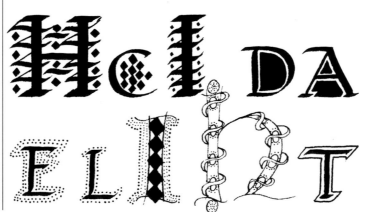

◀ There are no hard and fast rules concerning the addition of decoration to a letter, so there is plenty of scope to be inventive. It is a skill which requires a lot of practice, but the rewards are great. Using the basic components of dot, line, shape and colour, select simple solutions to begin with and then expand, develop and combine different ideas.

DOUBLE POINT

The simple act of securing two identical instruments together introduces you to an adventure in calligraphy and an opportunity to gain a better understanding of letter construction.

Take two pencils, HB or B, and strap them together with elastic bands or masking tape at about 40mm (1½in) from each end. With this inexpensive and portable tool, your lettering immediately assumes an adventurous feel. A double pencil is a splendid instrument for practising strokes and experimenting with new ideas.

Although the two points make a wider stroke than most nibs, the same rules of letter construction apply. Whatever the width of the double pencil, begin by working with the correct proportions of the letters, corresponding to the pen angle, and height in nib widths of a particular style. The distance between the two points can be adjusted by carefully paring away some of the wood along the adjoining lengths of the pencils. It is obviously easier to work with pencils that lie flat together down their length.

The pencil points make bold outline letters that can simply be filled in with colour. They are good models for practice in applying decoration. The freedom afforded by using a double pencil that, unlike the broad nib, can be pushed and pulled in any direction is also a good opportunity to invent new borders and motifs.

This easily manipulated tool is a great asset when you are planning and roughing out a project, particularly if large lettering is to be included in the final work. It is also useful to carry around, to record any interesting examples of visual interplay between letters that you might observe when travelling.

The two-points concept can be applied to other tools. Try chalks or fibre-tip pens, or try combining two different pencil points, such as a B and 6B pencil, two coloured pencils or crayons.

Using double pencils
1 Working with two pencils secured together provides an insight into the construction of letters. The two points are treated as the corners of a broad nib.

2 A completed piece of double-point writing can inform on how the letters are constructed and where mistakes may have occurred. It is easy to read the weight of the strokes and to ascertain whether the distribution is correct.

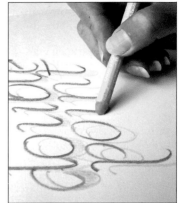

Using double crayons
1 Many different instruments are suitable for linking together to make double points. Experiment with as many combinations as possible. Two crayons glide well over paper and can create a textured letter stroke.

2 The bold outline letters produced with double points provide an opportunity to experiment with applied decoration. Simple solutions of shading and filling-in can precede more imaginative methods.

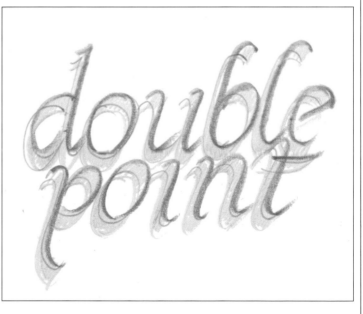

3 The lighter green crayon has been used to fill in the strokes, creating a shadow letter effect. Experiment with different combinations of colour and tone.

DROPPED CAPITAL

For a time, before the development of highly decorated and illuminated manuscripts, single initial letters had been pulled out of the body of the text into the margin. They were often made slightly larger than the letters in the text body and indicated changes in the text, such as verses, or drew something specific to the reader's attention. At first these letters were made in the same colour of ink as the text; later, red, then green and yellow were introduced.

The actual positions of these individual letters in relation to the text varied, but all present viable solutions for the modern calligrapher. In some early scripts, the interlinear spacing allowed the enlarged letter to be fitted within the body of the text without disrupting the fall of the lines. In other cases, letters were placed half in the text and half in the margin, sometimes disturbing the line fall for three or four lines. Some letters share the base of the first line of text, either rising above or dropping below it.

Further variations occur in the actual letter shapes. Letters with a vertical stroke on the right-hand side immediately indicate where and how the adjoining lines begin. Letters with counter spaces created by protruding round shapes and diagonal strokes work best if the lines of text are moved into the counter area.

Unlike the decorated letter, the dropped capital has little or no distortion other than the enlargement of the letter. It can be an enlargement of the same hand as that used for the text. If this is an unsatisfactory solution, you can consider

ROMAN CAPITALS, RUSTICA, VERSALS, UNCIALS, LOMBARDIC or GOTHIC majuscules.

Incorporation of dropped capitals can enliven many calligraphic works: marking each verse of a poem; beginning paragraphs; highlighting names; even, in some pieces, introducing each line of text.

▲ First used by the scribes making manuscripts many centuries ago, this method pulls the initial letter into the margin. The letter is enlarged, and the top of the capital is aligned with the x-height of the first line of text.

▼ An enlarged letter at the beginning of a work, particularly one with no illustrative material, will draw attention to the piece. This letter aligns with the baseline of a line of text, and provides the alignment for the left hand edge of the text.

▲ This enlarged letter is dropped into the text, and in this position it disrupts several lines of the copy. The words are aligned with the initial letter on the left hand side.

◄ Letters can be enlarged and placed in the margin outside the text area. This works very effectively with lists or poems.

▲ Enlarged initial letters with a large or open counter shape, or as in this case with a slanting stroke, can either be surrounded by text, or have the text aligned with the edge of the shape.

▲ These letters are enlarged and dropped into the text. The text aligns with the letters on the left hand side.

FLOURISHING

Flourishing, the ornamental embellishment of a letter or letters, requires some study before it can be used effectively. There are innumerable examples that you can refer to, in books, manuscripts held in museum collections, and the work of engravers on glass or metal. In all these examples, a wealth of challenging ideas can be confronted. Look for common elements and develop a personal working language for flourishing. Make sketches, and, where possible, put tracing paper over the flourishing and trace the flowing lines. Discover the shape formed by the flourishing, what space it occupies, how thick lines cross thin lines and diagonals run parallel.

The most obvious context for flourishing would seem to be as an extension of formal scripts, but this is not its only place. There are plenty of opportunities, but proceed with caution. In learning when and where to apply flourishing, bear in mind that the basic letters of the work must be well formed.

In work that technically could form the basis for splendid flourishing, the nature of the words, or of the job itself, may dictate otherwise. Studying the text together with the guidelines of the brief will quickly reveal whether the work should be treated to a subtle or elaborate amount of flourishing – if any at all. There are occasions when a measure of controlled flourishing is quite sufficient and the result is more effective for the restraint applied. Other situations provide a challenge that should be met with flourishing that is innovative and inventive.

Begin with simple solutions, always remembering that the strokes must be perceived as a natural extension of the letters, not as additions. They should flow freely and be naturally incorporated into the whole design. They should not bump into or obscure the letters of the text. Always plan flourishing well in plenty of rough workings.

Practise with a relaxed arm movement, using whatever instrument feels most comfortable. A fine pointed nib works well. Experiment with taking thin strokes upward and working the down strokes with more pressure applied. Applying pressure on upward strokes has disastrous consequences – the nib digs into the paper and ink splatters on the work.

Accomplished and elaborate flourishing can look wonderful, but needs much study and practice. As you gain confidence, flourishing will become quite a logical extension to much of your calligraphic work. Signwriting, memorial inscriptions, civic documents, certificates, letterheads and single-letter logos, and delicate personal messages all provide potential for flourishing.

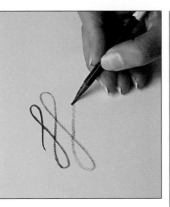

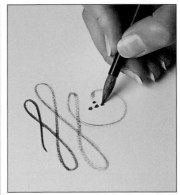

Using a pointed brush

1 Successful flourishing requires practice so that the strokes can be accomplished in a relaxed manner and flow naturally. Flourishes should blend with the work and not appear too contrived. A pointed brush is an excellent tool to assist in developing a rhythmic and fluid style.

3 Flourishing exercises can be interesting pieces in their own right. Here the addition of red dots, made with the tip of the brush, provides a finishing touch.

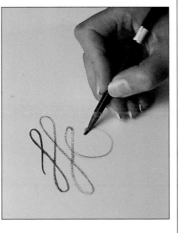

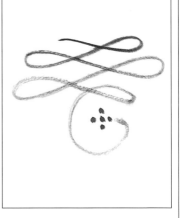

2 The brush moves with great agility to create expressive arcs and lines. Varying the pressure on the brush produces lines that vary from thick to thin in one continuous stroke.

4 Practise making traditional flourishing shapes and simple marks before attempting to apply the lines as letter extensions.

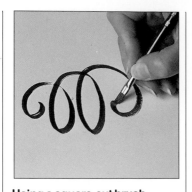

Using a square-cut brush
1 A small square-cut brush will mimic the thin and thick lines of a broad nib but not create too much resistance in its movement.

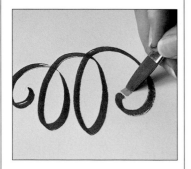

2 A large square-cut brush is used here to add red dots as a finishing touch.

▶ JEAN LARCHER
An exuberant display of flourishing using copperplate-style lettering. The final piece was produced by silkscreening one colour in reverse. The artwork was prepared in black on scratchboard.

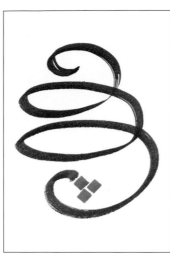

3 Exercises like these will demonstrate how thick and thin strokes evolve, especially when using a square-cut brush. They will also help develop your ideas on layout.

Using double points
1 Employing double points to make flourishes provides an opportunity to introduce letters to the exercises. The double points are treated in the same manner as a square nib, but can be manipulated with greater freedom of movement across the page.

2 Double pencils allow an energetic flourish to emerge and be applied as an extension to a letter. The flourish on the italic h is drawn to resemble a ribbon unfurling.

▼ IEUAN REES
An energetic but controlled flourish which adds great interest and balances the work. Note how the bold lines which form the basis of the flourishing are parallel.

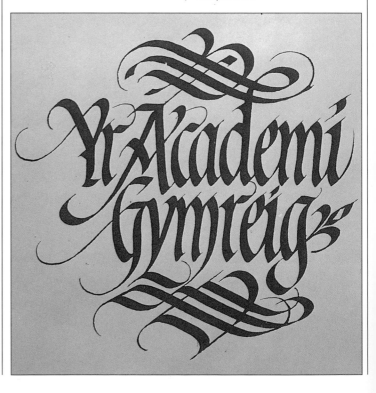

FOUNDATIONAL HAND

The British scribe and designer Edward Johnston (1872-1944) has been largely accredited with the revival of interest in hand lettering and calligraphy During the course of his extended study of early manuscripts, Johnston devised the simply crafted round hand, written with a broad pen, known as the foundational hand.

The best guide to the basic letter shape is the O, truly rounded, as in the early Roman alphabets. The letterforms are upright with serifs. A broad pen held at a consistent angle of 30° produces the thick and thin strokes correctly. The hand is extremely basic and lends itself to a measure of simple and refined flourishing, especially hairlines added to the serifs.

With letters of such roundness, care must be taken with the spacing between them. Minor amendments to those letterforms that specifically create problems can solve any visual inconsistencies that may occur.

The serifs of the ascenders are ideally made in a three-stroke sequence, the third stroke being the actual upright stroke of the letter. The first and second strokes of the serif can be performed in either order: one is a thin slanting stroke, made simply by holding the pen at the prescribed angle; the second a hook pulled to the right and down from the line.

A simpler serif can be made by hooking from the left before plunging down into the upright stroke. The letters finish at the foot of the vertical stroke with a hook to the right. In upper case letters, this appears to be more of a trailing curve.

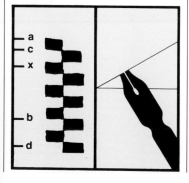

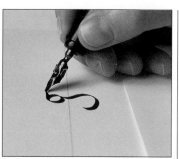

1 The letters of this hand are quite wide and open. Place the pen on the page at the prescribed pen angle of 30°. This is the thinnest part of any stroke. Make the first curve of the bowl of the letter. The second stroke encloses the upper bowl of the g. It should be slightly smaller than the o.

3 The final stroke is an extension from the top of the letter, and executed with the pen at a slightly flatter angle. Pull the flag serif out to the right of the top of the letter to effect the finishing touch.

2 The third stroke is the longer descender, which begins at the lower right part of the bowl. It pulls slightly to the left, before gently curving to the right. The stroke travels downwards and finishes with a slight curving back to the left. It also finishes at the thinnest part of the stroke, which corresponds to the pen angle.

4 The finished letter.

◀ This stroke diagram shows how the letter is constructed. The serif at the base of the first diagonal stroke gives a solid base to the letter. The extension to the top of the letter can be shorter in length.

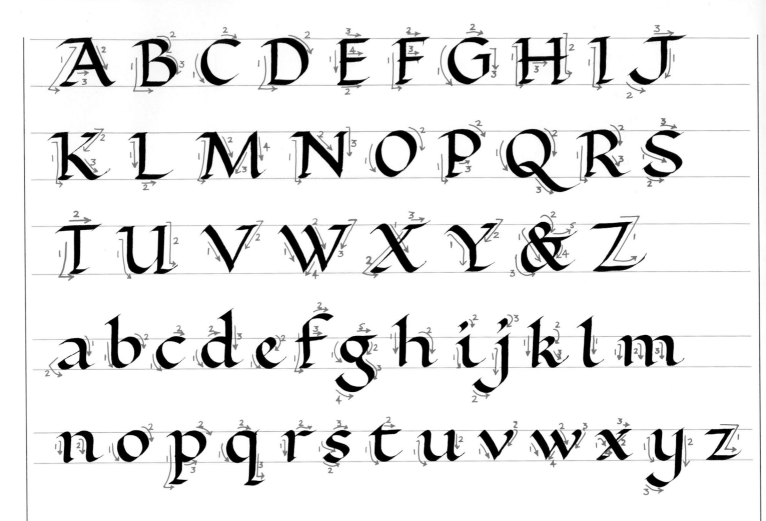

Foundational alphabet

The pen angle for Foundational hand is 30°-40° and a letter height of four nib widths. The lower case letters are based on the circular o. This alphabet requires a considered space between the lines so that the ascenders and descenders do not become entangled. A minimum of double the x-height of the letters can serve as a guide. Keep the letters well rounded and the pen at the flat angle which gives these letters their distinctive look.

In common with many hands, a good rule to follow when learning a new alphabet is to place the letters into groups of related strokes. Thus, in this hand, round letters most closely associated with the o are: b, c, d, g, p and q. A second group which uses a section of the o in their construction is: a, h, l, m, n, r, t and u.

GILDING

There are two distinct techniques of applying gold decoration to calligraphic design. One is the flat method of gilding, the other RAISED GOLD. The true art of illumination stemmed from the practice of applying a medium with a metallic finish that would reflect any surrounding light, although the term also referred to the introduction of any colour in order to draw attention to something in the text.

Many of the finest manuscripts of the past two thousand years are richly adorned with gold. In Greece, where the concept of working with gold may have arrived from the East or from Egypt, there were early references to some of the scribes as "writers in gold". There is evidence to suggest that by the second century AD, Rome was influenced by the Greek example. Gloriously ornate manuscripts were produced solely for the wealthy citizens. The exorbitant cost of materials, particularly gold and vellum, prohibited their use to most people. To make vellum early scribes meticulously prepared the skins of calf, kid or lamb, if necessary staining them to the colour required for the baseground of the manuscript. Sometimes the entire skin would be gilded. This involved many processes including, after the initial washing, beating, stretching and drying, smearing with egg whites, and then more washing, drying, rubbing, pressing and polishing and finally applying gold leaf. Egg whites were usually used as the fixative for the application of the gold.

1 One of the most accessible methods of applying gold to a work is the modern flat method. Begin by preparing all the equipment and materials. Then make a very light pencil outline of the letter to which the gold is to be applied.

2 Gum ammoniac is the traditional compound used as size. PVA, a plastic adhesive, also works well, although it does not have the inherent long-lasting qualities of gum ammoniac. Mix the size with a little gouache and, if necessary, some water. The colour provided by the gouache will make the letter clearly visible on the page. Paint the outline and fill in the letter with the mixture using a small pointed brush.

3 Allow the letter to dry completely. Depending on the working conditions, this could take from 30 minutes to one hour.

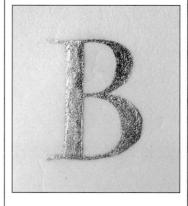

4 Carefully cut out a piece of gold leaf large enough to cover the letter completely. Breathe on the letter to create a tacky, adhesive surface ready to receive the gold leaf. Press the gold down firmly with the thumb, working gently over the area being gilded. Apply a second layer of gold in a similar manner if required.

5 Brush away the excess gold leaf with a soft, long-haired Chinese brush. Burnish the letter with great care using a burnisher made from haematite or agate.

6 The use of PVA will not give the superior quality of finish obtained with RAISED GOLD. However, the method provides a more readily accessible way of applying gold and can produce pleasing results.

The many ancient recipes for preparing to work with gold read like an alchemy instruction book, the only difference being that the scribes already had the precious metal. Other metals were also used, including silver, brass and copper. If none of these were available, a scribe could simulate gilding using tin and saffron.

Great care is required in the application of gold, as it remains an expensive commodity. Gold leaf, or sheets of gold transfer leaf, is excellent for decorating a page with a highlighted initial letter, filling in an ornament or providing a baseground. The leaf must be laid on an adhesive ground. The process of laying gold leaf is very delicate, as it is a fine, clinging material.

The less lustrous powder gold is obtainable loose or in cake form. When mixed with distilled water to a working consistency, it creates a reasonable finish. Gum arabic used as a binder improves its adherence to the page. Powder gold can be applied with a quill pen, nib or brush and is a direct and less complicated medium for gilding than gold leaf. Both types of gold can be burnished when absolutely dry, but powder gold never attains the gleaming surface quality of burnished gold leaf.

Inexpensive alternatives to real gold are naturally inferior in quality, especially in surface finish. Various metallic gouaches, inks and fibre-tip pens are available. These are all excellent for use in rough workings and may in some circumstances be suitable for finished work.

Preparation for gilding

There are two materials that can be used as the size to prepare the surface of a page for gilding. One is polyvinyl acetate (PVA), a plastic adhesive. It consists of resin in suspension in water, together with plasticizers and stabilizers that prevent settling out of the resin. When PVA is applied to a surface, the water evaporates and the resin particles coalesce into a continuous film.

The other size, gum ammoniac, requires preparation. Supplied in solid form, it must first be reduced to fine granules and soaked overnight in distilled water. Next, stir the gum and strain it through a fine mesh of muslin or nylon. Gently heat the strained mixture and strain again. The straining process may have to be repeated several times until the resulting liquid is of a suitable consistency for use with a pen. Any gum not used can be stored in an airtight container.

Before applying either type of size, colour it slightly with some gouache, so that you will be able to see it clearly on the page. Check the work surface is level, so that the size will not collect at the bottom of a letter stem or decoration. You can apply size with a pen or brush.

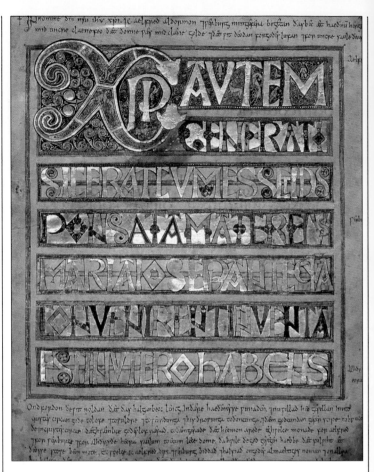

An extravagant use of gilding is displayed on this page from the Codex Aureus. An interesting balance has been achieved in applying the gold alternately to a line of letters, and as a background to the next line. Traditional elements of ornament decorate the page.

GOTHIC

Numerous styles of lettering evolved during the Gothic era, the period broadly straddling the twelfth to sixteenth centuries. The developments in writing reflected changes of style in the built environment, where lancet arches replaced the rounded Roman arches, and ribbed vaults and thrusting flying buttresses appeared.

A variety of Gothic hands emerged sharing many common elements, including a heavy, dense black form, angular letters, rigid verticals and, often, short ascenders and descenders in relation to the height. Sometimes the emphasis on angularity renders the work almost illegible to modern readers. The many variations, both formal and informal, are attributable to the number of people who adapted the forms to suit their own requirements. Often small changes in structure occurred simply through the need for speed and economy in writing. Some rounded versions of Gothic lettering did persist and develop, such as Rotunda. Other Gothic forms practised today are Blackletter and Textura (see below).

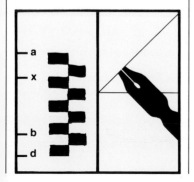

A Gothic hand can be produced using a broad pen held at an angle of 45° and a height of five nib widths. A height of six nib widths achieves a slender letter with more clarity.

A neat, tidy and textured work results from making the white spaces within and between the letters the same thickness as the upright strokes. With due consideration, Gothic lettering can be very effective. To use it successfully, plan the piece carefully and do plenty of rough workings, developing your ability to space the letters consistently. When working on the final piece, execute the strokes with determination.

Originally, there were no specific capital letters in the Gothic forms. Usually, a decorated letter was dropped in, and this worked surprisingly well. The Gothic upper case now used is distinctly open, even rounded, compared with the lower case lettering. The height is seven nib widths. Gothic capitals work best on their own as individual letters. Seldom are they used successfully for an entire word.

In the lower case letters, a square serif is used which sits atop the strokes. In the upper case forms, the same square serif is seen, but more usually sited on the left-hand outside edge of the upright strokes.

Blackletter

Blackletter was born of a need for speed and economy, like so many developments in writing. The style is composed of thrusting, upright strokes that create an overall vertical effect, but the eye can find rest

1 The first stroke of this Blackletter is formed by holding the pen at an angle of 35° and making a fine line diagonally to the left. Almost immediately the pen is pulled down into the strong vertical line. Before this stroke reaches the base line it is stopped, and a strong diagonal stroke is pulled down to the right, and onto the base line.

2 The pen returns to the top of the letter, and rests at the pen angle where the first stroke began. The pen is pulled to the right, beyond where the next vertical line will begin. The vertical stroke that becomes the descender curves out to the right before it reaches the baseline. At about two nib widths below the baseline, the stroke is pulled back to the left, and to the thinnest part of the stroke, where it stops.

3 The final stroke begins with a hairline drawn from the end of the diagonal stroke resting on the baseline. It travels down to the left. To complete the descender, a wave stroke is made to the right, where it joins up with the middle of the descender.

▼ The splendid Gothic S is easier to execute than it appears on first viewing. Breaking it down into its constituent parts to work out how it is made, it transpires that it is constructed of similar strokes travelling in the same direction, as the stroke diagram illustrates.

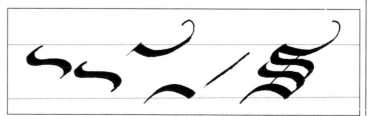

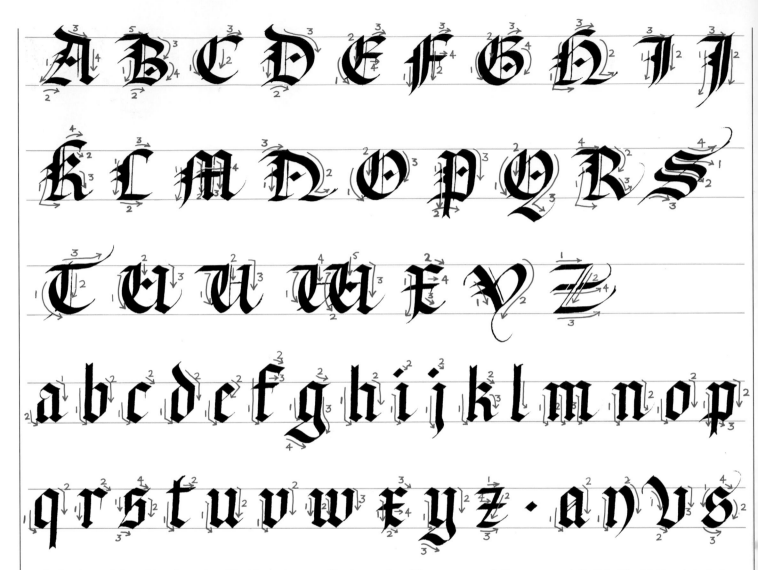

in the horizontals breaking the spaces at top and bottom of the letters.

To write this hand, you hold a broad pen at an angle of 30°-40° to the writing line. The weight of the letter can be varied by adjusting the height between three and five nib widths. The counter spaces, the vertical strokes and the spaces between letters are usually of identical thickness.

Blackletter is exceedingly economical, as constant condensing means more letters per line and more words per page. The spaces between lines can be reduced, and the ascenders and descenders shortened to a minimum to create a very dense texture. This occurs in the version of Gothic lettering known as Textura (see below), which can be seen as pure pattern.

The upper case letters, seven nib widths in height, are not conducive to use in whole words, as legibility becomes a problem.

This Gothic hand works surprisingly well with decorative capitals, and there are many fine historical examples. Contemporary uses for Blackletter occur in various contexts, including presentation documents.

Gothic Blackletter alphabet
The upper case letters of seven nib widths in height have a roundness which contrasts well with the angularity of the lower case letters of five nib widths' height. The distinctive, angular o is a good guide for the lower case letters. The short ascenders and descenders permit tight interlinear spacing.

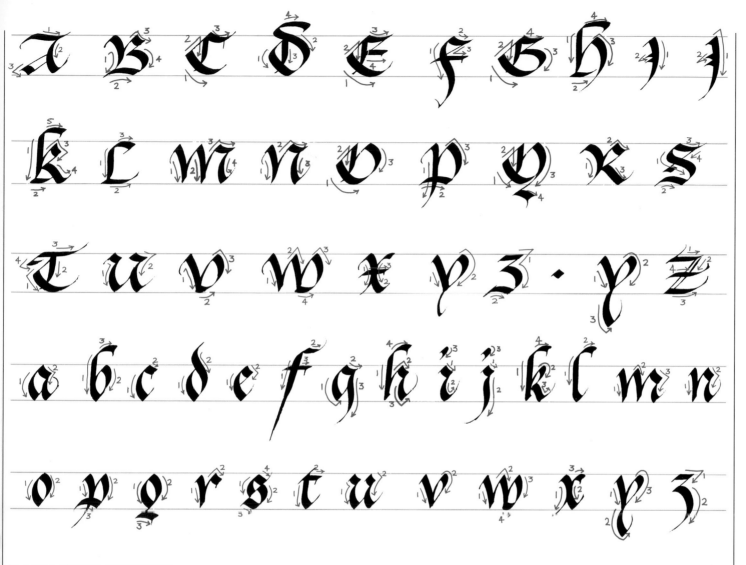

The Gothic cursive upper case A is presented in a shape more recognizable as a lower case letter. The cross stroke, which begins the letter at the top, holds and balances the rest of the letter. The fine lines must contrast with the bold strokes to give this hand its own particular identity.

Gothic cursive alphabet

This elegant hand is perhaps less well known and therefore not widely used. A single upper case letter used with lower case letters can be used for a heading with eye-catching effect. The lower case letters are written four-and-a-half to five nib widths high.

The letters have a distinctive almond (mandorla) shape, thought to have been a Middle Eastern influence. The letters are pointed where they touch the baseline, and some have fine line extensions from this point. Some of the descenders end in sharp fine line extended strokes. The upper case letters are written six-and-a-half to seven nib widths high. Many of these capital letters are more recognizable as lower case forms. It is evident when looking at the lower case letters, that this hand evolved to be written at speed.

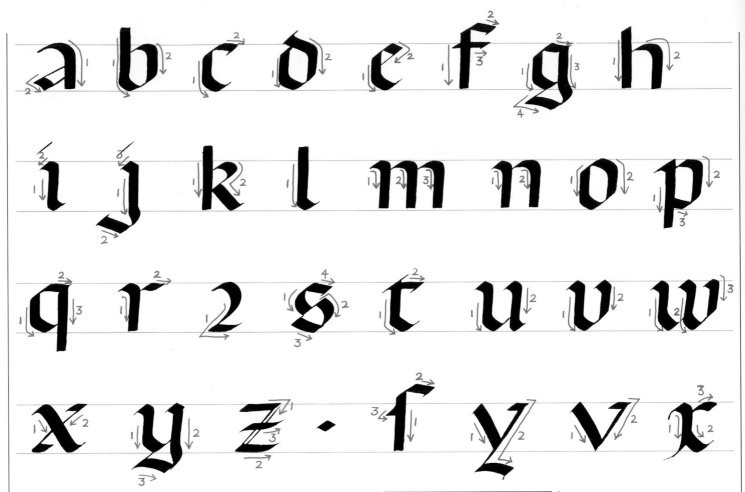

Rotunda (Rotonda)

Variously referred to as Italian Gothic, half-Gothic or round Gothic, this crisp hand was used as a bookhand in medieval and Renaissance Italy. While in northern Europe, the hard, dense Blackletter styles flourished, in the southern countries there was a distinctly softer form, especially by comparison with the compact and angular Textura, a style never seriously pursued in Italy. However, a further comparison with the Gothic hands practised in the north reveals that in the spaciousness of Rotunda there is a slight angularity, particularly pronounced on letters with enclosed counter spaces.

Medieval Italian manuscripts show the form exquisitely. The ascenders and descenders are often minimal, which creates a very even linear texture. The space between both letters and words is often pronounced, but there still exists a balanced letter structure of bold upright strokes and fine, thin strokes. The serif style varied according to the preference of the scribe. Fine hairline extensions are often applied, and many

Rotunda minuscules need practice to obtain the roundness of the counter shapes, and still retain the slight angularity of the corners, so typical of Gothic hands.

Rotunda minuscule alphabet

The Rotunda minuscule is a more open and rounded Gothic hand. The letters are written four-and-a-half to five nib widths high, and with a pen angle of 30° to the horizontal. The letters maintain some of the obvious Gothic characteristics. The ascenders and descenders are short, but the distinctive lozenge-shaped serif is seldom used. Many of the letters have strokes which have square endings. There is a distinct softening of stroke compared to the more familiar angularity of some Gothic hands.

strokes simply terminate with the pen angle. There are a few examples that show the use of the truly Gothic-style lozenge-shaped serif.

The simple, clean letters need to be carefully formed in order to display their pleasing proportions. The letters are written with a pen angle of 30°.

This rounded, open hand was skilfully combined with splendidly illuminated VERSALS. Some early manuscripts include pen-drawn capitals constructed in a similar manner to letters in the body of the text, but they are more rounded.

Textura

This Gothic script, which was mostly practised in northern Europe, takes its name from the Latin *textum*, meaning "woven fabric" or "texture". Used as a bookhand and widely found in early psalters and prayer books, this lower case alphabet developed in many formal and informal styles. Two of the formal hands were *textus precissus* and *textus quadratus*. The former was characterized by strong upright strokes standing flat on the baseline, the latter by distinctive diamond-shaped serifs and forking at the tops of the ascenders.

The Textura hand, as its name suggests, is built of condensed, bold black verticals. These are identical in thickness to the counter spaces and the spaces between the letters. The spacing between lines is minimal, which is ideal for accommodating the typically Gothic short ascenders and descenders.

To execute this hand, you hold the broad nib at 40°. The letter height is six nib widths. Variations in height create further interest in the texture of the overall design.

The letters have a distinct angular stress. Extra hairlines can be added by lifting one corner of the pen at the end of a stroke and dragging a little wet ink outwards to become the hairline extension.

A recognizable feature of manuscripts written in Textura is the line filling. Where a line finished short of the right-hand margin, the scribe would complete the line with exquisite patterning. If the line was short by only one or two letters, a simple flourish or pen pattern would serve the purpose. This is a solution that can be utilized for many design problems. The patterning must pay respect to the lettering style: thus, for Textura, it must be quite solid.

RENATE FUHRMANN
A fine example of Textura – a dense Gothic hand which at its most extreme displays no difference in thickness between vertical strokes, counter strokes and letter spaces. Delicate tonal changes occur throughout the text, which has been written using watercolour. Distemper and wood tar are the other materials used.

HEADINGS

Many factors combine to make a calligraphic design successful. One is the presentation of the work as a whole, and an important contribution to this is the treatment of the heading or title.

The role of the heading is multifaceted. The word or group of words has to attract the attention of the viewer – to the whole work and to the title itself. Having captured the focus, it must allow the reader to read the text. It has, therefore, to stand out and be emphasized in some way. Bold lettering, contrasting colours, good letter spacing and careful use of rules or decoration are all effective devices for catching the eye, but in so doing they must not render the information illegible.

The position of the heading is important. In order to make a visual impact on the reader, the words need to be placed slightly apart from the main body of the text. This does not mean that they stand in total isolation; there are several solutions to creating this space apart from just physically separating the title and text.

The first considerations are the size, weight, style and colour of the letters. Then, although the name suggests that a heading should be at the top of a page, this is certainly not the only place nor, for some works, the best place visually.

The information given by the title is important and must be seen to relate to the whole design. A heading is not an appendage. However, you can experiment with headings in different positions on the page. A single-word title could run vertically down one side of the page. If the text is composed of individual verses or independent pieces of information, the heading could be located in the middle of the page and centred.

Alternatively, it could run across the base of the work, be placed at an oblique angle, or aligned at one side. Look for the solution that offers the most visual impact without loss of meaning.

Study early and modern examples of calligraphy to see how the problem has been solved before. Observe the variety of solutions and do lots of roughs, working thoroughly through as many options as possible. Mark in the body of the text with lines, ruled if necessary, to indicate the area it will occupy, so you can better perceive the balance of space.

If a heading has not been supplied and one is required, you must give careful thought to the wording. The heading should be thought of as a descriptive statement of the contents of the text, expressed both precisely and succinctly.

If you have to include the name of an author, a date or a reference relating to the text, consider this at the same time as the heading. Often it is this important data that can create a balanced feel to the work, Do not neglect it; like the heading, it is not an afterthought.

Subheadings

It was a relatively common practice of the early scribes to include in their manuscripts one or more lines of words with letters of a smaller size than those of the title, but larger than the text. The words would appear below a heading or after a decorated letter. Usually, they simply formed the beginning of the text, on occasions extending to quite a lengthy introduction. The concept can be most effectively employed and often works particularly well combined with a decorated or dropped capital.

Expert scribes used numerous variations of this arrangement and the best way to understand them is to spend some time looking at the manuscripts. Keeping reference notes and sketches of unusual layouts will help you to expand your repertoire.

Although some difficulty may arise in working out the letter size to fit the available space, this practice can make a good contribution to achieving a finely balanced work.

Headings serve many purposes and their design and placing deserve careful consideration. Experiment with different arrangements on the page to find the most suitable and aesthetically pleasing solution. It may be useful to use a grid system to assist in working out the layout of the page. Most printed matter – books, magazines and newspapers – is designed using a grid, enabling the designer to align the work in a clean, legible manner, both horizontally and vertically. Look at some examples and see how the text and images are laid out on the page, often in columns of a specific width. Rough sketches are initially sufficient for working out the position of a heading. Once an idea has evolved, begin to work some of the text into the sketches.

▲ PAUL SHAW
The red words of the title of this work are ranged right, an alignment method that requires good planning. The letters of the alphabet have been placed centrally to the work. Here, they are both an illustration and a heading. The names of the authors are treated as subheads in size and position of lettering.

HUMANISTIC

The flowering of the Italian Renaissance owed much to Humanist scholars. Striving to shake off the Gothic mantle, they created a renewed interest in classical Rome, including the incised Roman letter. The search for a manuscript hand to supplant Gothic and Half-Gothic minuscules, led to the rediscovery of the mass of works that had been produced in the CAROLINGIAN style many centuries before. The Humanists called this *lettera antica* (ancient letter).

Initially the letters were copied most precisely. The ancient hand provided only a lower case alphabet, so the classical ROMAN CAPITALS were also adopted. The scribes of the fifteenth century noticed the inconsonance of the two styles, since one was an incised letter and the other a pen hand. A more harmonious relationship was established by the addition of serifs and small finishing strokes.

This hand, which in real terms had only a short existence, actually serves as a very important link in the history of lettering. It connects Carolingian minuscule with the ITALIC forms that followed humanistic script, which in turn provide the basis for many

of the most classic typefaces in use today. In fact, with the advent of printing in Italy, humanistic writing presented a model that was almost a readymade typeface, now instantly recognized as "Roman" type.

The graceful forms of this bookhand are best effected by using a medium-sized nib held at 30°-40° to the horizontal, with a height for the lower case letters of four-and-a-half nib widths. By maintaining a consistent pen angle, you should naturally develop the right relationship of thick and thin strokes. The well-rounded contours of the letters provide good support for the often exaggerated lengths of the ascenders and descenders.

The upper serif is formed as a small angled stroke that precedes the upright stroke. At the base of the letter, the serif completes the stroke to the right. For the informal version of *cursiva humanistica*, the slant is 8°-10° from the vertical and the round letters are narrowed, almost becoming oval.

The distinguishing features of humanistic manuscripts, as compared to their medieval counterparts, are clean presentation and an absence of excessive ornament. The aestheticism was simply attained through the elegance of the lettering and the overall design.

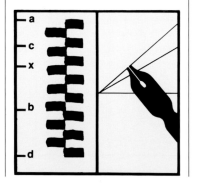

1 The upright version of this hand is executed with a broad pen held at an angle of 35°. The lower case letters are four-and-a-half nib widths high. The first stroke is the long vertical. The pen is placed on the paper at the ascender height of the letter, and pulled down slightly to the left. The strong main vertical stroke is then made.

2 The second stroke begins at the same place as the first. It is a small hook out and down to the right.

3 The final stroke is the crossbar, and it begins on the left of the vertical. The pen is moved to the right across the vertical stroke to complete the letter.

Humanistic Italic alphabet

The Humanistic Italic is illustrated here as an alternative to the more usual upright letterforms. The elegant letters with fine, thin strokes and hairline extensions, particularly on the upper case letters, can be used for a wide range of work. The hand displays a greater emphasis between thick and thin strokes compared with Italic forms. Also, in the lower case letters the thin strokes finish higher up the thick stroke, as shown on the letters a, d, q and u. Similarly, the thin strokes begin further down the thick stroke, as shown on the letters b, h, m, n, p and r.

Pay particular attention to the shape of the spaces enclosed, or bounded by these joins. Where thick strokes become thin and vice versa the change is sharp and angular, compared to the more rounded version of the better known Italic letterforms. The upper case letters sustain the elegance found in the lower case.

▶ The upper case letters are elegant and lightweight in appearance, but in no way lose their sense of grandeur. The thin and thick strokes are balanced by the serifs which end and support them. The first stroke of the M illustrates this well.

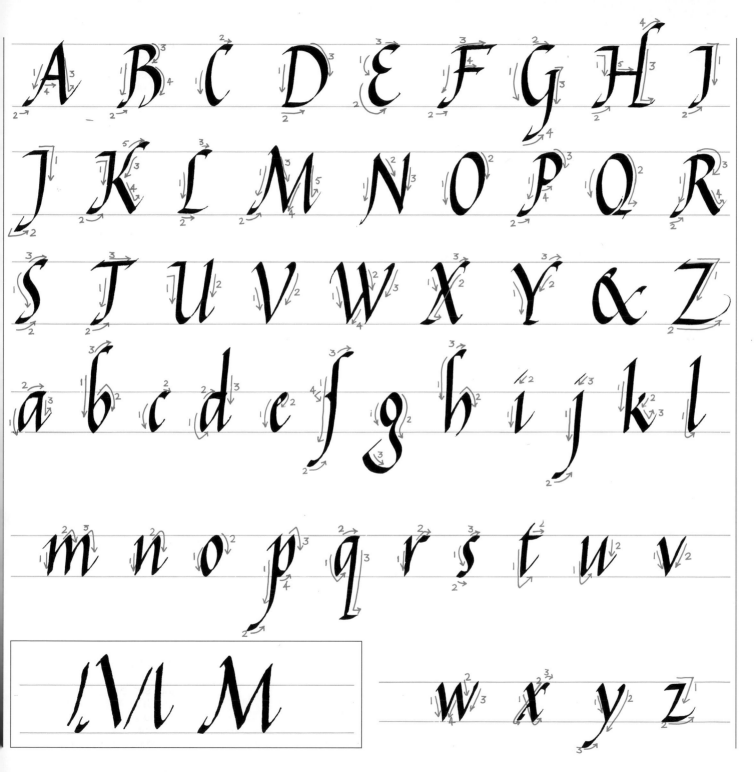

ILLUMINATION

Originally, illumination referred to the simple act of including colour, usually red lead, in a manuscript with the body of the text written in black. This was done to draw attention to a particular passage by identifying the first letter or word of the section in colour. Some minimal colour decoration may also have been used.

In time, the interpretation of illumination expanded to include manuscripts on stained vellum adorned with gold or silver. The letters and decoration executed in the precious metals reflected the surrounding light. Also included were richly ornamented pages displaying a profusion of colour.

Initially, the scribe responsible for writing the text added the ornamentation but, in time, as different aspects of the work developed, other crafts people joined the workshops. However, the illuminator, as the most skilled, became a designer, colourist and illustrator. In great style, illuminators accomplished their task of bringing life to the page.

Illumination is really about the calligrapher's own experience, especially in terms of design sensibility and colour sensitivity. It presents a wonderful opportunity to exploit pattern, from the most simple to the outrageous, as well as colour, texture and pictorial imagery. There are no rules to follow, but you can understand the range of possibilities if you spend time looking at some fine examples of the illuminated page.

Excellent examples of illumination can be found in museums, libraries, art collections and books. To begin to appreciate the intricate nature of these works, make sketches and notes of solutions that appeal to you. Looking at the works can be quite an overwhelming experience, so start by studying one section at a time. For example, select an enlarged letter shape and observe its origins – perhaps ROMAN, RUSTICA, UNCIAL or VERSAL. Is the letter distorted or elongated? Which areas of the letter are decorated? Does the decoration extend to counter spaces inside or outside the letter? Do the strokes and stem of the letter have applied decoration? How has the scribe treated the serif?

Work through the ways in which each of these areas have been manipulated. Observe where patterning is repeated, or identical motifs are employed, sometimes with simple variations. Follow foliage or knotwork patterns and notice the shapes of the spaces they occupy – circular or triangular, for example.

Breaking down a complex design into understandable sections helps to demystify the art of illumination. The same procedure can be extended to borders, margin decoration and the whole relationship of the illumination to the text. At the same time, you can study the quality of the COLOUR work and GILDING to see which techniques might be appropriate for your own illuminations.

Lots of rough workings and colour experimentation are the cornerstones of good illumination. This is an opportunity for great freedom of expression in calligraphic design. Build a checklist of design considerations so you can refer to the options. Basic ingredients are dot, line, shape and colour. Many patterns can be built, for example, based solely on dots or circles. Treatment for an initial letter may include enlargement, elongation, creating a picture that incorporates the letter, applying texture to the body of the letter, or letters made out of patterns, leaves or animals. The same ideas are suitable for counter spaces and borders.

When working out the area to accommodate the illumination, do not ignore the text area. Indicate text with lines in your rough workings and aim towards a balanced look for the final work.

The presentation of a piece of calligraphy can be enhanced by the introduction of a decorated letter. The letter may be very simply decorated, grossly distorted or heavily embellished with marks, lines and symbols, forming ornate patterns. Careful thought must be given to the positioning of the letter in relation to the body text and to the layout of the page as a whole. Some of the traditionally used arrangements are illustrated here.

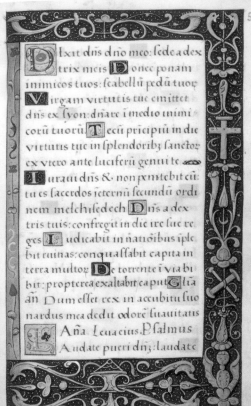

▲ This spread from an early sixteenth-century French Book of Hours has an uncomplicated layout. A decorative border frames the Humanistic script inscribed text, which has minimally illuminated initial letters. The illustration is surrounded by an architectural device in a style common at the time of the Renaissance.

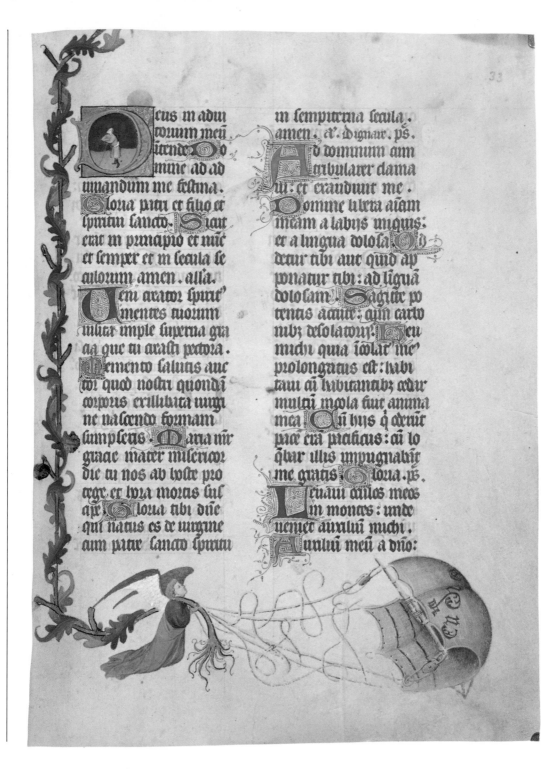

A page from the Egerton manuscript has a refined border on one side which continues off the top of the page. At its base, the foliage border is linked with the illustration, dragged along over the shoulder of an angel. A miniature painting is contained in the counter shape of the first initial letter. Linear and spiral patterns and trailing fine lines decorate the Lombardic versal letters, and the strong influence of Uncial letter shapes is clear.

ITALIC

The Italic hand developed in Renaissance Italy. There was a need for greater speed in writing, particularly for copying large amounts of text. Through studies of classical manuscripts of the ninth century, Italian scholars evolved this compressed and more than usually slanting style.

The compression is based on an elliptical o. The slant is maintained at an angle of 5°-10° to the vertical. The broad pen is held at an angle of 45°, which achieves the characteristic contrast of thick and thin strokes. The hand has simple serifs and ascenders and descenders that can be varied in length. Simple or elaborate FLOURISHING and SWASHES can be introduced as an extension to many letters.

Together, these characteristics constitute a truly elegant hand that, with practice, should retain its graceful proportions even when written at speed. These are the factors that render the formal Italic hand so suitable for use as the basis for many fine handwriting styles in common use today.

The height of the lower case letters is five nib widths, of the upper case letters seven nib widths. Ascenders and descenders are usually about three to four nib widths. A lighter weight can be achieved by increasing the lower case letter height to six nib widths.

Italics work well in many situations. The style is excellent for work that needs to be easily read and comprehended. It has a curious ability to be appropriate in both formal and informal settings. Blocks of text rendered in Italic can be given textural variation by the introduction of another hand, for example, FOUNDATIONAL, for headings and subheadings. With the addition of suitable flourishing, menus, name cards, invitations and certificates can be rendered as designs of character and elegance without loss of legibility. Try not to overdo the amount of flourishing: too much makes the lettering difficult to read and less pleasing to the viewer.

There is plenty of room for inventiveness on the part of the calligrapher, such as experimenting with double letters and connecting letters. The two main connectors are horizontal and diagonal lines. The object is to achieve a join that appears to be a natural extension of the letter shapes.

Another area for exploration, which is sure to arise when you use Italic, is where you find noticeable space between the last letter of a line and the natural end of that line. The piece may not be justified on the right-hand margin, but sometimes too much white space looks out of keeping with the overall design.

Line filling can be approached from two main directions. The first is to extend the last letter: unfortunately, this does not work with all letters. The second approach is to fill the line with a subtle arrangement of, for example, dots made with the broad nib. Consider the ideas explored in BORDERS and you will find some satisfactory solutions.

1 The elegant proportions of the Italic hand are achieved by maintaining a constant pen angle of 45°, and modelling the letters on the elliptical o. The letter g, shown here, shares the same characteristics as a, c, d, e, o and q. The first stroke moves from the pen angle to the right. It is almost a straight stroke and forms the top of the letter.

2 The second stroke begins at the same place as the first. It pulls round to form the first half of the elliptically shaped bowl of the letter.

3 The stroke continues round until it reaches the thinnest part, and then climbs steeply towards the top of the letter.

4 The backbone of the letter is the third stroke, which begins at the top, and plunges down into the descender. The stroke finishes in a slight curve to the left, which becomes the thinnest part of the stroke.

5 The last stroke of this letter starts in the white space to the left of the descender. The small finishing stroke is pulled to the right to meet the slightly curved end of the descender.

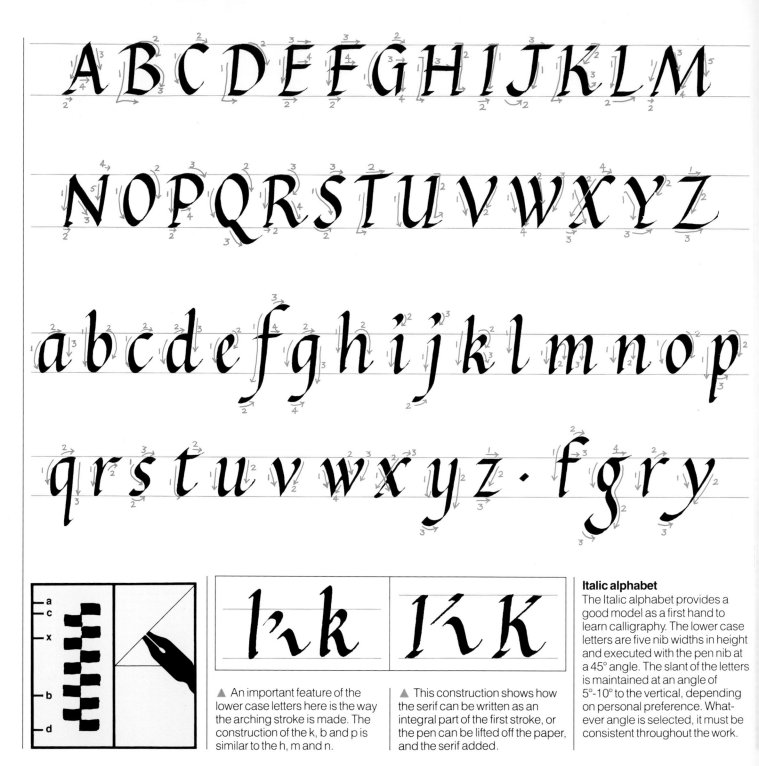

**An important feature of the lower case letters here is the way the arching stroke is made. The construction of the k, b and p is similar to the h, m and n.

**This construction shows how the serif can be written as an integral part of the first stroke, or the pen can be lifted off the paper, and the serif added.

Italic alphabet

The Italic alphabet provides a good model as a first hand to learn calligraphy. The lower case letters are five nib widths in height and executed with the pen nib at a 45° angle. The slant of the letters is maintained at an angle of 5°–10° to the vertical, depending on personal preference. Whatever angle is selected, it must be consistent throughout the work.

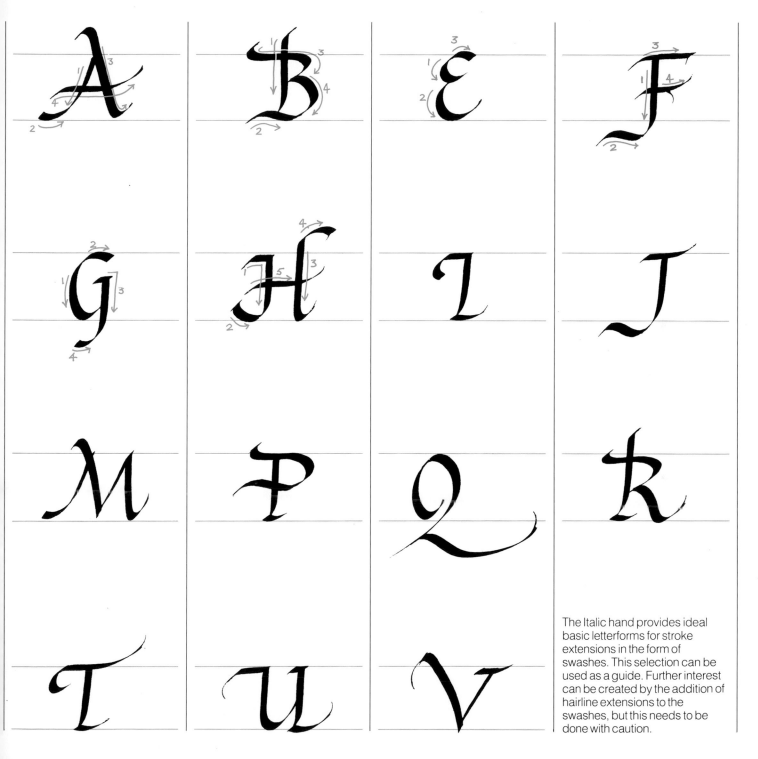

The Italic hand provides ideal basic letterforms for stroke extensions in the form of swashes. This selection can be used as a guide. Further interest can be created by the addition of hairline extensions to the swashes, but this needs to be done with caution.

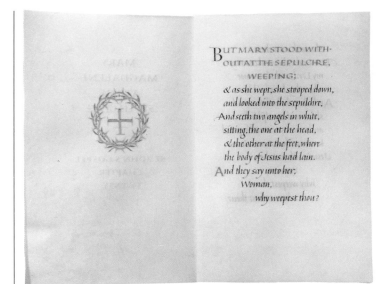

◄ JOAN PILSBURY
These opening pages of a manuscript book display a spacious and well considered layout, with generous margin widths and interlinear space. The story of Mary Magdalen is written in black and green on vellum. A burnished gold letter introduces the words, which are rendered in a beautiful example of formal Italics. (The informal style is recognizable by ligatures which join individual letters, creating the cursive Italic.)

▼ DAVE WOOD
The Italic hand, with its informal and formal styles, has great flexibility. Bolder or more condensed forms can be created by decreasing or increasing the letter height (by varying the number of nib widths). This logo is a speculative design, presented as a possible solution to a particular visual problem. The Italics do not dictate a specific image; they make the design accessible (and in turn the product/client) with a timeless and ageless quality.

LAYOUT

For many calligraphy assignments, there are recognized, standard formulas on layout to be followed. This is particularly so for certain official documents, certificates, ecclesiastical services and invitations. Some other types of work may also be commissioned with guidelines provided by the client. However, planning the layout – arranging the words or groups of words to fit the page, and determining their size, weight and style – will still be necessary.

For all layouts, there are many decisions to be made. In order that nothing is overlooked, a good working practice is to draw up a checklist or list of actions. This may cover the following elements of the work: heading, subheading, text, name of author, date, name of calligrapher, decoration. If the work is an invitation, the list of information includes name, place, date, time, and so on. This list-making, breaking the job down into parts, helps you to determine the visual and literal importance of each item of information.

Scanning the words will provide more valuable information to contribute to the layout and begin to provide answers to questions, such as the following – what are the words about; what style of lettering lends itself to the mood or occasion; who is this for, and who will read it (which may affect size and shape); does it need decoration or colour; what kinds of materials would be suitable; where is the piece to be displayed, and is it to be printed or is it a one-off?

Creating margins

1 The areas of white space surrounding a piece of work are integral to the design of the page as a whole. One method of achieving a balanced and pleasing effect is to calculate the margins in ratios of 2:2:2:3. In this format the margins at the top and sides are equal and the base margin is slightly deeper.

2 A second ratio for calculating margins is 1½:2:2:4. In this case the top margin is narrower than the two sides and the base margin is the deepest.

3 Many contemporary designs include text and headings which are positioned "off-centre" and may have certain elements which "bleed off" the page. These works may have adjacent margins equal or no margins equal.

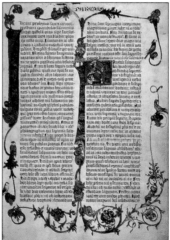

▲ The early typefaces mimicked the letterforms developed over many centuries by the scribes. Gutenberg's 42 line Bible illustrates this imitation, which extends to the layout and decoration of the page.

Margins

The size and shape of the work may not be a foregone conclusion, in which case, you can determine these elements when playing with rough layouts. If the shape is not round, square or irregular, it will be a portrait or landscape rectangle.

Margin widths are an important factor in the design. The relationship of the margins to each other will help to balance the entire work. Generally, equal margins around the whole piece do not work well visually. The two most commonly used options are: sides and top of equal depth and the base slightly deeper; or sides of equal proportion, the top slightly less deep and the base deepest of all.

Visual faults occur if the margins are ill considered. Too much surrounding white space will cause the words to be lost, or to appear to float in the centre of the page. Unless a small amount of white space is an integral part of the design, the words will appear cramped and the work ill-conceived. Mounted and framed pictures in a gallery best illustrate traditional proportioning of margins.

Some designs do abandon a regular and properly proportioned margin arrangement. These are designs in which, for example, the colour or decoration, or a rule, runs off the page. This is called "bleeding off". This is a perfectly valid solution and can be used very effectively in contemporary works. Look at lots of examples in printed matter – such as books, magazines, advertising leaflets

or posters – and identify how other designers have used this method.

Style

When you have determined the importance of the order of the information to be transcribed and have become more familiar with the subject of the text, you may have a preference for the choice of lettering style. If this is not yet the case, read the copy again and try matching a feeling or mood to the words – elegant, gentle, quiet, tasteful, sombre, excited, blunt, outrageous, colourful, and so on. This exercise should also give you initial ideas for the design that will evolve as you sketch out lots of roughs.

Calligraphic design is sometimes tight and controlled, but also has great potential to be extrovert and free. Depending on the nature of the work, subscribe to the most applicable mood. Do not apply rigid layout methods to words that resound with life and energy. Equally, do not take a light-hearted approach to the design for a serious and solemn text. Think of the mood and colour of the words while roughing out various ideas as to how they can be fitted to the page.

On your rough layouts, indicate areas of text with lines, and get an idea of where the line breaks will occur. It is not necessary to transcribe all the words laboriously in early rough layouts, but include some indication of special features such as bold lettering, capital letters, patterns, illustration, bullet marks, borders and rules.

As you work on the ideas,

there should come a time when you feel that the design is beginning to "gel". At this point, working more towards the finished size of the piece, you can include more detail. In turn, this should lead to a finished rough complete with colour concepts and the basic structure of any patterns, borders and illustrative material.

The finished rough provides the model for the final work. A working practice will develop as confidence grows, and some procedures will become more condensed and automatic.

The layout should create harmony on the page and be pleasing to the eye. Nothing should appear jarring. Collect ideas in a notebook and make a cuttings file of solutions that inspire you. Renew and update your file as both design styles and your personal preferences change.

DAVE WOOD
An advertising leaflet aimed at calligraphers. The list of available equipment provides a textural ground, over which an enlarged Copperplate elbow nib is superimposed. This is a successful and original concept: it includes all the relevant information and presents it well.

Letter spacing

Letter spaces are nearly identical, depending on which letters are adjacent. Aim for a balance between the counter spaces of the letters and the spaces between letters to achieve a balanced rhythm to the whole work.

Word spacing

Until you become more familiar with lettering styles, produce evenly spaced words. As a guide, allow the width of an o between words.

Interlinear spacing

Allow enough space between lines of words to ensure that ascenders and descenders do not become entangled. Take particular care if you intend to include FLOURISHING.

Line length

There is no rule that covers all eventualities. In time, you will develop the ability to make a visual assessment based on the proportions of the letters in relation to the proposed size of the work. In some pieces, the longest line will provide the guide for the width of the work. Try out different line lengths by using different nib sizes that alter the lettering size. If necessary, incorporate slight variations in the spaces between letters and words. If a line falls shorter than planned, consider introducing an extended letter flourish.

Letter style

Do not use too many different styles. The advantage of pen lettering is the ability to change the weight and size of the same style to create an impact without introducing another hand.

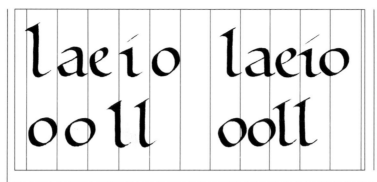

◀ Letter spacing

The style of the lettering provides the clue to correct spacing. Some hands are round and open and dictate a need to allow space for the letters to "breathe". Conversely, straight, angular styles, such as some Gothic hands, demand less space. Too much space can make reading uncomfortable and difficult, but so can too little space.

▲ Word spacing

The width of an o is a good general guide for determining the space between words.

Centring text

1 Many calligraphic works lend themselves to a centred layout. There are several methods of centring; making up a dummy layout is a quick and accurate way. Begin by transcribing the text in the chosen style and size. Write the text with the correct word spacing and in the individual lines that will make up the final piece.

2 Cut out each line as close to the writing as possible. Fold each strip in half so the first and last letters cover each other. The fold marks the centre point of the written line. Alternatively, simply measure the half-way point between the outer stroke of the first and last letters and mark this centre point very lightly in pencil.

3 On a clean sheet of paper lightly mark with pencil the vertical centre line. Assemble the strips and align each fold or centre mark with the pencil line. Tab each strip into position with masking tape. Pay attention to the space between the strips, especially if a final decision on this space has not yet been reached.

Marking up

To prepare the text, transcribe all the words in the chosen style and size onto layout paper. Carefully cut around the words, phrases, titles and so on, and compose and rearrange them on a sheet of paper the same size as the final work.

Alignment or justification

The way the lines fall on the page is an important consideration. There are recognized ways that this can occur. Centred text is evenly distributed on either side of a centre line. Justified text aligns on both left-hand and right-hand margins. Alternatively, the work can be ranged (aligned) left and ragged (uneven) right, or vice versa, or the lines can form an asymmetrical arrangement.

For all methods of alignment, the rough transcribing of the hand and all the spacing requires special attention. If a space is enlarged in the final version, then the line will be, for example, off-centre. In whichever method you employ, use the rough transcription as a guide to check that your spacing is consistent.

Depth

A useful item for ruling up and determining the depth of a work is a depth scale. This provides a practical method of fitting the lines of text. The basic mathematical formula for determining depth in an evenly spaced work is: number of lines of text × letter height + number of interlinear spaces × space height.

Planning the piece

When planning a piece you will need to determine the size of the lettering in order that all the information can be fitted. For a poem or list of items, select the longest single line and use that as a guide when working out the size of the letters. The size of the lettering is determined by the width of the nib, so the words have to be written-out in the chosen style in nibs of various sizes before discovering the size that fits. The examples below illustrate the different line lengths obtained by using a variety of nib, ranging from very broad to fine. Each uses the same number of nib widths for the height of the letters.

Reversing out

Calligraphy, with its strong patterns of black and white, lends itself well to reproduction in print. A work designed for reproduction in black on white, or on a colour, can be given further dimension by reversing out part of the design. This can be done as artwork by hand, but it is easier to submit the piece to be reversed out as finished artwork in black on white to a printer, who will do it photographically in the darkroom. Further interest can be added by having part of the design – a box or rule – bleeding off the page.

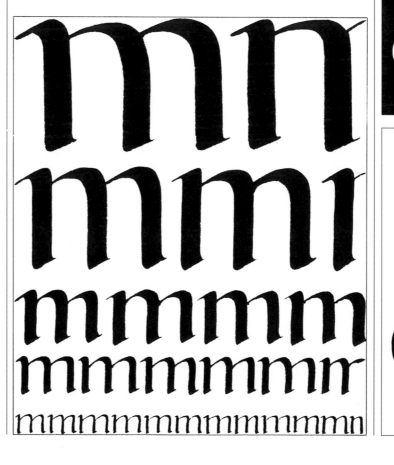

Exploring different alignments

1 An asymmetrical arrangement of lines on the page.

3 This text has lines aligned left and right; that is, it is justified left and right.

Assessing depth

1 A depth scale is a useful item for ruling up and determining the depth of a piece of work. On the edge of a piece of paper or card, mark the height of the letters as determined by the number of nib widths.

2 Calculate the amount of space required between the lines and mark this on the depth scale. To do this, measure the amount from the base line of the letter height. Starting at the same point on each side of the paper, mark off the line depths and interlinear spaces. Use either pencil or the points of dividers and keep the marks as close to the edge of the paper as possible.

2 On this page the left-hand margin is aligned ("ranged left") and the right-hand margin is unjustified ("ragged right").

4 A centred arrangement of lines is a pleasing layout for many calligraphic works.

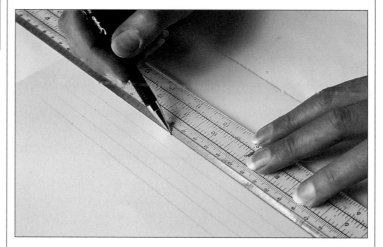

5 Here the "ranged right, ragged left" alignment produces the opposite effect to number 2. This style does not make for easy reading, so is best suited to short pieces of display text.

3 Rule up the writing lines using the marks as a guide. If using a T-square or parallel motion, mark off the line depths on one side of the paper only.

LOMBARDIC

Lombardic letters are a rounded and more elaborate form of VERSAL letters that originated in the Italian region of Lombardy. They show the strong influence of earlier Lombardic scripts and, in particular, of UNCIAL letters.

The letters were primarily used as initial capitals because their shape and structure provided excellent potential for adding decoration and rich ornament. Occasionally, the first word would be executed in Lombardic capitals and some embellishment added. This worked well with the accompanying CAROLINGIAN minuscule.

Written with a fine nib or quill, these letters, like VERSALS, can be filled in with another colour using ink or paint. Many of the letterforms are based on the circle. Some retain the feeling and shape of the Uncial form that they were derived from, particularly in the case of D, H, M, W.

The upright strokes, waisted like the Versal, broaden at the ends before being cleanly finished with hairline serifs. The serifs of Lombardic letters can be slightly bolder than those of Versals and they provide a suitable opportunity for extra FLOURISHING and embellishment. The letters have similar proportions to ROMAN majuscules, and their basic form is circular. To maintain the roundness and attain well-proportioned letters, work to a height of eight to 10 × the width of the stem.

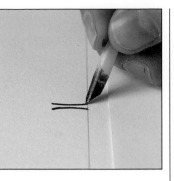

1 The Lombardic is a Versal, built-up letter. As you can see from the start of the downstroke (done here with a QUILL PEN), it is also a slightly "waisted" letter.

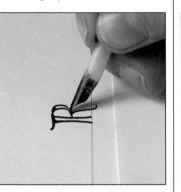

2 The outline is continued, giving a curved serif to the top of the letter, and the second part of the downstroke, continuing into the top curve. The inside stroke is added afterwards.

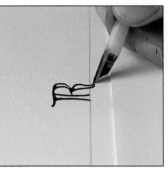

3 Continuing the tail of the letter, the final curve is added with the inside stroke.

4 The outline is carefully filled in with the pen. The bottom serif on the straight downstroke is a single downward curve, matching the width and height of the serif above.

5 Completing the filling-in. This is known as a "drawn" or "filled-in" letter, as opposed to "written". The filling-in can be done in a contrasting colour, and the hand lends itself very well to decoration. It is often used as a DROPPED CAPITAL.

Most letters with vertical strokes should have these slightly waisted strokes constructed first. Append the hairline serifs to the top and bottom of the strokes to enclose the shape, ready for application of colour or decoration. Draw the inner stroke of the counter shape first to establish the correct shape. (This applies to open counter shapes too.)

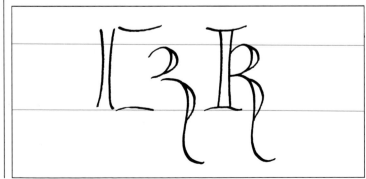

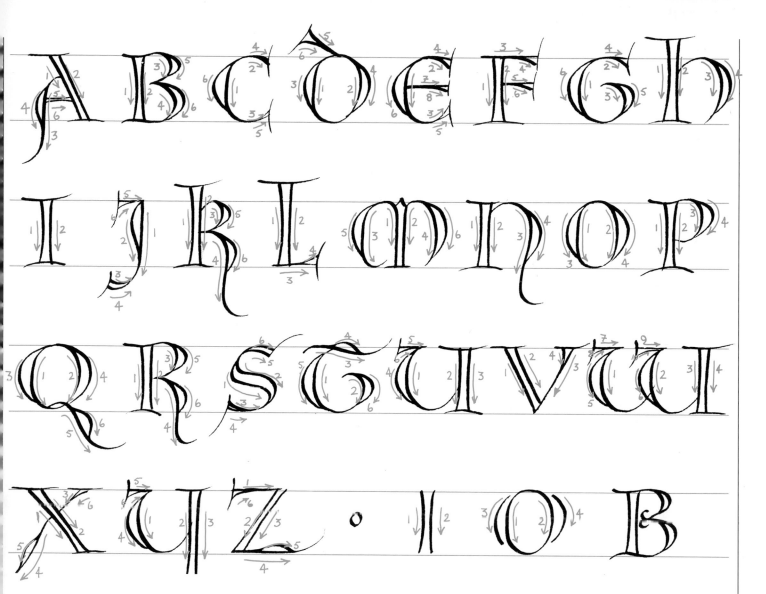

Lombardic alphabet

The influence of Lombardic scripts and Uncial letters is sustained in this version of the Versal letter. This is particularly obvious in the shapes of D, H, M and W. The letters are composed of elegant waisted strokes, and exaggerated hairline serifs. The forms are more rounded than the Roman style Versal, although constructed in a similar manner. Use a quill, metal nib or fine pointed brush, and make the inner strokes first to establish the correct counter shape, before adding the outer strokes. Do not over-emphasize the slight waisting of the vertical strokes – it is very subtle. Use these letters with further embellishment and create exciting decorative letters.

MANUSCRIPT BOOK

A manuscript book made by a calligrapher today may closely resemble one made before the advent of the printed book in the fifteenth century. A basic early manuscript consisted of well-prepared sheets of vellum on which the text was transcribed and illuminated. The completed sheets were folded and sewn through the fold at the back. The threads were fastened to strong strips of vellum or leather and the loose ends of the leather thonging were laced or pegged into wooden boards that formed the book "cover". Often the boards were elaborately decorated with precious metals and carved ivory plaques.

In the same way, the modern manuscript book consists of a cover, endpapers – a board sheet and fly leaf – and the text block. When you decide to make a manuscript book you need to spend time planning it before you actually begin to make it. Assuming that the subject of the book is already conceived and the length of the text has been considered, you must determine the quantity of materials that you will need.

An extremely useful first step is to borrow the working practice of the book designer – the preparation of a page plan, or flat plan. This is essential for multi-section books, but it is most helpful for any style of book and can eliminate costly mistakes. It is in the nature of making a book that if a step is missed, or taken out of order, the processes are mostly irreversible. The page plan is basically a diagram that allows you to plan the order of text and illustration material in sequence page by page.

Preparing the pagination is very easy. For a single section book, rule up on a sheet of layout paper several rows of small rectangles – 5cm (2in) by 2.5cm (1in) is ample size. Divide each rectangle vertically down the centre. Each rectangle represents a spread – two facing pages.

As you plot the running order of the work on the page plan, you can determine how many pages the manuscript book will need. In traditional design of the printed book there is a recognized running order which begins on a right-hand page (recto) with the half-title. The next page, on the left-hand side (verso), is blank or has a visual on it. Following this, the page sequence reads: title, imprint, contents, introduction, chapter one. The start of the first chapter, like the title page, falls on the right (recto).

In a calligraphic manuscript book, the strict sequence of the running order may have to be abandoned for various reasons, but the following is the traditional procedure. On the first page (verso) of your plan, pencil the words "board sheet"; then write "fly leaf" on the recto. The verso of the second spread will be the other side of the fly leaf, the recto will be the title page. Some manuscripts dispense with a title page and open after the fly leaf with an illuminated spread.

Working with the text, continue to map out the page plan, indicating what part of the text content falls on each page and including illustration, blank pages and colophon.

Finding the grain direction
For the book to open well, the grain of the paper must run parallel to the spine. Establish the grain direction by bending the paper without creasing, first along the short side then the long edge. The bend with least resistance indicates the grain direction. Pencil an arrow indicating the direction in one corner of the paper. This can be referred to when folding the text block is completed, to ensure the grain is running parallel to the spine.

2 Still holding the paper, place a bone folder midway along the fold and slide it to one end. Repeat in the other direction.

3 Fold the paper in half again, using the bone folder as before. This gives a smooth fold without creasing or marring the paper on either side.

Folding the text block
1 For a standard 16-page single section book made from one sheet of paper, fold the paper in half holding the edges together, lined up and straight.

4 The second and subsequent folds must be split just beyond the halfway mark. This prevents creasing and distortion from occurring by forcing the folds against air trapped in the section. (The knife shown is a cobbler's knife commonly used in bookbinding.)

Endpapers

Choose a strong paper that complements the colour of the binding; Japanese or marbled papers are suitable. Measure and cut two single sheets of the decorative paper and one sheet of plain (waste) paper to the size of the open text pages. Fold these sheets following the direction of the grain, and place around the text block, waste sheet outermost. Decorative papers must be placed right sides together, so that when the book is opened the pattern runs across the first spread.

Strengthening the binding

The binding can be strengthened by inserting a strip of mull (open-weave cotton), 60mm (2⅜in) wide and 20mm (¾in) shorter than the book height, between the waste sheet and fly leaf, before sewing. This is an optional stage.

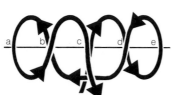

Five-hole sewing

Pages which have been decorated and written on need to be visually aligned and collated in the correct order. Starting at the midpoint of the book, and working outwards from the centre pages, five holes are pierced with a bradawl along the spine. Using thread about two-and-a-half times the length of the book, sewing commences from the centre hole in a figure-of-eight pattern. Follow the sequence c, d, e, d, b, a, b, c. Finish off the stitching in the centre pages, by catching the centre stitch firmly in a knot. Cut the ends of the thread to 10mm (½in) in length and fray them with the point of the needle. Place a piece of card under the thread so the pages do not get scratched. If the threads are left unfrayed, the imprint of the thread will appear on the pages when the book is closed. Weight the sewn book for 24 hours between clean pressing boards and waste paper.

Trimming the pages

1 Unless the design requires hand-torn edges, the pages need to be neatened by trimming. Use

a carpenter's square to measure a parallel cutting line along the fore-edge. Cut the head and tail edges at right angles to the spine.

2 Place a cutting mat or a thick piece of card underneath the book. Trim the edges with a sharp knife held against a metal ruler. Hold the ruler steady and use light firm strokes, drawing through a few leaves at a time. Accuracy is essential, so do not hurry this task.

Cutting the boards

Extra protection is afforded to the edges of the book by allowing the cover to overlap by 3mm (⅛in) at the head and tail. The width of the cover is the same as the text block. Using these guidelines cut two lightweight boards, with the grain direction running from head to tail. Draw a pencil line on both sides of the book 5mm (³⁄₁₆in) in from and parallel to the spine. When the boards are pitched to this line the overhang of the fore-edge will be correct.

Gluing the boards

1 Apply PVA glue to one side of the board, working the brush with a stabbing action. Ensure an even distribution, working from the centre out or from side to side.

2 Offer up the boards to the pencil line, and ensure an equal distribution of the overlap. Repeat the procedure for the second board, and place the book under a weight. From this stage the book can be bound with a quarter, half or full binding. Quarter binding is described overleaf.

Making a dummy

When you have completed the flat plan, introduce another safeguard into your working practice by numbering the pages. Mark the text opening as page one. Then, using the information contained in the page plan, you can make a dummy manuscript. The number of sheets of paper required will be half the number of spreads marked up on the flat plan, since you use both sides of each sheet. Include at least two sheets for endpapers.

Any paper in a size close to that of the intended size of the manuscript is suitable for this task. Fold the sheets in half and clasp them together along the fold (spine) with an elastic band or twine. Work through the dummy, indicating clearly as much information as you feel is necessary. For example, mark the number of columns on the page and the area for illustrative material. When you have completed this, the mock-up should give a good impression of what the manuscript book will be like.

Number the pages of the dummy as it is this, not the page plan, that provides your guide to the pages of the final version. Facing pages on the actual sheets you work on will not be numbered consecutively. It is at first confusing to discover that, for example, in a sixteen page book, the work on page two faces the work on page fifteen.

Materials

For the cover, choose a strong paper or lightweight board and either a decorated paper or bookbinding cloth. The paper for the text block must be suitable for ink or paint, if painted decoration is included. For endpapers, marbled papers have traditionally been used, but you can select any decorated paper or plain cover paper.

Also assemble bookbinder's linen thread or very strong button thread; a bookbinder's needle or medium-sized darning needle; a bradawl; PVA adhesive; paste; a pencil, ruler, eraser and scissors. Other useful tools and materials are mull, silicone, release paper and a bone folder.

Transcribing the book pages

You work the actual manuscript pages on sheets that have been folded, marked up and lightly ruled to give you the guidelines for margins. The dummy pages are your guide for the sequence. Complete all the transcription and decoration of the text pages before preparing the title page. This is best left to last so that it can set the tone for the book.

Bindings

There are many variations of binding styles suitable for calligraphic books, especially different types of stitching; or attractive and simple bindings can be made using ribbons, braids or cords to tie around the folded spine. You can search out different styles and experiment with the techniques of binding. There is an excellent variety of papers suitable for binding manuscripts – machine-made and handmade paper, or decoratively finished, marbled and textured sheets.

Quarter binding

1 On the front and back board, rule a pencil line parallel to the spine and approximately one quarter the width of the book from it. Use a slip of paper wrapped round the spine from pencil line to pencil line to obtain measurements to make a paper template for the covering cloth. Allow 15mm (⅝in) turn-in at head and tail. To attach the cloth mark a line in the centre along its length, and lightly glue the cloth and pitch it to this line. Alternatively, glue the cloth and pitch it to one of the pencil lines on the boards. Carefully draw the cloth round the spine, moulding it to the shape of the book. Rub lightly with a bone folder through a waste sheet.

2 Using the end of a bone folder carefully turn in the cloth at the head and tail. Press the book between boards under a weight. Select a decorative paper and find the grain direction. Cut two pieces to cover the boards with the grain running parallel to the spine. Allow an extra 15mm (⅝in) turn-in at head, tail and fore-edge.

3 Glue one of the paper sides and pitch it to butt against the cloth. Open the book and cut the corners of the overlap at 45°, leaving one-and-a-half times the board thickness. Turn in the head and tail, moulding them well to the board so no air is trapped. Before turning in the fore-edge, nick in the corners where it meets the head and tail. Rub the cover down with a bone folder through a waste sheet. Repeat with the other board and press. Open up the front of the book and insert a waste sheet under the fly leaf. Spread paste on the fly leaf including under and over the mull if used. Repeat on back board. Do not open the book to see if the endpapers have gone down uncreased. Slide the waste sheet out, and replace with silicone release paper or absorbent paper. Leave to dry under weighted boards.

Paper jacket

Follow the procedure for folding the text block. Cut a lightweight

card cover to the height of the pages, and 3mm (⅛in) wider each side of the open text block. Include this cover in the sewing operation. The board can be lined (covered with paper on the inside) before sewing. Select a decorative or strong cover paper and cut it the same height as the book, and 75mm (3in) wider each end than the open book. Lightly fold the paper in half, and wrap around the book. Fold in the flaps of the front and back covers.

Laced style

1 Find the grain direction, and assemble the pages and endpapers for the text block. Select a decorative tape or ribbon and decide on the number of strips, their position and style of finishing. The tapes can be left long and threaded to emerge near the fore-edge, where they can be tied to secure the book. Sew the text block onto the tapes; this means catching the tape in the stitch, not piercing through the tape. Each stitch begins and finishes on either side of the tape. Lightly press between weighted boards while preparing the cover.

2 Cut a lightweight board for the cover allowing a 3mm (⅛in) overlap all round. Choose a covering cloth or decorative paper for the cover, and cut enough to cover the board with 15mm (⅝in) turn-in all round. Glue the covering material and fix to the board, cut the corners at 45° before turning in the edges. The inside cover of the board can be lined with decorative paper. This is necessary if the endpapers are not going to be pasted to the board. On the inside of the cover mark the position for the slots through which the tapes will be threaded. Begin at least 12mm (½in) from the spine. Score the slots with a sharp knife held against a metal ruler.

3 Very carefully manipulate a sharp chisel to complete the making of the slots for the tapes.

4 Fix a small piece of masking or adhesive tape over the ends of the tapes to be threaded. This will aid the threading process and prevent unnecessary fraying. Thread the tapes through the slots, systematically working away from the spine. In this style of binding the tapes hold the text block to the cover board, so they need to be firmly threaded and not move about in the slots.

5 When threading the tapes work them through the slots very carefully, and keep checking their progress on the outside of the cover.

6 When all the tapes are threaded, the endpapers can be pasted down to the inside board of the cover. This will not be necessary if the board has been lined. Open the front cover, and slip a waste sheet below the fly leaf. Spread paste evenly on the fly leaf, remove the waste sheet and close the book. Repeat with the back cover. Without opening the book more than 6mm (¼in) slide silicone release paper between the endpapers. Place the book between clean pressing boards under a weight.

MARKS ON PAPER

For work in any visually creative area, time and space need to be made for pure experimentation and discovery. Activities that simply allow you to play with techniques and explore ideas are an important feature of creative development.

You may get ideas and inspiration in any place and at any time. You must find time to see if any of the ideas work. This is an opportunity to break the rules and have some fun. Unusual colour work and exploration of textures and letter shapes can provide additional "vocabulary" for your calligraphy. The following ideas are selected to provide a springboard for your own experiments.

Sponging

A sponged ground can be used solely to provide a decorative finish, as a border or base on which to write. You can make a textured ground of one or many colours.

You can also experiment with leaving different periods of drying time between colour applications. Sometimes, if you put a wet sponge on an already wet surface the result is a very muddy colour mix. You will get a better effect by allowing a little more drying time. With care, a very delicate colour can be laid over a stronger tone. You can even add gold or silver to create a rich finish.

Some sponges have a finer texture than others, and the coarseness of the sponge may be relevant to the decorative effect you wish to achieve. Rinse and squeeze the sponge well between applications of different colours.

Wet into wet

This technique simply involves working one colour over another while the first is still wet. It can be applied to letterforms or background colour. There is an element of accidental mixing that can result in an interesting fusion of colours, but you can get a measure of control by planning the colour sequence carefully. The work surface needs to be flat to prevent the pooling of liquid at the base of the work.

Unusual tools

Experiment with making marks using found or made objects. For example, cardboard, balsa wood, dowelling, twigs and feathers are all "tools" that can be dipped in ink and used to draw letterforms.

Consider the finished texture that the material may produce. Balsa wood, for example, is relatively absorbent and the paint may begin to dry out as you move the wood across the page. This can result in a similar finish to that obtained by working with a large brush.

Try different mediums on different surfaces, with special regard to texture. If it is your usual practice to work relatively small, try working on a larger format – be expansive.

Masking techniques

The use of low-tack or pressure-sensitive masking tape to mask out areas of the paper can be an interesting challenge. The linear nature of the tape can be exploited – it is available in several different widths – and you can apply letters and patterns across the paper, working freely over the masked shapes. You must remove the tape carefully after the ink or paint is dry.

Masking fluid suitable for use with a pen allows you to mask out letters or words very precisely while colour is introduced to the work. The fluid can be mixed with water to improve its flow through the nib. The masked letters can be coloured, shadowed or left open when the masking is removed.

Sponging

1 Paint for sponging should be neither too thick nor too watery. The best sponge to use is a natural (marine) sponge; it is more pliable than a synthetic sponge and its irregular texture produces more interesting patterns. Soak the sponge in water, then squeeze it out until just damp (do not wring). Brush a thin layer of paint onto a palette or a piece of paper or board and dip the sponge into the colour. '

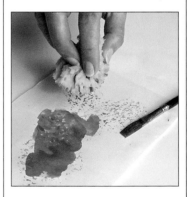

2 Start by making some test prints on scrap paper. If there is too much paint on the sponge it produces a wet, over-heavy print, so keep dabbing until you get a soft but well-defined impression.

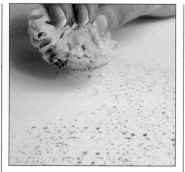

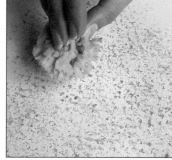

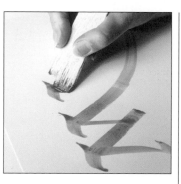

3 Apply the colour to the writing surface using a light, deft dabbing motion. The sponge should make contact with the paper, leave a mark and be lifted straight off – do not drag it across the paper or press too hard.

5 Interesting colour effects can be achieved by sponging with two or more colours. In this case, keep the first sponge prints fairly well spaced out. When these are dry, fill in and partly overlap with prints in the second colour. Alternatively, sponge the second colour on while the first is still wet, to produce softer, more blurred patterns.

Using found objects
1 Apart from the normal pens and brushes, creative possibilities are offered by all manner of objects, both found and made, for use as writing implements.

2 Here a small piece of wood, found on a beach, has been dipped in paint. The end of the stick naturally mimics the capabilities of a square-cut nib or brush, and letters with thin and thick lines are produced quite easily.

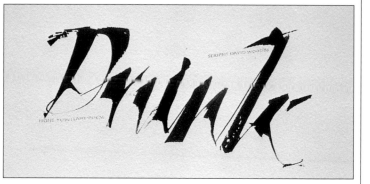

4 If you are using a single colour, overlap the prints slightly for an even, all-over texture. Or you can produce a variety of tones by dabbing more heavily in some areas than in others.

6 Here, blue and yellow have been applied, overlapping in some areas to make green. Light touches of red were then added to create a vibrant, "impressionist" effect.

DAVE WOOD
These letters, with their irregularity of surface texture and quirky shapes, present a complete picture on their own. Successfully creating an evocative quality such as this often comes when experimenting with different instruments and media. It can be difficult to recreate a spontaneous solution on the chosen background for the final work.

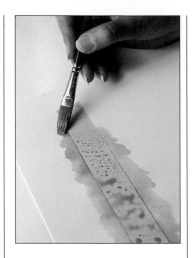

Masking tape

1 To preserve an area of paper with a sharp, clean edge, a strip of masking tape is placed in position, and a colour wash is applied to the surrounding area. The paint-resistant surface of the tape can be painted over quite freely.

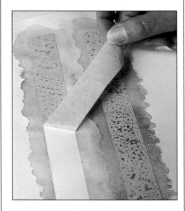

2 A wash of blue paint is applied to the area beneath the first strip. When this is completely dry, a second strip of masking tape is placed in position over the blue wash. Further colours are now loosely painted over the surrounding area. When the paint is completely dry, the first strip of masking tape is carefully peeled off.

3 The second strip of masking tape is removed, revealing the preserved area of pure blue.

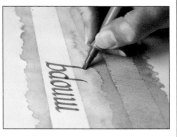

4 The strips preserved by masking are now ready to be written in or decorated. Here a broad fibre-tip pen is used to write letters based on an Italic hand. Ascenders or descenders can cross from the white area to the painted ground, providing a link between the two areas.

5 The finished piece. A broad fibre-tip pen is useful for trying out new ideas. The clean, sharp edges of the nib are perfect for calligraphic work, and the pens write well on a painted surface.

Masking fluid

1 The advantage of masking fluid is that it can be applied in any shape you desire, and it can be used with a brush, pen and nib, or ruling pen. Always wash the writing instrument in warm, soapy water immediately after use, to prevent the rubber solution from drying hard and clogging up the nib or brush. Here a large, soft brush is used to apply the fluid. The brush moves freely over the paper if it is well loaded with fluid.

2 To provide a contrast with the thick strokes made by the brush, a pen with a broad nib is used to add some finer lines at the base of the letter. The nib is loaded in the same manner as if working with paint. There should be enough masking fluid to make a complete stroke, but not so much that it results in flooding.

3 Leave the masking fluid to dry completely, otherwise the paint or ink will seep under the mask and spoil the work. The fluid dries to a paint-resistant film which can be painted over without affecting the paper underneath.

4 When the paint is completely dry the mask can be removed by gently rubbing with your fingertips or a soft, clean eraser and peeling it away. Rub gently so that the surface of the paint area is not disturbed.

5 Letters and shapes created with masking fluid can either be left as hollow shells, or decoration, outlines and shadowing can be added. This technique provides broad scope for experimentation.

NUMERALS

The letters that constitute the western alphabet evolved over a long period of time from the variety of Roman writing styles. For many centuries, the Romans used a numeral system that employed letters – I (one), V (five), X (ten), L (50), C (100), M (1000) – in various combinations to write the numbers. This style persists for specific purposes and is well represented on monuments, clocks, watches and sundials, and in the particularly modern context of film credits.

The Roman numeral system is attractive, but in the Middle Ages came to be considered cumbersome. In western Europe, a new system of enumeration was adopted. The numerals probably originated in the East, but came to Europe direct from Islamic culture. The numbers are commonly referred to as Arabic numerals.

When numbers are included in calligraphy, they need to be considered in terms of the overall design and appearance of the work. They must not be "dropped in", as this can create an imbalance and disrupt the intended harmony of the design. The basic aim is to achieve numerals that blend with the style of the letters and do not disturb the texture of the work.

The height of the numerals is accorded a variety of considerations. They can be contained within the same space as that used for the letters, for example, when used with upper case letters only. This gives a strong feeling of consistency, with nothing out of place. An alternative is to view some of the numbers as containing

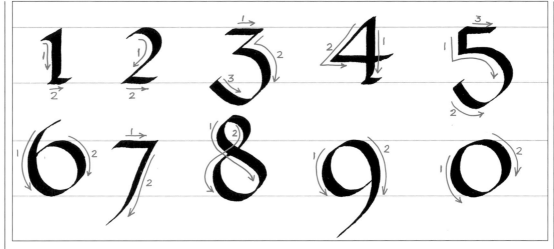

ascenders and descenders. The numbers 0, 1 and 2 are written to the same height as the body of the letters. The remaining odd numbers are styled with descenders and the even numbers are given ascenders.

Whichever concept you follow, the numbers need to be integral to the work, and are constructed along the same lines as the letter style they accompany. This means the same arrangement of thick and thin strokes, the same weight and, where appropriate, the same serif structure. The pen must be turned on some strokes, particularly the diagonals.

▲ Numerals require the same amount of care in construction as the letters they may accompany. Attaining well proportioned figures with a balance of thin and thick strokes remains a priority. The pen angle for these upright numbers can be quite flat.

▼ These numbers show how they can be adapted to suit different styles. A pen angle of 45° was used for these numerals written in an Italic style. The diagonals need to be written with the pen nib at a steeper angle.

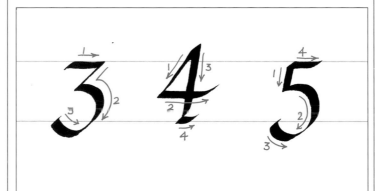

◀ Some designs require numerals which do not break through the x-height of the letters, or which are to be placed beside a line of capital letters. These boldly formed figures will work with many styles of lettering. A more slender version can be constructed by increasing the height of the figures.

ORNAMENT

Changes in artistic style can often be seen as running parallel to social and political changes occurring in particular places and times. The evolution of ornament falls within this pattern of events, reflecting the rise and decline of early civilizations and the interchange of ideas between different cultures brought about by trade, military conquest and religious influences.

An example of this was the development of decorative patterning derived from Islamic silk fabrics. Following ancient tradition, the silk weavers incorporated goodwill expressions in their designs. With the increase of trade around the Mediterranean, the art of silk weaving spread and the Muslim fabrics were copied, including the inscriptions. As the words were incomprehensible to European weavers, the scripts were copied as mere scribbles. Gradually, some of the Arabic letters were put into more symmetrical forms for mechanical weaving, resulting in "mock Arabic" devices.

The Romans, more concerned with expanding their boundaries and creating wealth than with developing an artistic identity, initially took their influences from Etruria and Greece. As their wealth and power increased, they employed Greek teachers and, in time, established their own recognizable monumental works. Roman ornamental style subsequently overpowered that of the Greek masters. The Romans used ornament in a naturalistic manner as shown in their architecture; decorated

Basic methods of arrangement
1 The best starting point for learning to apply ornament is to study the basic construction methods. Simple patterns can be generated on a network of lines crossing each other at different angles. Begin by building patterns along lines placed at right angles to one another and at equal distances (squared paper is useful here). Fill in individual shapes to produce squares and diamonds, and adjacent squares to produce oblongs. Introducing oblique lines that cut across the squares and oblongs produces triangles.

capitals with curling leaves, entablatures with ox heads and lions, rosettes and festoons were all incorporated.

The collapse of the Roman Empire heralded a linking of Christian ideals and the remains of classical art. With strong Byzantine influence, ornamental art underwent a transformation. By the fifth century, the symbol of the cross was included in many inscriptions and provided a base for all-over patterns and the development of the "gammadion" device. The greatest exponents of ornament were the scribes of Ireland responsible for the fine Celtic tradition.

2 To create ornament based on hexagonal shapes, the lines are placed at an angle of 30°, and crossed by vertical lines.

Succeeding centuries saw a flourishing of key patterns, intricate knotwork, spirals, mosaic and geometric patterning. Elements from the natural world were drawn on, including vegetation – both imagined and real – leaves, flowers, palm fronds, lotus, acanthus and vine. Animals were an important feature, making a major contribution to ornament design – dogs, lions, lambs, snakes, eagles, doves, peacocks, fish, and fantastic imaginary beasts. In medieval and Renaissance manuscripts, miniature paintings and detailed figurative illustrations incorporated within the letters reflected the life of the time.

3 Placing lines at an angle of 45°, and crossing them with vertical and horizontal lines, creates octagonal shapes.

Designing calligraphic ornament
Ornament may fill an entire margin, create a border for the text, or a background for a capital letter. Delicate patterns and repeated symbols can complete a line where the text falls short and does not align. The intention in using ornament in calligraphic design is to achieve absolute harmony throughout the entire work and it must be planned in from the start, not added as an afterthought attached to a plain work.

Special attention needs to be paid to proportion and the symmetry of shapes and colours. Begin by including

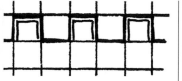

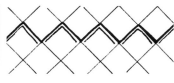

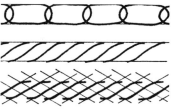

Developing methods of arrangement

1 Altering the lines and shapes applied to the basic network of lines begins to extend the language of ornament. Here the horizontal and vertical lines provide the framework of a pattern used extensively in heraldry known as embattled.

2 Here the lines of the embattled pattern have been curved to create a meander.

simple geometric figures that constitute the basic vocabulary of ornament: square, circle, triangle, oval and lozenge. Introduce a connecting element with lines, chains, spiralling cables, interlacings, zigzags, waves or a running scroll. Repetition of any of these motifs can create pattern areas within the design. More ambitious solutions can be attempted by starting with basic shapes and then including simple motifs from the natural world.

Consider carefully, through rough working sketches, the power of a simple design solution, incorporating selective ornament with an

3 A squared grid, set at 45° to the horizontal, creates the diamond, which is used here as a framework for the chevron zigzag.

4 Using the same network, but curving the apexes of the zigzag, creates the wave.

5 The same network, with the addition of horizontal lines, is the basis for the blunted zigzag and the interlaced patterns.

6 The geometric lines of the zigzag are here rounded to produce the scallop. The interlaced pattern is adapted to produce the scale pattern.

7 The squared network provides the foundation for construction of the fret. This familiar geometrical figure forms the basis of many fine ornamental borders.

8 The spiral is created by rounding the straight lines and sharp angles of the fret.

9 The wave and the running scroll are adaptations of the spiral.

10 The interlacing constructed on the network of crossed diagonal lines can be enlarged to form a double wave or meander.

11 By converting the rectilinear network to one of circles and ellipses, further ornamental elements can be added to your repertoire. These include the chain and cable.

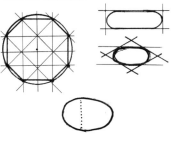

12 The curved series evolves from a softening of the basic shapes. The octagon becomes a circle. The oblong and some proportions of the diamond are altered into elliptical shapes. The ellipse and the circle produce the oval.

elegant letter. Compare this with a fussy and over-embellished design where the strength of the letter shape is diminished.

The size of ornament should relate closely to the scale of writing and size of the page. If the ornament is in a MANUSCRIPT BOOK, the scale should remain consistent throughout the volume. Take care in selecting the ingredients of ornament drawn from the natural world – use a good model. If the ornament is imagined and repeated, be consistent in the repeats: work from a well-prepared finished rough.

Spirals, knotwork, frets and other linear forms require careful attention. The construction methods of Celtic ornament provide the best key to this kind of interlacing. To avoid confusion, complete each stage of the construction throughout the entire design before moving on to the next stage.

Laying out ornament

1 The diagrams on the previous page illustrate some of the elemental forms and lines found in styles of ornamental art, and upon which more elaborate details can be built. The same principle of networks is used here to show some of the methods of laying out ornament. The method shown here involves filling in each square. This is known as diapering.

2 Working on the same squared grid, but omitting alternate squares. This method is known as chequering.

3 Diapering and chequering can be effectively combined to create solid patterns.

4 Employing the same principle, but allowing larger spaces between the filled-in areas. This is referred to as spotting or powdering.

5 Applying the ornament in rows, and leaving some rows void, creates striping. Versions of striping constructed in a narrower vein are called banding.

6 A combination of striping and banding produces another layout, called panelling.

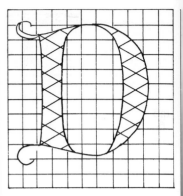

Combining ornament and letters

1 Working with these methods of organizing ornament provides a valuable foundation for illumination and decoration. In this example, the basic squared grid is drawn, and the letter is superimposed. The letter has a network of lines arranged at 30° to the horizontal.

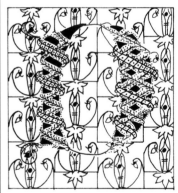

2 Using the arrangements of lines, ornament is applied to both the letter and the base ground. The squared grid provides the basis for a repeat pattern. To repeat this particular pattern, the lateral repetition has been achieved by lowering the pattern to fit two sections together.

Geometric design

1 Fret patterns can be used as borders on their own, or they can be incorporated with ornament, and embrace an enlarged letter. The basic structure of fret patterns can be used as a framework for decoration not composed solely of straight lines. The simplest forms use lines which are all either vertical or horizontal. The distance between the lines is the same as the width of the lines. As with other basic ornament structures, using squared paper will help you to plan your designs accurately. This geometric border is six widths wide, the top and bottom lines are continuous, and the vertical lines are three widths high. Developing this nature of analysis is the best method of understanding how to construct these designs.

3 This pattern, known as the key pattern, provides an excellent example of a design in which the white space is almost as pleasing in shape as the black form. The balance of black and white, or negative and positive, is an important feature in fret designs.

4 The introduction of slanting lines to the framework produces a sloping fret. Here the horizontal lines are retained, but the vertical lines are replaced by lines set at an inclined angle.

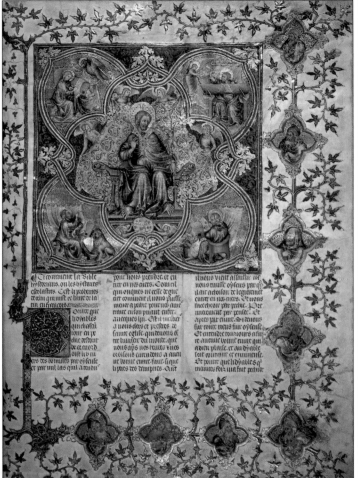

2 This pattern is seven widths wide. It is an expanded version of the first example, with the introduction of horizontal lines. In these patterns the "negative" shapes formed by the ground (in this case the white of the paper) are as important to the appearance of the finished design as the "positive" shapes of the marks made.

5 This is a pattern of interlacing strap work. To build patterns in this style, begin working with vertical and horizontal lines, and lines placed at a 45° angle. This particular example has been expanded and used at a flatter angle.

▲ In the wide margins of this page from the fourteenth century "Bible Historiale", decorated, "barbed" quatrefoils containing individual portraits set against patterned backgrounds are placed at evenly spaced intervals. The vine provides a linking device, and anchors the pictures to the page.

QUILL PEN

The quill pen has been in use for over two thousand years and remains unsurpassed for some of its excellent qualities. This extraordinary tool was developed at the same time that vellum became the preferred substrate, being of superior quality to papyrus. The development of the formal ROMAN CAPITAL alphabet, with its elegant proportions parading a fine balance of thick and thin strokes, also demanded a writing implement with flexibility and the ability to produce fine lines.

The quill pen had all the characteristics required to write early scripts. It enabled scribes to write legibly, establish a rhythm, and produce good, rounded shapes with a consistent weight of stroke, as required.

The variations possible in preparing the nib of a quill strongly influenced the hands for which it was used. The nib could be cut at a variety of angles, or could be sharpened to a very fine point. The angle of the pen could also alter the strokes and the forms described on the page. This resulted in instruction books being made, containing illustrations of how the quill pen should be held and its angle of manipulation. There are many fine engravings that show a scribe manipulating a chunky instrument. This is the quill pen. Some pictorial references show the barbs of the feather intact, which is not convenient for writing.

There are many excellent sources of quills. The primary flight feathers of geese, swans and turkeys are ideal. For delicate work, crow and duck quills provide a very fine shaft.

The natural curve of the quill is important, so that the instrument sits comfortably in the hand. Left-handed calligraphers should select quills from the right side of the bird, and right-handed calligraphers from the left.

The quill needs to be thoroughly dried out before it can be prepared and cut for use. During the drying process, the natural oils are eliminated. Ideally, this should be done naturally, but that could take many months. A source of gentle artificial heat can be substituted. Exposure to the heat source is very brief, otherwise the quill is rendered too brittle. The heating alters the quill from the original opaque soft-textured form to a harder, clarified shaft.

There are several methods of applying heat and each calligrapher needs to find the one that produces the right flexibility and hardness according to personal preference. The simplest method of heating is to position the quill about 5cm (2in) above a hotplate and rotate it slowly for about ten seconds.

After heating, scrape off the greasy membrane from the outside of the quill and remove the pith from inside. When you have polished the quill it is ready for cutting. A suitable length is 18-20cm (7-8in). You can shape the quill nib with a scalpel or sharp steel knife. To maintain the writing quality, it can be retrimmed frequently.

Cutting a quill
1 Strip the barbs from the shaft. Using the back of a penknife, scrape the length of the barrel to remove the outer membrane. Rub the shaft with a rough cloth.

2 Before cutting, the quill must be hardened and clarified. First, cut off the sealed end of the barrel, then soak the quill in water overnight. Next morning, heat some silver sand in a shallow tray or pan. Take the quill from the water and shake it vigorously. Using a long point, such as a knitting needle, push the "coil" inside the quill to the end. Spoon hot sand into the barrel and, when it is full, plunge it into the heated sand for a few seconds. Then cut the top off the quill.

3 Make an oblique cut, long and slanting, downwards to the tip of the quill.

4 Make another oblique cut below the first to shape the shoulders of the quill. This gives the familiar stepped arrangement of shoulders and nib tip. Remove any pith remaining in the shaft. Make a small slit in the shaft to aid the flow of ink down to the writing tip. Do this very carefully: a length of 6mm (¼in) is adequate.

5 Work on a smooth, hard surface, such as glass, for the final shaping of the nib. There are two ways of holding the nib for this stage. The first is to rest it on the edge of the glass, underside down. The other method requires more care: place the nib underside uppermost and hold it firmly. Make a clean cut down the nib tip in a single vertical movement. Pare the nib finely and obliquely on the topside to complete the quill.

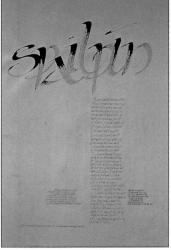

▲ FRANCES BREEN
A free composition using text from "The Hidden Ireland" by Daniel Corkery. Both a quill and a reed pen have been used in writing this piece.

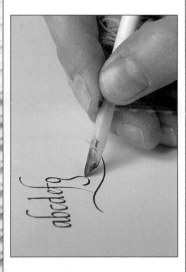

Using a quill pen
Use a brush to load the quill pen with ink, and begin to write. The quill can produce fine and thick lines as required for calligraphy. If used often, the nib will need to be recut.

▲ FRANCES BREEN
This is a trial presentation of the poem "The Wave". The wave form highlights the texture of the paper with its arc of watercolour. The poem is written with quill and ink in a Celtic style which clearly illustrates the flexibility of the quill as a writing tool. The demands of written Gaelic for a long fine stroke for the accent (*fada*), which indicates elongated vowel sounds, are ably met by using a quill.

RAISED GOLD

Among the finest medieval manuscripts are those that include the application of gold. Elegant capital letters and complex patterns adorn the pages in a grand demonstration of the manuscript as an item to be admired and revered. To produce such fine work, lengthy processes of preparation were assiduously followed. First, the preparation of the substrate, then the selection and treatment of pigments for colour decoration and, finally, the ground for the gold leaf. The processes for applying raised gold remain largely unchanged since medieval times. The work is planned and the text written out, leaving the gilding until last. The gold is laid on a prepared ground and, when dry, is brought to a high lustre by burnishing.

Raised gold is a particularly fine effect of gilding, as the leaf is laid on a raised ground forming a low "cushion", a three-dimensional element that causes the gold leaf to reflect even more brilliance than when it is laid flatly. It catches all the available light that falls on the page as it is viewed and turned.

Gesso provides the ideal ground for raised gold decoration. This is, basically, a mixture of plaster and glue that can be applied with a quill or brush. It has a slightly tacky surface that receives the gold leaf evenly. When dry it is solid but relatively flexible, so that it will not crack when a page is handled. Preparation of the gesso ground is the most lengthy procedure involved in applying raised gold decoration.

Gold leaf is sold in booklets in which the fine gold is interleaved with tissue. Other metallic leafs are available: palladium, derived from platinum, and silver. The burnisher used to bring up the shine on the gold after it is dry is traditionally made of agate or haematite.

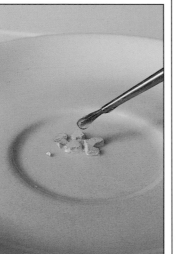

1 Prepare the gesso by breaking up the coloured plaster into an egg cup or a small dish. (The plaster is coloured so that when applied to the page it will show up against the background.) Add a few drops of glair – a solution of egg-white – or distilled water to make the gesso into a workable medium. Leave the mixture to dissolve for at least 20 minutes.

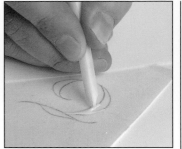

2 Cover the gesso with distilled water and mix to a smooth, creamy consistency. The end of a quill pen, or a bone folder, can be used to stir the solution and get rid of any air bubbles. If bubbles persist, a drop of oil of cloves dripped from the end of a toothpick should solve the problem. The gesso is now ready to be used with a quill or metal nib.

3 The best substrate for working on is vellum. Care must be taken to ensure that the vellum is free of all impurities such as grease or tackiness. To do this, treat the surface with pumice, and then carefully brush off all the powder.

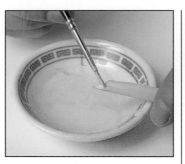

4 Lay the vellum flat on a sheet of glass. Flood the letter with gesso to give a raised "cushion" effect. When the letter is completely filled in with gesso, allow a minimum of 12 hours for it to dry. The drying letter can be left overnight, and the gold applied next day. Sometimes the final result is better for the waiting. Laying the gold must be done quickly, so it is important to have all the necessary materials and equipment to hand before you begin.

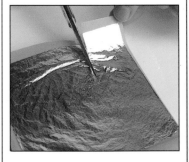

5 Gold leaf is a very fine and sensitive material, so extra care must be taken in the handling. The scissors used to cut the leaf should be cleaned with silk, to stop the material sticking. The gold leaf is supplied in book form, interleaved with tissue paper. Cut through both layers to a size slightly larger than the letterform.

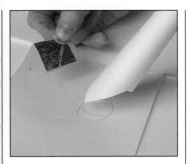

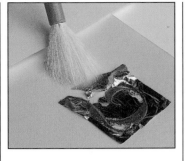

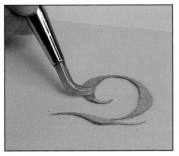

6 Holding the gold leaf with its backing sheet ready, blow gently through a paper cylinder onto the gessoed letter. The still-tacky gesso is now ready to receive the gold. This must be done quickly.

8 Using a haematite or agate burnisher, rub firmly on the crystal parchment. After working with the burnisher, remove the parchment.

10 Using a dry soft-haired brush, remove the excess gold leaf from around the letter. Use light, short brush strokes to flick the gold away, rather than dragging the brush.

12 Here, a dog-tooth agate burnisher is used to work the gold leaf to a final brilliance and smoothness. This burnisher is specially shaped to ensure that the leaf is worked into the edges and rounded parts of the letter.

7 Apply firm pressure through the backing sheet, to encourage the gold leaf to adhere to the gesso. Remove the tissue backing sheet, and replace with a piece of crystal parchment.

9 Clean the burnisher on a piece of silk, and burnish the gold leaf directly. Work the gold leaf around the raised letter, paying particular attention to pressing the gold into and around the edges.

11 Continue light brushing until all the gold leaf surrounding the gilded letter is removed. A second layer of double gold leaf is now placed over the gilded letter. Crystal parchment is again placed over the gold and firm pressure is applied. Clean off the excess gold with a soft brush as before.

13 The gold leaf is now burnished until it is completely smooth and shines brightly when it catches the light.

REED PEN

Reed pens, among the earliest forms of nibbed writing instruments, were commonly used by Middle Eastern scribes because of the plentiful supply of sturdy and suitable reeds in their regions. The Egyptians, too, made reed pens and soft reed brushes for writing on papyrus. The Romans, having adopted the use of papyrus, found the reed pen a most suitable instrument with which to write. It was sometimes referred to as a "calamus", after the particular species of palm that provided the raw material. Cut to shape, the reed pen was used to apply ink to parchment and linen as well as papyrus.

A reed pen can be made quite easily and certainly cheaply. Garden cane is the material most commonly available now that provides an equivalent to the original type of reed. The hollow cane is easily cut to length and shaped, using a sharp knife, to form a writing nib. Inspect the cane carefully to make sure it has no splits or imperfections that could result in any number of disasters when you start using it to write. Cut it to a manageable length – 200mm (8in) is recommended.

The cane, being nothing but a hollow tube, provides an excellent reservoir for ink. You must take care not to let it flood the writing, so work on a flat or only slightly inclined surface. In common with most calligraphic implements, the reed pen resists a pushing motion and you obtain best results from pulling the stroke.

In comparison with the quill, the reed pen has less flexibility. It cannot sustain such fine and accurate shaping, and the overall effect of work written with this pen may not be as eloquent. It does have excellent qualities, however, which make it a valid implement for many styles of writing. The calligrapher can select canes of different sizes and prepare a varied range of nib widths accordingly. The resulting bold letterforms are highly effective in poster work, headings and titles, and can be matched to specific "one-off" jobs where a particular nuance is sought.

The Romans used the reed pen in the execution of their square capitals and rustic hands. The method of holding the pen between the index and middle fingers must have influenced the way RUSTICA letters evolved, with thin uprights and thick cross strokes. Other variations occurred with these letterforms, including a slight pull to the right in curved strokes and a condensing of the overall shape, especially as compared to the roundness of the ROMAN CAPITALS.

Making a reed pen
1 Assemble the materials – a suitable reed or cane, a sharp knife, and a hard surface to cut on. Soak the reed or cane for at least 15 minutes, then cut it with a sharp knife while it is still wet. Cut the cane to a comfortable working length – about 20cm (8in). The first cut, shown here, is an oblique slash down towards one end.

3 Firmly hold the pen on the cutting surface and trim the end to nearer the eventual nib length. Turn the pen through 90° and make a small slit down the centre of the nib, at right angles to the writing edge.

2 Shape the shoulders of the nib. Then, using the point of the knife, clean out any pith inside the cane which has been exposed by the first cut.

4 If the nib seems too thick, very carefully pare it down to make it thinner. Holding the nib underside up, make a vertical cut across the nib end.

5 Make a small diagonal cut on the upper side of the nib, down towards the end. This will produce a fine writing edge.

6 The reed pen is now ready to use. A brush is used to transfer ink on to the underside of the nib.

Using a reed pen
1 A reed pen has a different "feel" to a metal-nibbed pen; because it is made all in one piece, it feels almost like an extension of your hand and is very pleasurable to use. The width of the strokes made with a reed pen is dictated by how wide the nib has been cut. This illustration demonstrates the firm and solid strokes which this simple instrument is capable of producing.

2 The reed pen has the ability to produce both the extremely fine lines and the thick strokes required for calligraphy. Holding the reed pen at the prescribed pen angle, a fine line is extended from the tail of the letter. To complete the line the right-hand side of the nib is lifted off the paper, and the left-hand side of the nib drags wet ink into a hairline.

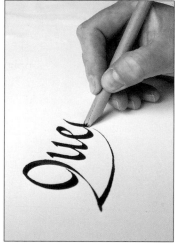

3 The lower case letters are written confidently, and show how a nib made from an inflexible material can produce very well the familiar characteristics of calligraphy.

4 When working with a reed pen, always keep the top side of the nib clean. Take care not to overload with ink, as this could result in blotting or smudging. This example shows an excellent balance between the thin and thick strokes, and a fine hairline extension to the last letter. This was performed by dragging wet ink with the left-hand corner of the nib.

ROMAN CAPITALS

The great legacy of the Romans includes fine letterforms of splendid proportions and sublime elegance. In keeping with other developments in Roman culture, the letterforms matured over several centuries. The shapes of the letters have a strong connection with the introduction of the rounded arch and vault into architectural style.

To record an event Roman capitals were extensively used incised in stone or marble, on monuments, tombs and arches. Many fine examples of this alphabet, executed by Roman master craftsmen, can still be found. The execution of the letters was not confined to the chisel. Reed brushes and pens and quill pens also produced the perfect proportions and balance of elegant thick and thin strokes.

The Roman square capitals incised in stone were called *capitalis*. When practised with a square-cut reed pen or quill, they were known as *quadrata*. The quadrata required exceedingly painstaking execution to achieve the forms correctly. Quite quickly, the rustic forms succeeded the round forms for use in manuscripts. These were letters of a style that could be written at greater speed and with some economy of materials. The square capitals continued to be well represented in headings, initial letters and special applications, as they are to this day.

In the classical Roman alphabet of 23 letters lie the origins of modern letter forms in the western world. The letters J, U and W were added during the Middle Ages. Close study of the letter shapes reveals adherence to basic geometric principles. The letters are carefully constructed using the square and subdivisions of it. The rounded letters C, D, G, O and Q can be represented by a circle or part of a circle within the square.

The pen angle for this vertical hand varies from 5° for the serifs to 20°-30° for most of the strokes. An angle of 45° is needed for the majority of diagonal strokes. A steeper angle is used for the slanted strokes of M and N, and a flat pen (0°) for the diagonal of Z. The pen moves from the top to the bottom of all vertical and diagonal strokes.

The letter height is 10 nib widths. Meticulous attention must be paid to the height and width of the letters to achieve and maintain their elegant proportions.

There are variations in the style and application of serifs and some are more difficult to execute than others. The simplest serif is added as a single separate stroke – a hairline formed by turning the pen to the flat angle (0°) for the horizontal stroke. A bolder serif can be executed as a precursor to or an extension of a stroke.

The classical Roman form has a considered serif extending on both sides of the upright stroke. There is an almost imperceptible flaring of the upright before it comes to rest in the serif. These elegant endings involve much turning of the pen. Apart from in C, G and S, all serifs are parallel to the writing line. A concise four-stroke pattern produces the desired effect. The first stroke is the vertical, the second the hairline – in some styles this is slightly concave towards the middle. The third and fourth strokes are identical, but reversed on either side of the vertical, joining the extremes of the hairline serif to the upright with a gentle curve. The procedure is the same for serifs at the top and bottom of the letters.

1 Holding the script pen at the correct 30° angle, draw the first downstroke.

2 The first cross stroke is then drawn in, incorporating the correctly angled serif on the left (the correctly held 30° angle of the pen makes the cross stroke slightly thinner).

3 The second cross stroke is drawn in, making sure that the pen remains consistently at a 30° angle.

4 The base serif is then added. The height of the completed letter should be exactly 10 nib widths.

A
Q
X

A B C D E F G
H I J K L M N
O P Q R S T U
V W X Y Z

Roman alphabet

Roman letters can be written with a broad pen, held at an angle of 30° for most of the strokes. Diagonal strokes require a steeper pen angle (45°), and the middle stroke of the Z is made with a much flatter angle. The serifs require further manipulation of the pen, including using only the corner of the nib to comploto their fine endings. The height of the letters is 10 nib widths.

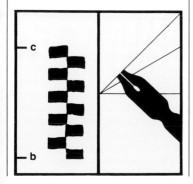

L B B

The construction of Roman letters depends on good pen control and achieving and maintaining elegant proportions. Begin and end the vertical stroke with a small hook, which provides the foundation of the serif. To complete it, the pen is turned to 0° to the horizontal writing line.

▶ Monumental inscriptions were carefully planned and executed, as shown by this example from the arch of Septimus Severus in Rome.

79

RULES

The principle of using hairline extensions to serifs, which so admirably puts the finishing touch to many letters, can be applied to an entire piece of calligraphic design in the form of a rule or rules. Thin rules and thick rules, broken rules and rules interspersed with other visual devices can be an integral part of the design.

The position of the rules must be considered at the planning stage – they are not an afterthought, and require as much consideration as any other element in the design. You should design them into the work in the same way that you would a more complex border or decorative device. An entire border, either a full or semi-enclosure, can be constructed from rules. An attractive border arrangement can be constructed by positioning rules of distinctly different thicknesses side by side. Rules can introduce the only colour element in a work, or act as a colour contrast.

Thin rules can separate blocks of text that share a theme but require more than physical space to indicate the end of one section and the beginning of the next. The rules must be positioned in a form that does not draw the reader's eye away from the calligraphy.

Using a ruling pen
The ruling pen is an excellent instrument for drawing up rules of various widths. It can be used with ink or paint, so is versatile for introducing or enhancing colour work. The pen consists of a handle to which two stainless steel blades are attached. One blade is straight and flat, the other

bows slightly outwards. The tips of the blades almost meet: the space between them forms a reservoir for ink or paint. By adjusting a thumbscrew on the bowed blade, you can alter the distance between the blade tips, which dictates the thickness of the line made by the ruling pen.

The medium is loaded into the pen with a brush, or using the dropper supplied with some ink bottles. No ink or paint must be left on the outer edges of the blades, as this could flood the paper if it comes into contact with the ruler used to guide the pen. The pen must be operated with both blades resting on the paper. Its movement discharges the fluid held between the blades.

Although the thickness of the line can be considerably varied by adjusting the pen, some rules may be of a thickness that is best achieved by drawing two parallel lines and filling in between them with a small brush.

A ruling pen attachment is often found in a standard compass set. It can be used in place of the pencil lead normally inserted in the compass, so that you can draw perfect circles of ink or paint.

For fine work, the ruling pen has perhaps been superseded by the technical drafting pen, also available as a compass attachment, but for the ability to produce rules of different weights and colours, the ruling pen remains unsurpassed.

Using a ruling pen
1 Use ink, or paint mixed to a fluid consistency. Insert the colour between the blades of the ruling pen with a dropper or brush. Wipe off any excess medium from the edges of the blades.

Using a compass
Load the blades of the compass attachment with liquid medium, place the centre pin of the compass onto the paper and draw the blades over the surface.

2 Place the ruler flat on the surface with the bevel edge sloping inwards and hold firmly. The thumbscrew on the curved blade of the pen should face outwards. Hold the pen at a slight angle to the ruler to avoid paint or ink flooding underneath the edge. Keep the drawn stroke light, smooth and steady, with the points of both blades on the paper to ensure an even flow of medium. It may be necessary to do a "dummy run" to check that the width of the line is correct.

Brush ruling
When using a brush to rule lines, avoid smudging by holding the ruler at a 45° angle to the paper so that the edge is not actually touching the paper. Gently draw the brush along the ruler, keeping the ferrule against the ruler's edge to ensure a straight line. When the line is completed, remove the ruler carefully to avoid smudging.

RUSTICA (RUSTIC CAPITALS)

Employing quills, reed pens or large brushes, scribes of the fourth and fifth centuries using the rustic alphabet were able to work quickly compared with the precise approach required for writing ROMAN CAPITALS. Examples of their work can still be seen on the walls of the ruined city of Pompeii.

Rustic lettering has an informal appeal, with an emphasis on condensed and elongated forms. It is distinctly more economical of space and materials than square capitals, so quickly became the main bookhand of its day. It was rendered in quite a free style, apparently with an easy movement of the forearm. Even after UNCIALS and CAROLINGIAN script took over as the preferred bookhand styles, rustica would still be used for headings and initial letters. The lettering was well adapted to taking ornament and filling of the white spaces, thus forming an alternative or complement to the more usual VERSALS.

Research suggests that the writing implement – the reed pen, for example – was manipulated between the index and second fingers. This possibly accounts for the thinness of the main stems of

the letters. To recreate this thin stroke, the pen angle varies from 10°-90°, taking approximately 60° from the horizontal as the mean optimum. The letter height is six to eight nib widths. The result should be a block of writing of even texture with the stress on horizontal and diagonal strokes.

The letter A was usually written without a cross stroke. Occasionally, some letters were written slightly taller than others to avoid any confusion. The most obvious are L and F, to avoid them being mistaken for, respectively, I and E. The spacing between lines was often less than the letter height. There is much scope for experiment with spacing and texture in writing rustic forms.

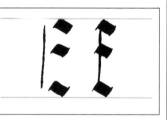

When learning Rustica, take special note of the spaces within the letters – both the enclosed and open counter shapes. Aim for a good contrasting definition between thin verticals, thick horizontals and diagonals. For this letter, turn the pen to an angle of 90° to the writing line to form the thin vertical stroke, and to a flatter angle for the cross strokes.

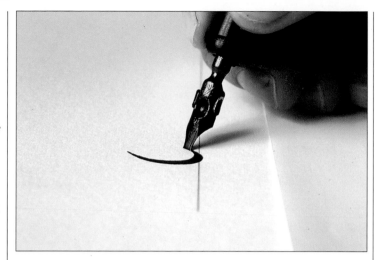

1 This comparatively informal hand was developed by the Romans and over the centuries was used exclusively for headings and titles. It has a strong diagonal stress and is very compact, but achieving consistency of stroke is difficult and each calligrapher has to develop a personal rhythm and uniformity of pen angle. Here, the pen is held at a fairly acute angle to make the first downstroke.

2 The second downstroke is added, to make the tail of the letter G.

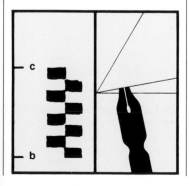

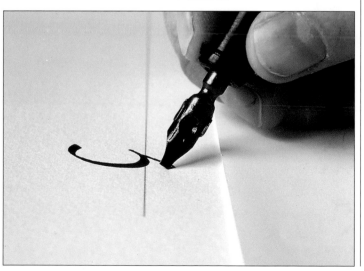

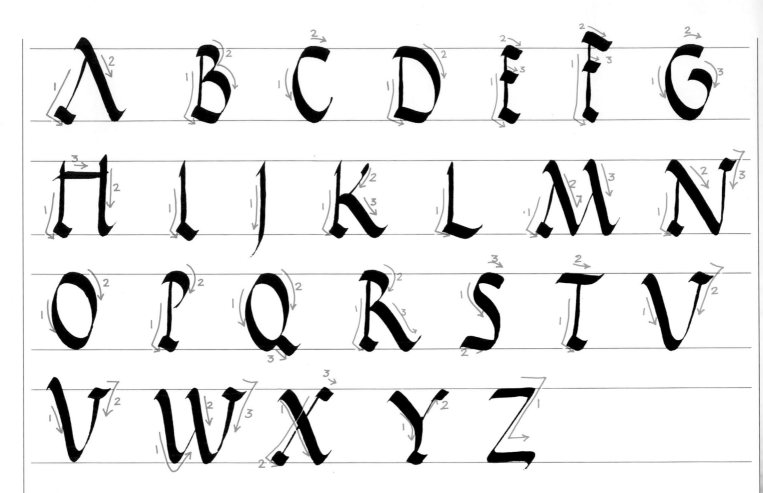

Rustica alphabet

This informal majuscule makes an excellent choice of lettering style for headings and titles. It appears deceptively easy to execute, but this is not so! The pen is manipulated through a variety of positions, ranging from 10°-90° from the horizontal. The letters are six to eight nib widths high, which contributes to the slightly condensed shape. These letters require minimum interlinear space if used in a heading of more than one line, or if chosen to write a piece of text. Notice some of the letters rise above the height of others. Begin working with a large broad nib, or a reed pen, so that the thin and thick strokes are well defined.

SPLIT NIB

There are many ways of enhancing calligraphic works, some predictable, some surprising – the use of the split nib can be classed in the latter category. In common with the DOUBLE-POINT, this nib demonstrates clearly the basic structures of the letters. In exposing the way the thick and thin strokes are formed as the pen moves, it can lead to greater understanding of the principles of calligraphy, including the stress of the letter shapes and the importance of the pen angle.

Most of the letterforms made with a broad nib can be written with the split nib. The nib is quite literally as named, a broad nib split down the middle into twin points. All the usual instructions for any style – such as pen angle and letter height – apply for implementing the split nib.

The open letter style made with the split nib can be employed as a single capital letter, a heading or an entire piece of work. For specific items, place cards or identity badges, for example, it is a pleasing alternative to solid letters.

1 Split nib pens can be of the dip pen variety, or, as here, the double-bladed type which is loaded with liquid medium in the same way as a ruling pen.

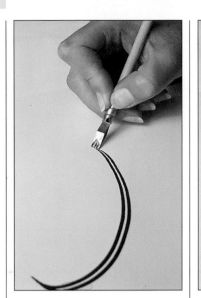

2 Holding the pen at a constant angle, the first curved downstroke is made.

3 Lifting the pen from the surface, the second stroke is made, to enclose the top counter shape.

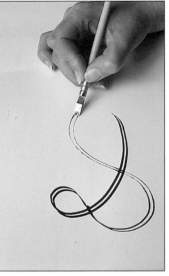

4 The second curved stroke is made, sweeping the shape of the letter over the paper. It can be seen that the ink is running low, but this adds to the texture of the letterform.

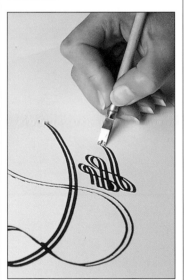

5 The pen is loaded again, and a series of scrolls are drawn back and forth, tucked into the main shape of the letter.

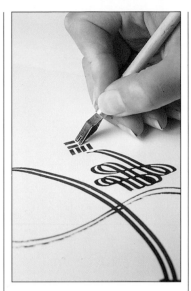

6 A series of short staccato pen strokes adds further ornamentation to the letterform.

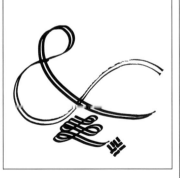

7 The completed piece. Taking a simple shape and embellishing it in this way is good practice – and also very satisfying.

Working with double points made by joining two pencils together may be the first experience of writing in outline. Writing with a split metal nib creates very elegant lettering which has instant appeal. Letters written in this way always capture the attention. This Italic alphabet, transcribed entirely with a split nib, shows clearly how the individual letters are formed.

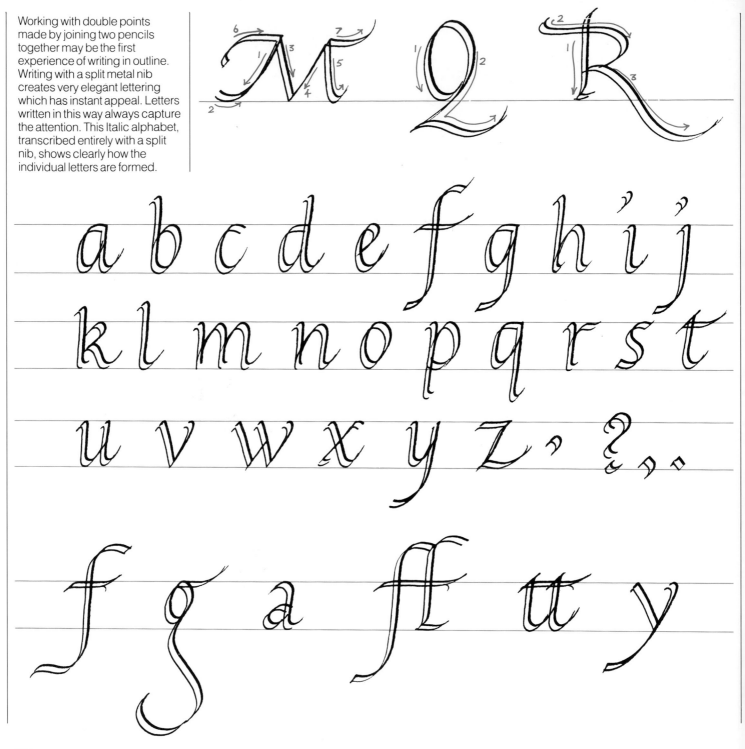

SWASH LETTER

This is a term more commonly associated with printing, where it refers to a decorative letter, often an ITALIC capital. In calligraphy, it is closely related to FLOURISHING, but only in so far as the enhancement of an individual letter is concerned. Where flourishing can be extended to a word, a sentence or an entire page, a swash is confined to the extension of a single letter. Like flourishing, swashes may have been added initially to fill vacant spaces where a line fell short or there was too much white space below a heading, but a swash may also be quite simply a logical, pleasing and interesting extension of a letter.

Swashes are very effective when applied to initial letters, single words and headings. In jobs that include names, requiring good legibility – invitations, place cards, identity badges – simple swash letters can create an interesting finishing touch.

Some letters are distinctly more suitable than others for transformation to swash letters. Excellent candidates are those that have in their structure a tail or strong upright or slanting stroke that is easily extended. These letters include A, K, M, N, Q, R, V, W, X, Y, Z.

The extension can travel in any direction, but you need to plan the letterform to avoid ending up with an ugly, clumsy or ill-proportioned shape. The swash letter should not obscure the text, or any other copy on the page or card. It must also relate successfully to the other letters in the same word or phrase.

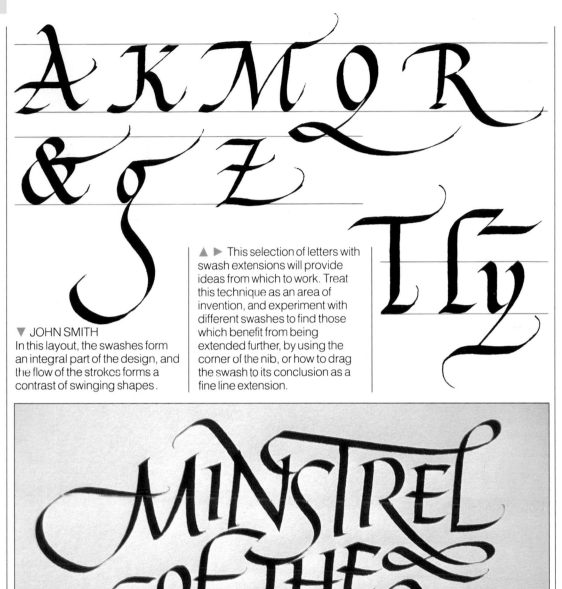

▼ JOHN SMITH
In this layout, the swashes form an integral part of the design, and the flow of the strokes forms a contrast of swinging shapes.

▲ ▶ This selection of letters with swash extensions will provide ideas from which to work. Treat this technique as an area of invention, and experiment with different swashes to find those which benefit from being extended further, by using the corner of the nib, or how to drag the swash to its conclusion as a fine line extension.

TEXTURE

Texture in calligraphic design takes many forms and operates in different layers of perception for both the calligrapher and the viewer. There are several ways in which calligraphic texture can be created. First, it can be considered in terms of the layout of the work, being seen in the balance of black and white areas and the way these elements are presented. Second, in a more intricate context, texture can be created by making specific choices of materials, tools and style, with careful planning of how these will be manipulated and applied to the work. Texture is about rhythm, and reveals a broad area for discovery.

In calligraphy generally, the overall aim is to create a piece of work that is pleasing to the eye and easy to read. This can be achieved by instituting good working practices and following the guidelines for the chosen styles. The natural texture of the hand is important – the elliptical O of ITALIC, or the round forms of UNCIAL and ROMAN letters each provide their own texture when well constructed and presented.

In more creatively ambitious work, texture can be played with in innumerable ways. It can be summoned to assist in actually communicating the text – in other words, you can make use of texture to interpret a text. The weights – light to bold – and the height and size of letters can also be explored and altered.

Words can be expanded, enlarged or contracted: words can run into words; words can dance across a background of other words or range alone across the page. Alterations to size and colour can create a wide range of exciting visual concepts.

There are so many variations to consider that you may find it hard to focus on a suitable interpretation. If this happens, reflect on the nature of the text and try to match it to something easily identified – such as a stone wall, or wind-blown clouds or waves. Tightly spaced lettering can resemble knitting, especially if some of the ascenders and descenders are looped and entangled.

You can take different approaches using the structure of the letters. One useful device is to repeatedly emphasize a particular stroke, such as a diagonal or serif. You can work through a block of solid text using a mixture of condensed and medium-weight letters. You could make all the round shapes very round, thus creating distinct white spaces that provide contrast with the remainder of the work.

Combinations of different letter styles can be effective, especially if they vary in size. Careful planning is required, as some hands work very well together while others contradict each other to disastrous effect.

You can introduce applied texture by making pen patterns that form borders to the work, or by preparing a textured ground before you begin writing, using sponging, marbling or collage. Whatever your choice, this is a time to break the rules, experiment, and have fun.

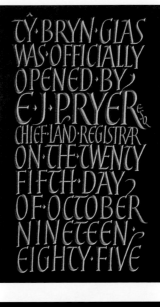

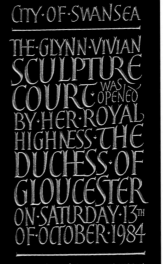

▲ IEUAN REES
The textural pattern which emerges on this plaque is mainly created by the changes in lettering size and the quirky nature of some of the letters, especially those which share a stroke.

◄ IEUAN REES
This plaque with incised letters shows a good example of visually created texture using the visual contrast of the shapes of the letter strokes, spacing of the letters, words and lines, and the change in lettering size.

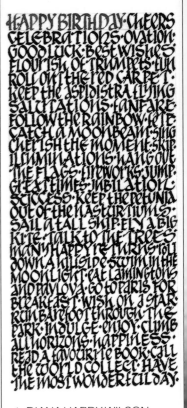

▲ DIANA HARDY WILSON
The textural quality of this informal birthday card is immediately apparent. A rectangle of black and white shapes is perceived before the information presented is absorbed.

UNCIAL AND HALF-UNCIAL

There are many early Greek examples of this ancient letterform and the use of uncials spread to the Roman empire while ROMAN square and RUSTIC capitals were still in use. The "new" hand provided some economy of strokes and more speed, but it retained formality. The Romans gave it the name uncial from *uncia* meaning "inch". Study of early Christian manuscripts shows that it became the main bookhand of the period.

The Uncial hand is upright and bold, with full and rounded letters. It has an uncomplicated construction sequence with, at times, only a mere hint of the existence of ascenders and descenders. The best tools for writing Uncials are a broad nib or square-tipped brush. The nib gives a very clean, sharp outer edge to the letters.

The old style of very round Uncial was made with the pen held almost horizontally, using a letter height of three to four nib widths. The modern, more open style is executed with a pen angle of 10°-20° and a

height of five nib widths. The clubbed serifs are made by forming a small angled stroke followed by the upright stroke. Some Uncials can be given a hairline serif as an extension of a non-enclosed stroke.

Spacing between the letters of this rotund hand requires some special attention. Each letter should be able to "breathe". Try to achieve a

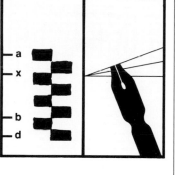

1 Uncial is a broad face, the pen being held at a very flat angle of 10°-20° to obtain the broad downstroke.

2 The pen is lifted from the paper before drawing the broad top stroke of the G.

3 The slimmer tail stroke is added. This face is characterized by full, rounded letters with very short ascenders and descenders.

Uncial alphabet

These majuscule letters are written with the pen held at a very flat angle of 10°-20° to the horizontal, which can be difficult and uncomfortable to execute. The letters are rounded and squat, with minimal ascenders and descenders. The serif is a small wedge, formed by a slightly angled stroke, which is followed by the upright stroke. Use a broad nib or square-cut brush to form these letters, making special note of the fine thin lines that offset the thick strokes.

The stroke diagram (left) clearly shows the quite delicate nature of the second stroke of the letter.

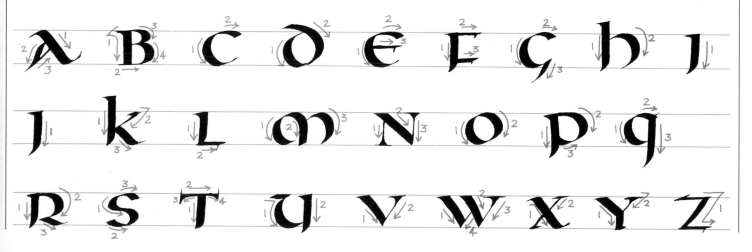

balance of black and white, increasing the spaces between words and lines as necessary.

When you see a page of Uncials, you get an overwhelming sense of the letters being compressed neatly between parallel lines. The need to combine Uncials with another hand frequently arises, to develop the texture of the work. VERSALS are the natural complement to this quite adaptable hand of thin horizontals and thick verticals.

Half-Uncial

The Uncial, with its minimal ascenders and descenders, is regarded as a majuscule hand. The Half-Uncial, although still seen as a majuscule, is often accredited with being the forerunner of most minuscule forms. The ascenders and descenders distinctly rise and fall from the bodies of the letters, making an immediate association with lower case letters. The Uncial and Half-Uncial are acknowledged as the inspiration for the Celtic insular script used to produce the famous Book of Kells.

If you have difficulty making the first stroke, divide the task into two strokes. Make the long horizontal stroke first, and then add a small stroke on the left-hand top edge. The main stroke of the letter may need some practice to achieve the correct balance of open and closed counter strokes after the application of the final stroke.

Half-Uncial alphabet

The Half-Uncial majuscule is closely identified with Anglo-Saxon and Celtic insular hands. The letters are four to four-and-a-half widths in height, with a flat pen angle. The letterforms are round, and have short descenders and ascenders, the latter with a distinctive wedge-shaped serif. The interlinear spacing can be kept to a minimum, although well considered spacing between the lines creates a fine image overall. Spacing the lines by as much as four or more nib widths allows room for a single letter at the beginning of a sentence to be enlarged and decorated. These letters are excellent forms to receive decoration.

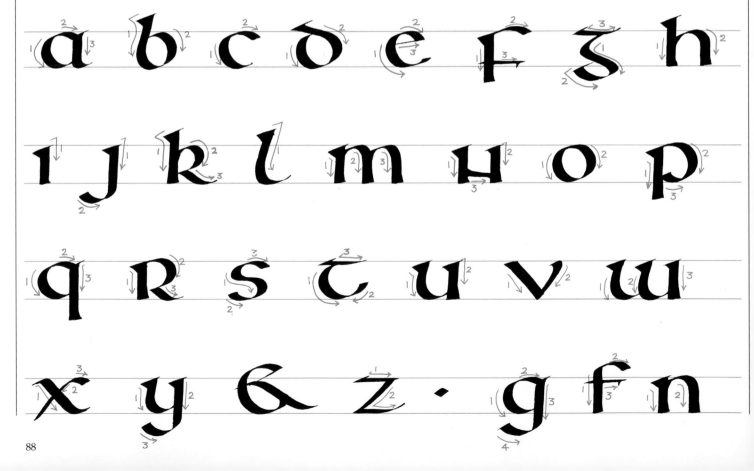

Modern Uncial alphabet

The Modern Uncial is derived from the traditional Uncial majuscule. The letters are quite heavy, and maintain the roundness of other Uncial forms. The letters are written with a flat pen angle of 15° to the horizontal, although an angle of 30° is acceptable. The letter height is four-and-a-half to five nib widths. The short ascenders and descenders of Uncial hands are maintained. Many of the vertical strokes and descenders taper off to the left, with no serif.

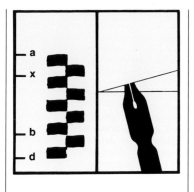

The first stroke of this letter should capture the roundness of the letter shape – based on the o. The second stroke completes this round quality. Finally the tail of the letter is added.

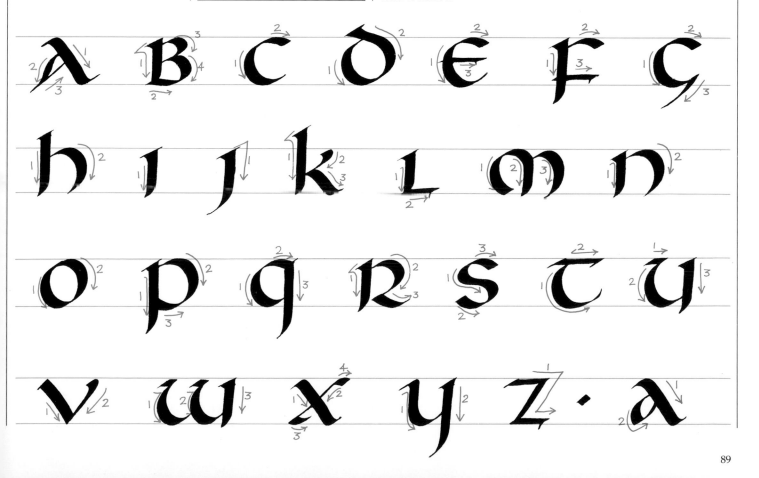

VERSALS

These elegant capital letters appear liberally throughout early manuscripts, but were seldom used to compose an entire block of text. Their main purpose was to serve as chapter openings, to draw the attention of the reader to an important section of the text, or to begin a paragraph or verse. Standing in any of these commanding positions on the page, these extraordinary letters were at times emblazoned almost beyond recognition. There were no minuscule forms, so the accompanying body of text would be executed in UNCIAL, Half-Uncial or CAROLINGIAN letters.

In medieval times, Versal letters used as initials were simply coloured green, red or blue. Richly burnished gold versions were limited to use in manuscripts deemed of particular importance.

The unusual feature of Versals in calligraphic terms is that they are built-up, not written letters. The construction appears straightforward, but it is curiously difficult to master. Most of the strokes are formed in the same way, whether they are curved or straight. As a guide to height, base the letter on eight to 10 × the width of the letter's stem.

It is advisable to begin by drawing a light pencil outline, so that the correct angles and counter shapes are established. Then you can work the letter stroke by stroke using a medium-fine pen, starting with the uprights. These are slightly "waisted", tapering inward to the centre and broadening a little at the ends. The diagonal strokes are similarly constructed. Unless you are adding colour, a single stroke should fill in the letter once the outlines have been drawn. The slightly extended hairline serifs are formed with the pen held flat.

Letters with rounded counters should fall slightly above and below the actual letter height. When making these letters, complete the inner line of the counter first, so that you achieve the correct proportions. The outer curves of the letters are slightly sharper than the inner ones. In letters that have crossbars, these are placed slightly above the middle.

The spaciousness of these graceful letterforms provides much scope for decoration. You can add a contrasting colour simply by using a pen or brush to make the filling-in stroke. A heading, or the first word of a text, catches attention when it is richly embellished with colour, has hairlines added and elaborate flourishes swirled into intricate patterns. Beginning a piece of work with a single versal also offers an excellent opportunity for gilding.

Contemporary design trends have provided new perceptions of works composed entirely of upper case letters. The elegant Versal works well in many contexts. A rhythmic texture can be created if careful consideration is given to the spaces the letters occupy. To achieve movement in the design, some of the letters may vary in size, but maintaining a constant letter size can result in a work of great credibility and elegance.

1 In this versal capital, the inner stroke is drawn first to establish the shape of the counter, and then the outer stroke is drawn. (On straight downstrokes, the stroke is slightly waisted in the middle.)

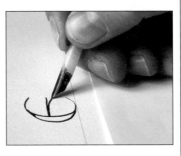

2 The two middle cross strokes start at the width of the nib and are splayed in two flaring strokes at the end to produce a wedge shape.

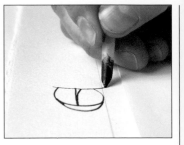

3 The enclosing downstroke is now drawn. These hairline strokes should be lightly drawn with the pen held at a 90° angle to the paper.

4 The skeleton lettering is filled in with a single stroke. Filling-in can also be done with a fine sable brush.

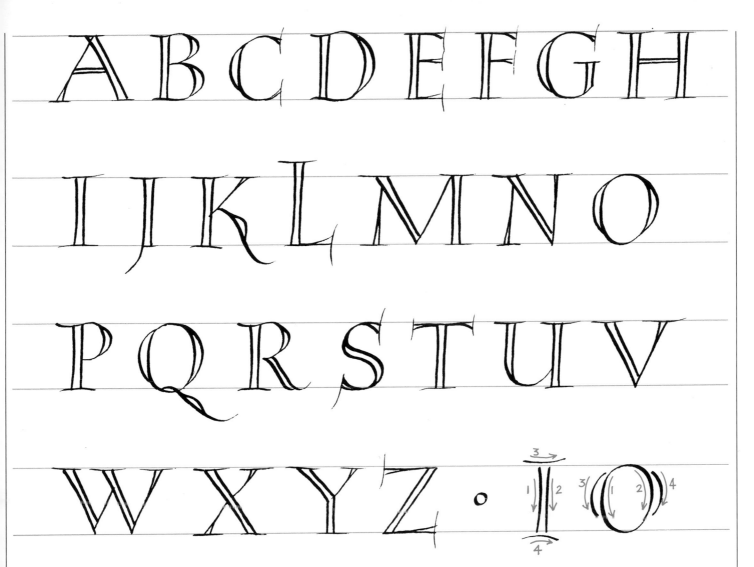

Versal alphabet

These built-up capital letters are excellent forms for headings and decorating, and work well with many calligraphic hands. The inner strokes are drawn first to ensure the counter shape is the correct proportions. The waisted vertical strokes are constructed with great care; the waisting is a subtle curve and must not be exaggerated. A metal nib, fine pointed brush or quill can be used to construct these letters. The instrument is manipulated at various angles to achieve a balance of thin and thick strokes.

The slightly waisted vertical strokes of the letter are drawn first. Turn the pen to 0° to the horizontal writing line, and draw the serifs. The inner stroke of the counter shape is drawn first to establish the shape, then the outer strokes are added.

PART TWO

THEMES

Calligraphic work can be greatly enhanced by the acquisition of additional and related skills. Several other areas of the visual arts and crafts, such as fabrics or ceramics, employ individual disciplines, working practices, materials and tools which are well suited to calligraphy. This may simply involve transferring calligraphic skills to materials other than paper or board, using similar or identical instruments to those used on paper, but it still widens the scope of the calligrapher. Moving towards less pliable media – such as glass, stone, slate or wood – requires expertise with a different set of tools, however.

The illustrations in this section of the book represent a diverse selection of work by many calligraphers. A variety of techniques have been employed, some singly and some in

combination. Seeing how other calligraphers have solved visual problems, created interesting layouts, combined techniques and explored unusual subjects makes an important contribution to an individual's development of personal style and the acquisition of calligraphic skills. The application of the techniques illustrated in this section will widen the vocabulary of all aspiring calligraphers, and allow you to explore all the possibilities available in the fascinating art of calligraphy.

LETTERFORMS

The twenty-six letters of the Western alphabet provide unlimited scope for exploration as individual graphic forms as much as they furnish a basis of communication when juxtaposed. The gradual evolution of the alphabet to the recognizable shapes employed today spans over two thousand years. The major contributions of style came from classical Roman incised letters, Carolingian hands of the eighth century and the Humanist bookhand of the Italian Renaissance.

A single letter can be an item of great beauty. A basic letterform with balanced proportions positioned on a page of well-chosen paper can command as much interest as an embellished letter. Calligraphy, like many activities, requires constant attention and practice. Playing with individual letters, from careful crafting to elaborate decoration, or even distortion, can provide many interesting insights. It is important to know the letter shapes well; they need to be very familiar and the calligrapher needs to have an intimate knowledge of their construction. This understanding of how and why letters are constructed in particular ways is a very basic requirement.

You do not acquire all this information just by learning calligraphic alphabets. Your appreciation of letterforms will increase over years of practice, with the continuing excitement of discovery and rediscovery. The pleasure that a calligrapher can find in crafting excellent letterforms should become evident in the work, giving equal pleasure to the viewer.

As your understanding of letter construction develops, you can explore a seemingly limitless world still composed of only twenty-six letters. In doing so you can find an individual style and expertise comparable to that of any other artist.

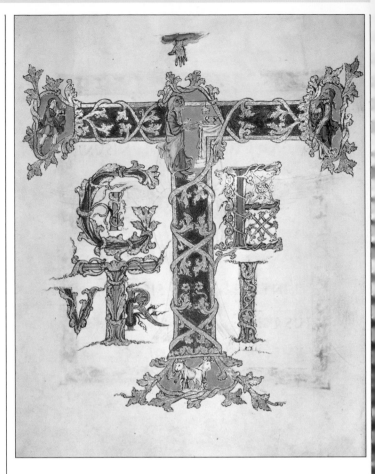

The Drogo Sacramentary, a fine Carolingian manuscript, contains pages of historiated initials. The Romanesque capitals are clearly laid out and have visual balance both horizontally and vertically. They read as an inscription, adorned with foliage. The outlines of the letters remain clear even though they are used as a trellis upon which the scroll work of the foliage is entwined. Miniature paintings of narrative significance are contained in the letter shapes.

LETTERS

Working with individual letters is a good basis for exploration. You will find it useful to try a simple exercise that can provide insights into calligraphic layout by focusing on the relationship of a letter to the surrounding space. Rule several squares of up to about 100mm (4in) and, using a broad nib and any style of lettering, write a single letter of any size anywhere in each square. The various positions will probably create different impressions. Some letters may take command of the space, others will provide a balance within the square of "black and white" space. These same letters can be used as the basis for applying simple decoration; for example, filling in a counter shape with a different colour. This may cause another change in the sensation of the letter in the square.

As a further exercise, experiment with "reversing out" the letter. Lay a sheet of tracing or layout paper over the square and simply fill in with solid colour the areas within and around the letter.

This instantly suggests another solution. Allowing an extension to a letter to break out of the square can provide a strong image. Follow up this style of exercise using combinations of two or three letters, trying to discover successful juxtapositions. This is a good method for developing the design of a monogram or logo.

◀◀ STEPHEN RAW
This letter was first drawn with a "scratchy" nib, then faxed. The fax scans the image as a series of squares. Enlargement accentuates this jagged quality.

◀ STEPHEN RAW
The decorative border and letterform were drawn on white paper using technical pens and black ink. The image was reversed to white on black by a photomechanical process. An irregular edge to the whole piece creates contrast.

◀◀ STEPHEN RAW
Two brush-drawn letters – one enlarged – are separated by the cut-out shape of a sans serif capital T.

◀ STEPHEN RAW
A letter drawn with a fine fibre-tip pen was reversed and enlarged on a photocopier, producing the thick lines and speckled background.

▲ STEPHEN RAW
Line and texture feature in an elegant capital R written on film, then reduced and repeated; wax crayon rubbed onto layout paper over a cardboard cut-out r; and an s written with automatic pen on rough watercolour paper.

DECORATIVE LETTERS

Learning to decorate letters may require some research to see how it is done. Looking at the manuscripts of past centuries can be an overwhelming experience, but it is better to be delighted rather than daunted. New discoveries can be made once you go beyond being dazzled by the invention and expertise of the early scribes and start to analyse their work. It is advisable to devise a personal method of looking at these exquisite items. Find a method to focus on individual components and follow their paths through in their entirety.

A device used extensively as decoration was the humble dot. This would be used repeatedly to surround a whole letter, forming either a single row or two rows. The dots might be placed to enclose the letter totally, following carefully every line, counter and serif. Sometimes dots fill the counter shape completely or even create their own shape around the letters of the first word. As you work out how these effects were created, you find that the dots do not seem to be randomly placed. First, they surround the letter; then more lines of dots are placed beside the first set. A similar treatment can be devised using linear marks.

A single colour painted in the enclosed or semi-enclosed counter was often used to draw attention to an initial letter. The use of painted coloured areas and dots together is a well-proven starting point to decorating letters. Do not forget to pay attention to the actual letter shape, which will need to be well formed. Some shapes are more suitable than others for the application of decoration. VERSALS are very good for decorating but difficult to learn to execute, so UNCIAL letters could be employed initially.

Finding confidence with decorating letters can take some time, so implementing simple solutions to begin with is good practice. The pleasure that can be derived from achieving a satisfactory decorative letter should provide impetus and encouragement for further exploration. While exercising new skills, continue to look at existing solutions.

Filling in a letterform with delicate patterns may present a difficult challenge so begin with areas of solid colour, lines, dots and combinations of simple marks. All of these can be elaborated or repeated to form a BORDER pattern that provides a balanced and considered result.

As you explore the possibilities for decoration of individual letters, introduce whole words so that when you finally include a decorated letter in a piece of work, it does not totally dominate the work (although there may be occasions when this is the intention). The first word of a text may have an illuminated initial letter but a relationship needs to be established with the remaining letters of the word. On many occasions, these too may require a measure of decoration, either to the actual letters or to the areas within and surrounding them, or both.

▲ The Lindisfarne Gospels of the late seventh century are written in Anglo-Saxon majuscules, which developed from the Insular half-uncial scripts used in Ireland. The letters display typical half-uncial characteristics – roundness, wedge serifs, and a flat pen angle. The interlinear gloss, added in the tenth century, was written in Anglo-Saxon minuscules. The decorated first word incorporates basic elements of embellishment: dot, line, filled counter shapes, interlacing, simple animal forms and colour.

▶ This title page from the late fifteenth-century Cartae Antiquae shows a decorated uncial form, with a miniature painting in its counter shape. The letter decoration includes dots, lines, and a tonal "shadowed" effect. The ends of the serifs are treated in an organic manner reflecting the vegetation that flows and grows from the main border. In the outer border, the foliage resembling peacock feathers is sympathetic to the weight of the informal cursive and Gothic-inspired script.

This splendid decoration is the title page of St Matthew's Gospel in The Book of Kells. It displays the supreme confidence and exuberance achieved by the Celtic illuminators. The profusion of geometric shapes is intricately woven into minute patterns.

The letter shapes have dark keylines marking their edges. Thick lines of purple and orange border the letterforms and create a framework to contain the ornament. The areas of ornament are further highlighted by the broad line of the border breaking the letter into sections of different patterns. The patterns range from intricate spirals, coils and knotworks, to simple, regular repeat patterns. The first letter also contains several squared grids. The counter shape of the second letter, the p, is dominated by the head of an angel, whose yellow hair lined with red is complemented by adjacent shapes containing simple interlacing.

Surrounding the letters, and as much a part of them as the pattern within them, is a further world of symbols. Each knotwork is constructed of one continuous line, symbolic of eternity. Down the long extended diagonal of the main letter are feet and human figures. Contained within the profusion of swirling shapes are elements of zoomorphic ornament – a speciality of the Celtic illuminators. In Celtic illumination, balance is achieved in both the importance of individual elements and in design of the page – neither letters nor ornament dominate, and great harmony sings from the page.

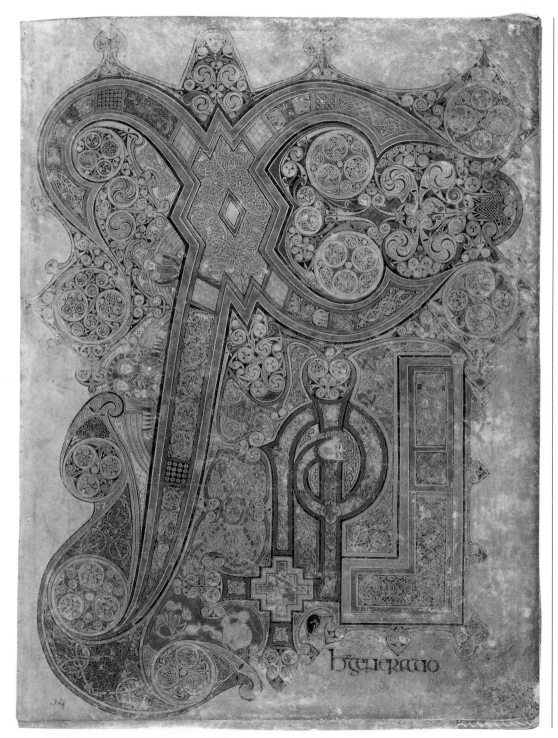

MICHAEL HARVEY

Roman majuscules, elegantly proportioned and flowing, are perfectly complemented by the block borders. These borders frame the initial letter and provide a perfect opportunity to introduce colour. The informal script of the left-hand column descends with a free rhythm; some letters break through the x-height to add to the visual movement. On the right, the capital script forms a different rhythmic pattern made by the angles of the letters.

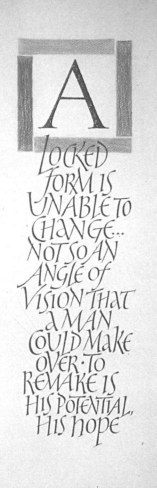

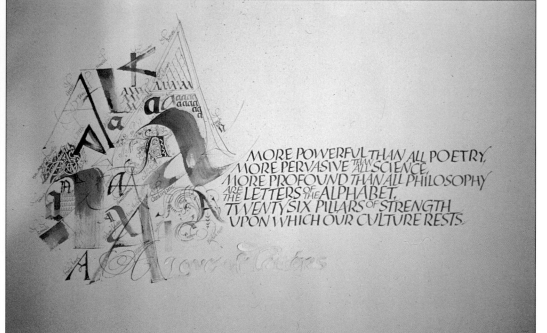

◄ DAVE WOOD
These free-flowing and vibrant illustrative letterforms (brushed, drawn and decorated) are arranged in a montage format, which complements the subject of the script.

▼ ISABELLE SPENCER
A Gothic letter is drawn with an emphasized double line and fine hairline extensions which add to the decorative feel of the letterform.

► CHARLES HUGHES
Alphabet letters drawn in an italicized monogram. Note the shared stroke linking C to Z and the swashed extension of the X, linking it to Z.

► SUZANNE GUEST
In a multi-media example which combines coloured pencil, split-pen and ordinary pen strokes, the pencil rendering simulates stone or metal work and the whole image swings out into the page in strong illustrative graphic form.

▶ DAVE WOOD
White Italic lettering with long ascenders and descenders forms the main linear axis of this design. The decorated letter used as ornament is carefully placed off-centre to provide balance to the design.

◀ DAVE WOOD
The detail shows how white ink on black paper, contrasted with coloured pencil work, has been used to a stunning effect. The A is roughly drawn but carefully ornamented with swirling leaf forms, the texture of the pencil shading also adding to the vitality of the design. Above the textline various forms and styles of the letter A have been superimposed, their vigour and movement enclosed in a formal border of alphabet letters in a diamond shape. Along the written white line, small diamond shapes of colour are attached, linking it to the main decorated letter.

Positioning of the text and decorated shape are important, but so, too, is choice of colour. Here the white lettering is complemented by shades of blue and lilac, with an audacious use of yellow in the top decoration.

▶ GEORGE THOMSON
This beautiful example of a decorated letter and script shows very strongly the historical influence of the Book of Kells and the illuminators of Lindisfarne. The script is a round, Uncial-style hand, the larger letters at its commencement having their counter shapes filled with colour. The wedged serifs also visually echo the type of decoration used, which is circular and enclosed.

The colouring of the initial decorated letter is soft, but with areas of black in the pattern to provide contrast. In its delicacy it is also reminiscent of the vegetable-based colours used in the old illuminated manuscripts. The main letterform has two black keylines enclosing a blue border. The curved stroke of the P sweeps round and is slotted through the main downstroke, curving up to end in a flourish. The whole letter blossoms with trefoil, leaf and circular shapes; the decoration inside is formal and contained, yet exuberant.

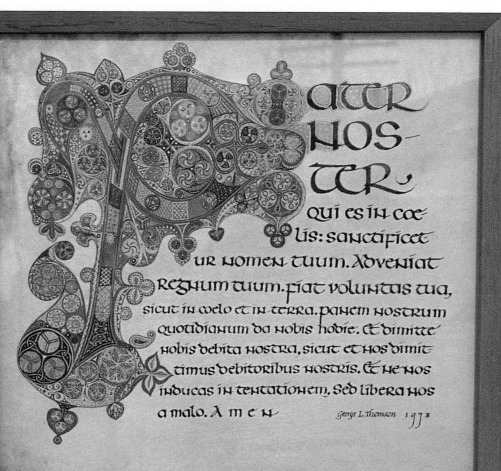

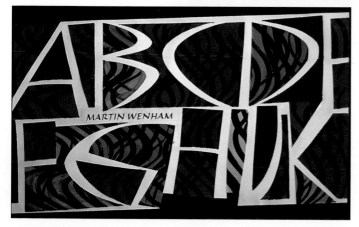

MARTIN WENHAM

◀ MARTIN WENHAM
This lettering is an interesting example of calligraphic letterforms being carried into graphic design. The lettering is not drawn, but cut out of the paper to show as white on the finished design. Strokes of black on areas of flat colour form the negative shapes around the sans serif letters, and the counter strokes of the B, C, D and G are styled to match each other. Note the way the C and D have been joined. A larger area of white bears the artist's name, and the whole design has been set slightly at a slant to echo the sharp, dynamic letterforms.

ALPHABETS

A device often used by the calligrapher is the transcription of an entire alphabet. Alphabets can, in themselves, form splendid pieces of art. The layout for an alphabet piece is ideally determined by involving the actual letterforms. This concept works better with some calligraphic scripts than others. A regular hand, where the letters usually occupy an individual space, as in the UNCIAL hand, presents fewer possibilities than a more freely constructed brush letter or an italic hand that can be flourished. Establishing close relationships between the letters is one challenge of executing an entire alphabet.

The spaces within and around the letters require some special attention. Some letters juxtaposed immediately above or below each other lend themselves to some kind of intertwinement; or two adjacent letters may have a coterminous or joining stroke.

The fall of the letters on the page can often work exceptionally well with very little prior planning beyond establishing a general idea. A spontaneous approach can work more successfully than a methodically prepared solution that looks contrived.

Frequently, the layout of an alphabet is constructed between five and eight lines. You can attempt variations by making more or fewer lines, and experimenting with line lengths. The addition of small motifs such as diamond dots in a contrasting or highlighting colour can put a good finishing touch to a piece.

Enclosing an alphabet within a border can create further interest. The border needs to be well placed so that the letters are not squashed into the enclosure. Consideration of design elements for the border need not be confined to simple marks such as dots and lines; it could be made by repeating the letters of the alphabet, or by forming them into words.

Transcribing the letters in colour can be fun and very effective. Exciting results can be derived from employing the technique of laying a wet colour next to (and overlapping) another wet colour. The colours will run and merge with very interesting effects.

▶ STUART BARRIE
Superimposed letterforms in black on grey form a dynamic pattern in the alphabet example. A grey felt marker was first used very loosely, followed by a black calligraphy marker. The rough strokes of the lettering flow quickly across the paper, creating a vibrant image.

▼ DENIS BROWN
This is an exciting presentation of Gothic Textura with textural variation. The basic alphabet has been carefully positioned in grey, and the other design elements superimposed on and around these letterforms. The design has also been enhanced by well-placed text panels, a small diamond shape containing red letterforms and an illustration.

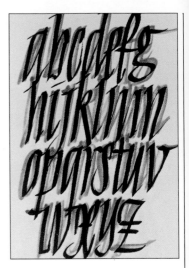

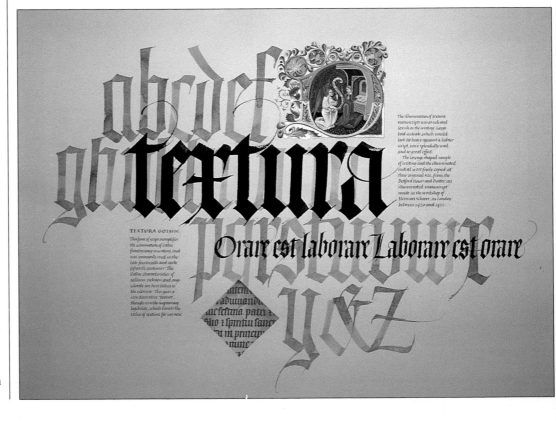

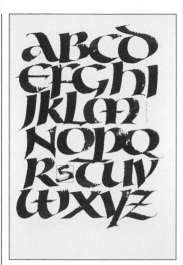

◄ PAUL SHAW
The rounded letters of an uncial form are the inspirational source for this alphabet, written in calligraphy ink on Arches paper. The personal mark of the calligrapher – the S in a box – breaks the linear arrangement. The "fraying" of the edges and strokes of some of the letters alludes to a distressing of the work, and creates an interesting feature.

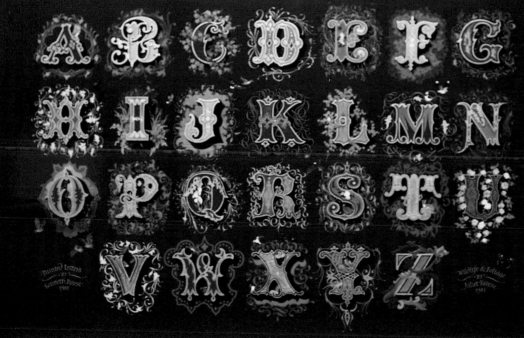

◄▲ KENNETH BREESE
The bold, bright colours of the individual letters painted on this panel immediately capture the viewer's eye. Then comes the discovery of how the letters are constructed. Organic forms curl and entwine to become letters. Each stands proudly against an individual background, which continues the theme with finer detail. Dot, line, shape and colour combine to construct and decorate the letters.

The detail picture of the letter H shows a regal letterform. The swirling foliage of fine lines and accompanying flowers that constitute the background provide a satisfying contrast with the solidity of the letter, complete with its painted shadow.

▶ MICHAEL HARVEY
There are many ways to introduce contrast in a single work. The juxtaposition of an informal and a formal lettering style creates both tension and harmony. Here, italicized stencilled letterforms, boldly coloured yellow, range down the centre of the page. The lines flow to the right and left of an imaginary centre line, creating interesting graphic shapes on either side. Into these shapes move the elegant formal versal letters, their classical nature contrasting with the weight and texture of the stencilled forms.

▲ MICHAEL HARVEY
Combined techniques may not always be successful but, with perseverance, exciting solutions should emerge. Here overlapping colour washes provide both a background to the overall work and a ground upon which to write the letters. The consonants are presented in a versal style, including some innovative lower-case versions. The vowels, in lower-case form, are placed in a prominent position in the lower half of the portrait-format work. The counter shapes of these letters are filled in with red, a basic method of decorating a letter.

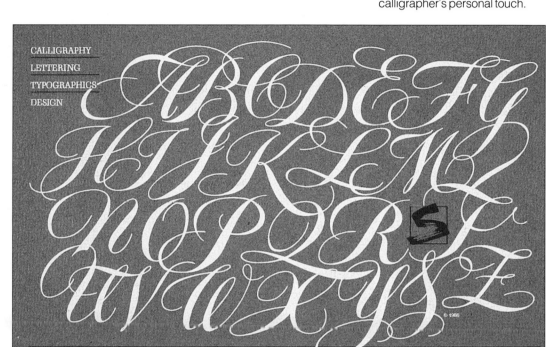

▼ PAUL SHAW
An original and well-designed business card is an essential item. This silkscreened card appropriately uses a calligraphic alphabet as the main image. The white letters display well the characteristics of Copperplate style: fine, thin strokes and bold loops. The red S in a box breaks the pattern and adds the calligrapher's personal touch.

◀ MEIC MORGAN-FINCH
The letters of the Welsh alphabet have been written in a style evocative of Humanistic italic with its exaggerated, thin strokes. A Welsh folk poem frames the alphabet which rhythmically descends the page.

ISABELLE SPENCER
Here is a calligrapher experimenting boldly with different techniques and materials. Worked on Tre Kroner paper, with Automatic pens and India inks, the experimental alphabet dances down the page. Elongated letterforms and others constructed of bold diamond shapes weave together to create an interesting texture to the layout. Balance and complexity are added with the insertion of a quotation decorated with burnished gold.

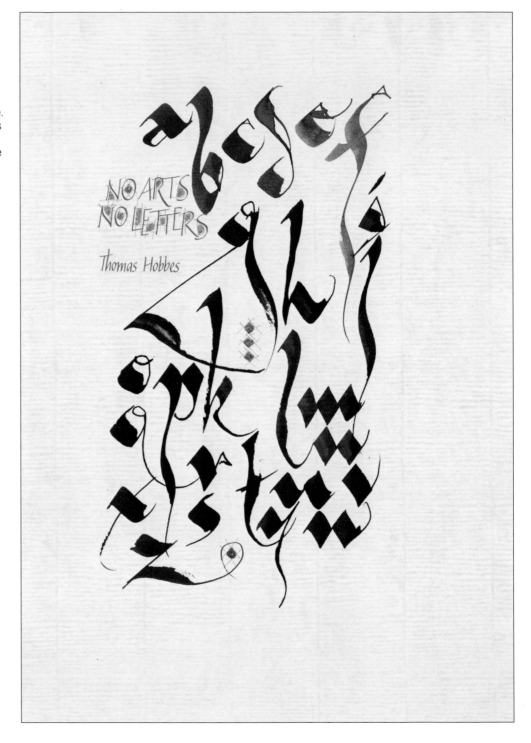

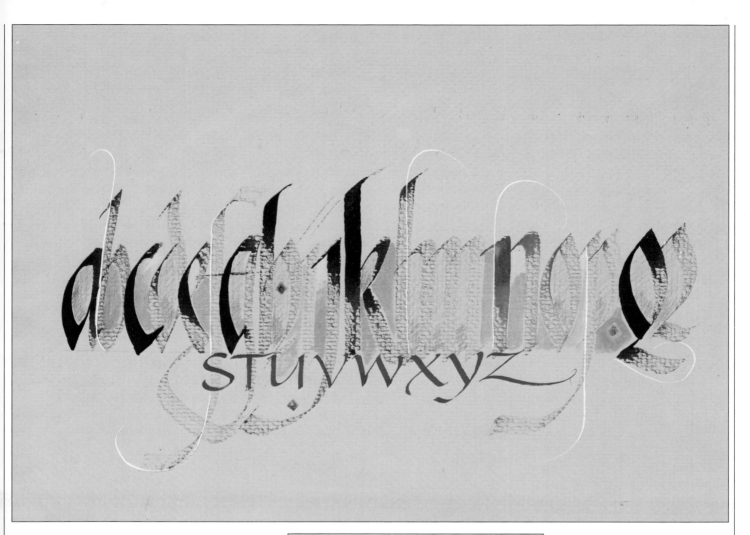

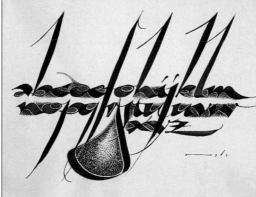

▲ ISABELLE SPENCER
Texture is an important feature of this work. Experimental pen-drawn letterforms have been treated with different materials, including crayons and gold gouache. Just skimming the surface of the Americana paper can be enough to exploit its texture. Burnished gold and fine white vertical lines add finishing touches.

◀ ARTHUR BAKER
The humble dot, massed to create texture, is most effectively introduced to the counter shapes and spaces between some of the letters of this alphabet. This graduated texture is an effective contrast to the solidity of the elongated ascenders and descenders with their hairline extensions.

FORMAL CALLIGRAPHY

When the conversation turns to calligraphy, the most readily recognized areas of work are illuminated manuscripts, civic and royal citations, certificates and religious works. The work of the illuminator will often precede recognition of the expertise and skill of the scribe. Sometimes the work of the scribe is not commented on at all. Museums, national libraries and places of worship all display (and possess) great manuscripts primarily for the richness of their ornamentation and illumination, so this specific area of traditional calligraphy does have a wide and appreciative audience.

The student of calligraphy can learn an infinite amount from studying the great works. Edward Johnston, who reawakened interest in calligraphy in the United Kingdom in the twentieth century, spent hours copying, taking notes and, most importantly, exploring letter shapes. When looking at manuscripts that include fine decoration, do not dismiss the work invested by the master scribe, who laboured carefully to produce the beautiful letterforms that combined to form the basis of the manuscript.

It is helpful to construct a system of observation; this could be divided into looking at ornament and pattern, then letterforms and their construction, followed by a review of how the constituent parts work together in the layout of the page and throughout the whole work.

On visits to see museum and archive collections, or an exhibition of fine traditional manuscripts or historical documents, always take a sketchbook. Make notes and sketches, paying particular attention to recording the areas and details that appeal to you personally. These might be the juxtaposition of some letters and ornament, or an inventive way of joining two letters, or an interesting combination of shapes. Write descriptions and allow personal ideas and thoughts to permeate, merge and be noted. Examining these glorious works can be a good exercise in learning to look at things thoroughly. Their splendid nature may simply astound you on first viewing, which is not surprising. Follow a basic design principle – break down the image into manageable parts and then begin by making notes and sketches.

If the opportunity to inspect closely very old manuscripts does arise, this will also afford a valuable chance to study the individual letter shapes and the variations applied to the classic hands by some scribes. There are advantages in not comprehending a transcribed language, although some words may be familiar. Studying works written in another language allows you to give full attention to the forms without distraction.

Upon scrutiny of a work that appears absolutely "perfect", it is reassuring to discover irregularities and inconsistencies in the make-up of the letters. This, rather than marring the work, lends character and reminds the viewer of the fallibility of the master scribes. If the language is unfamiliar, look for repeated letters, allowing that they may vary. The Books of Durrow, Kells and Lindisfarne each provide wonderful examples of a single manuscript with a diversity of letter shape for the same letter. Often, letters are extended to the right to complete a line, the available space being too small for the next word.

Ceremonial documents

There are recognized and standard layouts for some documents although, when considered, these have probably developed simply through scribes referring back to what had been done before. It is unlikely that any strict rules were ever made, so there is scope for original conceptualization. The solemnity of the occasion being recognized can be retained even with a slightly adventurous layout. In the same vein, a creatively original layout can remove an unnecessary gravity of tone.

Variations in layout may occur naturally, dictated by the information to be written. If the work involves a list of names to which, in time, more will be added, there are restraints imposed before planning begins.

Some work may involve a large amount of copy

(text) and information of varying importance. The wording on certificates, diplomas and ceremonial pieces is often of considerable length, so time will be well spent in planning how to fit it all on a single page in an attractive and legible manner.

The words at the beginning of a presentational document are usually the most important. These words will proclaim the purpose of the citation and its intention. Due consideration given to the construction of the words and layout will focus the reader's attention on them. You can borrow a technique used in early manuscripts that can help to convey the significance of these words. This involves transcribing the first sentence or paragraph in a lettering style that is presented in a bolder manner and size than the bulk of the text. You might even consider transcribing these words in a different colour.

Since the advent of the printed page, there has been a steady decline in the demand for calligraphers to produce ceremonial or legal documents, charters and other formal works. There are many contributory factors to this decline, including social, political and economic changes. There has been, however, an increase in the need for, among others, educational diplomas and certificates. As the work required to produce all these completely by hand would be prohibitive, the documents are printed from art work either prepared by a calligrapher or designed using typefaces with calligraphic features. The calligrapher is then assigned the task of writing in the date and the name of the recipient. There may still be a few occasions that require a formal document to be completely hand-crafted.

The inclusion of traditional ornamentation on a work of a ceremonial nature is good practice. It may be necessary to include a coat of arms, heraldic shield or religious motif depending on the nature of the work. If none is specified by the client or dictated by the piece, many of the early styles of illumination can provide inspiring ideas.

The application of gold, particularly RAISED GOLD, in selected areas is a standard set long ago in this style of work. The raised gold, highly burnished, lends a very splendid finish to these pieces and should be seriously considered.

By its very nature, work of this category can be overwhelming in concept, heavily steeped as it is in long historical tradition. There may be occasions when a bold approach can be ventured and some deviation from "accepted" designs may be tried, and approved by a client. There is always the possibility that a new creative approach could, in time, form the basis of a new set of standards.

JOAN PILSBURY
There are many individual items of information which have to be included in a single ceremonial work. A concise and balanced layout can be achieved, as illustrated in this entry in the City of Rochester's Custumal Book. The information has been sorted into levels of importance, and in the final result they have their own spaces, are related to one another, but do not compete for attention. This has been achieved by varying colour, lettering size and style.

▶ HARRY MEADOWS
The arrival of heraldry in Wales makes an excellent subject for this work. The layout, designed to include 36 individual shields and a synopsis of the development of arms in Wales, has been well considered. The title lettering is rendered in a split form, with swash extensions to some of the letters. An effective and simple method of decorating letters – counter shapes filled with solid colour – is exploited using blue, red and gold. The first sentence is written in blue capitals and stretches across the width of the work. Both the heading and sub-heading make use of interesting letter shapes, including the A with the half-diamond crossbar. The Italic hand of the text has slightly exaggerated descenders which add to the texture and formality of the work.

▶ HARRY MEADOWS
The detail shows clearly the fine swashes and hairline extensions to some letter strokes in the headings. Interesting shapes are created by overlapping some of the letters: MA, LA, and RY in the sub-heading. The shield is the most important part of an armorial bearing. Here the shields display the splendour of gold, and detailed design motifs. The use of a fine nib and smaller writing to caption the shields is an important feature of the layout. The two lines above each shield have the effect of anchoring them to the page and in turn relating them to the whole design.

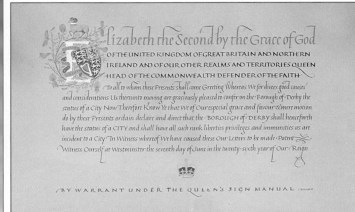

▲ JOAN PILSBURY
The clarity of the layout of this work immediately catches the eye. The work is a Letters Patent granting City status to Derby in 1977. It is executed on vellum, and begins with an enlarged gilded letter, that on its own might have been too dominant for the page. However, with foliage and flowers applied to the surrounding space, the banner unfurling down the vertical stroke and the shield angled into the letter, it is prominent but not distracting. The italic hand of the opening line has well-considered space between the letters, and extended ascenders. These extensions are echoed in the text copy, which has well-judged interlinear spacing to accommodate them. The generous spacing also lends formality to the piece.

▼ GEORGE THOMSON
The scroll is an ancient and viable solution to a request for a formally presented work. This vellum scroll begins with the motto scroll placed above a splendid rendering of the coat of arms, whose shield breaks into the text space. An Uncial form is used in the original layout, beginning with the first two words ranged left. An extension to the letter t completes the second line of the main text. The scroll is secured by means of red ties, which are seen here laced through at the top and bottom of the unfurled vellum.

111

▶ IEUAN REES
In this declaration of friendship between two communities, the layout triumphs over the amount of information to be included on one sheet, and is sympathetic to the content. Thus the work is accessible and friendly – most suitable qualities for the occasion! The title is written in a Gothic-inspired style, decorated with controlled flourishing appended to the capital letters and ascenders. The main text is written clearly, with very fine hairline extensions to some letters. Each of the text areas works well alone, and in the piece as a whole. A small amount of linear decoration binds and anchors the three circles containing the heraldic devices. Final balance of the layout is achieved with the rendering of the right-hand column of information.

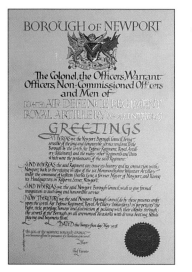

◀ HARRY MEADOWS
The introductory part of this work is centred, creating a harmonious balance to the layout. The various lettering styles – Versals, Foundational and Italics – work well together and have been well chosen for the information they present. The tight letter spacing of the gilded lines, worked in raised gold, creates splendid illumination, brilliantly picking up the light. The word "Greetings" has been executed with a split nib, and has subtle swashes and hairline extensions. The red W nestling under the G of "Greetings" serves as a good linking device.

IEUAN REES

A short history of the association of the Dynevor family and the ravens that appear on the family coat of arms is beautifully presented on a coloured paper. The chosen colour allows the black ink to appear strong and opaque, and the colours used in the writing and decoration around the circle to stand out. The piece is dominated by an excellent rendering of the family shield surrounded by the title of the work. The history is given in two blocks of text, written in Welsh on the left and English translation on the right, balancing the work.

Note in the detail picture the flourishes added to descenders in the title, and as letter extensions in the upper half of the circle. In the lower half of the circle complementary additions have been made into the space above the letters, thus creating a separate ring of decoration. This circle of flourishes interspersed with diamond dots breaks the space between the shield and the lettering of the title.

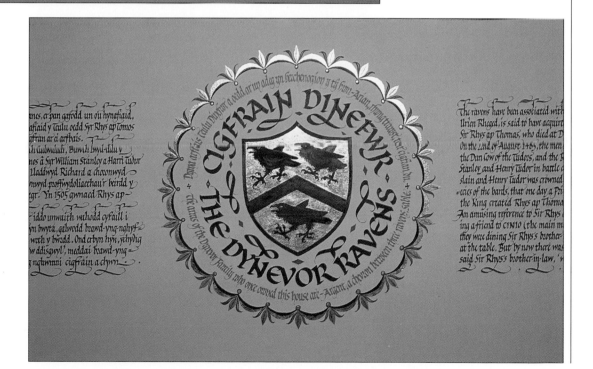

HARRY MEADOWS

A message of greetings is arranged in two columns, Welsh on the left, and English translation on the right. The two columns are balanced by the juxtaposing of the college crests, at diagonally opposite corners of the piece. The historically old technique of beginning a new paragraph with a coloured and enlarged capital pulled into the margin is employed to fine effect. Both the headings and body text make good use of extending letters to fill lines, so the work lines up in the headings, and balances on the right side of the main text. Although the lines are still ragged-edged on the right-hand end of the columns, this technique is put to good effect. The Italic of the text body has some extended ascenders and descenders, but they do not interrupt the clear legibility of the words. In the detail picture, the raised gold on the college arms is more clearly visible. The positioning of the date with the final words is worthy of attention. This is a clever solution. The consideration afforded to small items – like the date – is often minimal, neglected or overlooked. Dates, like all information, are important and are there for a reason.

IEUAN REES

An accentuated long portrait shape has been used to present this very traditional piece of work. All the ingredients of an historical item are included, beginning with the coat of arms of the borough, richly reproduced with dense colour and gold and silver. Single lines of words rendered in red and blue highlight pertinent information, and appropriately break the black text copy into manageable portions. Each of these lines begins with a single small flourish extending from the margin. The intrusion into the final paragraph of the raised gold crown provides a good linking device between text and illustrative matter. The armorial device is not isolated and apart, it is enveloped. The angling of the final two lines, offset against the foliage-bedecked banner is an inventive method of including information seemingly of less importance. The overall work which culminates in the embossed red seal has a feel of an award – like a medallion on its special striped braid ribbon.

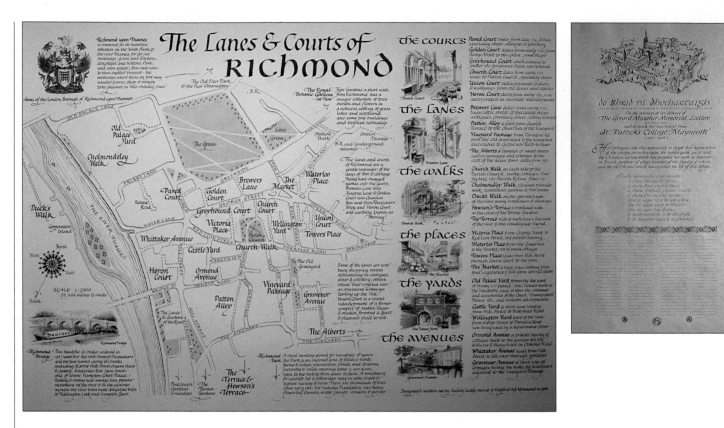

▲ **AUDREY LECKIE**
Like so many examples of work displayed in this section, this is a piece that has required much time to be spent on determining a balanced, pleasing layout. All the information needs to be assembled, and its order of importance assessed, from which the position in the final presentation and an indication of lettering size can be deduced. Changes of lettering style and colour have been used to give prominence here, even though space is limited.

▼ **DAVE WOOD**
The presentation of this work most suitably reflects in its originality the dual occasions it salutes. The loose Versal letterforms are written with rhythm and many letters share space, with strokes linking and crossing each other. Corded ribbon in the colours of the country seals the celebratory nature of the work.

◀ FRANCES BREEN
A presentation piece written out using a quill and Mitchell nib, with Chinese stick ink, gouache and shell gold. The paper has a marbled finish. The aerial line drawing of the college and grounds is an innovative way of beginning a work of this nature. The red letters of the Irish script are beautifully rendered. In the first line the decorated letter technique of simply filling in the enclosed counter shape is applied. An elegant enlarged letter is used to introduce the main text block, causing the first two lines of copy to be indented.

▶ DOROTHY AVERY
A small traditionally influenced work, whose form may reflect the shape of the windows of the building where it hangs. The ground is stretched and mounted vellum. The style of the decorated letters in the title is ecclesiastically evocative, with the rich maroon shapes filled in with dots. The letters are of Gothic origin. The solidity of these decorated capitals is offset by the light and delicate nature of the foliage and flowers behind the shield. Further decoration has been applied at regular intervals to the line separating the two columns of names which, quite unobtrusively, creates more interest than a plain vertical rule.

▲ DAVE WOOD
The format of this extraordinary retirement presentation is creative and original. It also firmly dispels any notion of a concept of standard rules for the layout of formal works. The name of the recipient is inscribed in expertly embossed Italics. The long extended flourish to the letter R plays a significant role. It provides, between its two main curved diagonal strokes, a natural space for the insertion of the text copy. At the end of the flourishing stroke, when it finally comes to rest, the shield of the educational institution is placed like a full stop. The Blackletters of the text are written with restraint, with limited use of accentuated letter extensions, and hairline additions to serifs and strokes.

WORDS

In the history and development of Western calligraphy there have been, since the beginning of Roman times, particular individuals ·recognized as responsible for providing certain forms of written communication. Before printing was invented this role was almost solely played by the scribes. With the invention of printing, the general attitude and approach to communication changed dramatically. Scribes and copyists were no longer needed for jobs which could be produced in great quantities on the printing presses, but were still required to produce single and small-quantity works.

The early wood-block and typeset pages of books mimicked the page layout and style of the scribes. Spaces would be left to be filled in by hand with colourful ornament and initial letters. Great effort was made to create an illusion of something being other than it really was – in this case, a printed work as a hand-crafted manuscript. In time, the page make-up of the printed book took on an independent appearance. Compared to the elaborately decorated manuscripts of such a short time before, the pages were quite plain and simply laid out. For a short period, even scribes attempted to emulate these pages.

The scribes found a new lease of life when they took advantage of the new technology of print. The interest in learning to read and write created a demand for people to teach these skills. A wider audience could be reached by the manufacture of copybooks, in which the scribes were freely able to dictate their own individual styles and predilections. The books with sample alphabets, instructions for handling the required instruments and details of letter construction are the forerunners of many contemporary instructional books on lettering and calligraphy.

The contemporary calligrapher can learn from some of the upheavals that confronted the writing masters when printing methods supplanted hand-copying of texts. The function of fine writing has inevitably changed because of the predominance of the printed word. The calligrapher produces something of great beauty, crafted work of individual quality whose *raison d'être* lies in this very fact of it being hand-crafted. Ideally it is not something that can be more effectively created or reproduced by machine. If it is thought that the end result could be better achieved by some other means, serious consideration needs to be given to the specific design quality of the whole. The adventure of calligraphy is in producing something that cannot be done another way.

MARTIN WENHAM
The watercolours used for this work were mixed on the paper by a lift-off technique. The resulting hues are truly evocative of the summer heat haze in long grasses. The tall, thin letters, flaring at their ends, echo the grass blowing in the wind below. This work is titled: Natsukusa (Homage to Basho).

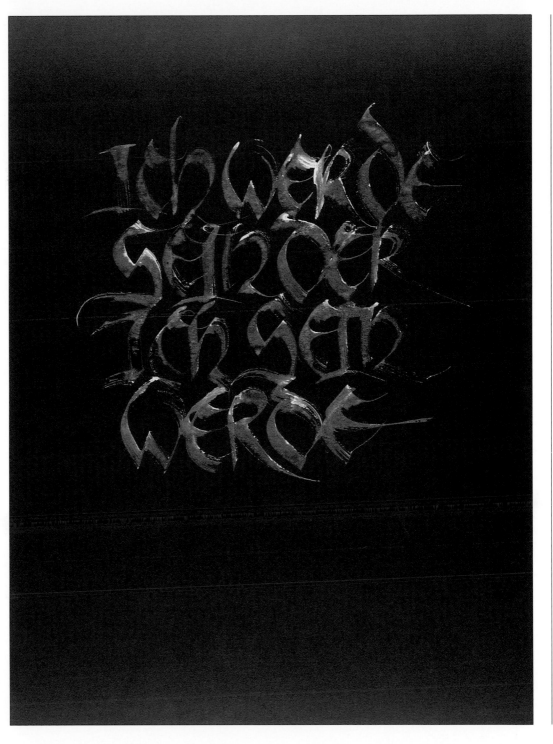

RENATE FUHRMANN
This extraordinary piece of work
in wood-tar and distemper
evokes both something ancient
and something contemporary.
The glorious patina on the surface
of the letters elicits a sense of
antiquity. The shapes of the letters
have the angularity of a Gothic
style, mixed with some aspects of
Uncial form. The freely used
instrument has left interesting
effects where the liquid medium
ran out. This results in a network of
fine lines that underscores the
solid treatment of the letters.

QUOTES AND POEMS

The sixteenth-century writing masters frequently included quotations from the classics and selections of Latin text in their copybooks. After the lettering exercises and alphabets, these were recommended for copying to encourage proficiency in writing. This approach continues in some writing instruction books today, to provide the student with succinct passages with which to try out the newly acquired skill. Encouragement is then given to seek out favourite lines from admired authors to transcribe. As an exercise, this presents the need to attend to several design considerations, from letter size and spacing to overall layout.

As literacy flourished after the Middle Ages, great importance was attached to the acquisition of good handwriting. Throughout the following centuries, practical application of writing was nurtured and held in high regard. By the nineteenth century it was taught in schools not only as a practical and necessary skill but to instill discipline and it was believed to be an aid to character building. In this way the writing out of small homilies or poems became quite common.

As a practice, the production of quotes and verses is supported today by an industry which produces small, often humorous sayings which can be hung on walls, placed on a desk or even displayed in a car window. Sadly, there is seldom any calligraphy or calligraphic art involved. A typeface resembling a GOTHIC Blackletter

for example, is sometimes used in an attempt to create a particular nuance.

Calligraphy is an ideal medium for presenting simple and often poignant sayings, or passages of elegant prose and poems. The calligrapher can first find pleasure in selecting a piece to transcribe, then consider how the words should be presented. Many choices have to be made – the paper, the calligraphy style, the size and colour of the lettering. Some words can be quite splendidly presented without embellishment or flourish, decoration or illustration. The work, if beautifully crafted with well-constructed letter forms and a well-considered layout, can stand on its own merits.

It is advisable to spend time on roughs for this type of work; first working to any size and then experimenting with the finished size, if previously known, or a size that seems to do the content justice. The usual layout considerations for calligraphy are applied: line breaks, interlinear spacing, margins, line arrangement on the page, and so on. A finished colour rough, if applicable, is recommended.

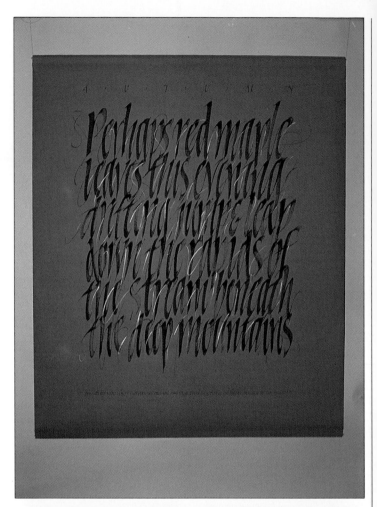

◀ DENIS BROWN
This work about autumn is one of four, each exploring a season. The background colour burns like the colour of the leaves described. The script is loose and layered, creating a soft texture. The single line repeating the words along the bottom of the page anchors the layout. In the detail picture, the surface texture of the lettering is clearly visible.

▲ ANGELA HICKEY
Using metal pens with gouache, watercolour and resist, the theme of this work is simply and eloquently presented.

THE BOOM
ABOVE
MY KNEES
LIFTS
AND THE
BOAT DROPS
AND THE
SURGE
DEPARTS

departs my cheek kissed and rejected,
kissed, as the gaff sways a tangent
cuts the infinite sky
to red maps & the mast draws eight
and eight across measureless blue.
The boatmen sing or sleep

◀ ANGELA HICKEY
Mould-made paper is the chosen substrate for the transcription of the poem "Sailing to an Island" by Richard Murphy. Using metal pens with gouache has resulted in an irregular laying of colour on the large capital letters that begin the work. This has a curious effect of light falling across the letters. Organizing the layout of a long poem is not easy: here two columns of unequal width work very well. The introduction of varying letter sizes creates texture and breaks up the text copy. The group of words in the lower right-hand column, centred by eye and running vertically, is another effective method of creating texture and interest right to the last line.

Where there is

may we bring

Where there is

may we bring

Where there is

may we bring

Where there is

may we bring

Where there is

may we bring

HOPE

Saint Francis of Assisi

HARRY MEADOWS

In the transcription of a succinct quotation from St Francis of Assisi, the considered choices of lettering style and colour combine to make this piece of work truly eloquent. The careful planning, including obviously well considered interlinear spacing, results in an excellent layout. Several of the words executed in red make use of very simple letter extensions to fill the line and create a balance with the remainder of the centred text. Some of these extensions originate from the crossbar of the letters, to great effect.

HARRY MEADOWS

Red handmade paper is the choice of substrate for this quotation, and it provides a dense and rich background for an interesting interplay of letters. Texture is an important factor in this work: in the paper, in the visual quality of the text – where words are written over words – and in the choice of lettering style. The calligraphy is freely written in an Italic hand. The rounded endings of the descenders and some ascenders contrast with the slight angularity of the body of the letters. The overlay of gold lettering on the same text written in black makes a very attractive presentation on the red paper.

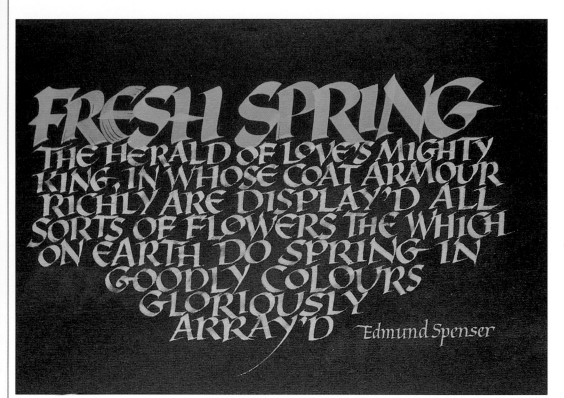

FRESH SPRING
THE HERALD OF LOVE'S MIGHTY
KING, IN WHOSE COAT ARMOUR
RICHLY ARE DISPLAY'D ALL
SORTS OF FLOWERS THE WHICH
ON EARTH DO SPRING IN
GOODLY COLOURS
GLORIOUSLY
ARRAY'D Edmund Spenser

JOHN SMITH
Bold and confident brush lettering introduces this Edmund Spenser quotation. Texture is a feature of this work, expertly written on black paper. In the text, with its minimal interlinear spaces, the roundness of the letters creates a rhythmic pattern. Very fine lines and serifs occasionally break the spaces to add another textural quality.

DOROTHY AVERY
A bought paper fan serves as an original presentation for a Shakespearean quotation. Each line is introduced with a simple device constructed from pen strokes and ends with colour decoration of a single flower and trailing foliage, executed with gouache and shell gold. The Gothic lettering has been written using Chinese ink.

HARRY MEADOWS
There are many original features in this presentation of a Francis Bacon quotation. The absence of interlinear space allows letters to touch or nearly touch, which creates tension. The strong diagonals of the A and slightly angled cross stroke of the T create further interest. The linking of the first four lines through vertical letter strokes is an interesting device, also applied to lines seven and eight. The raised-gold bird and motifs resting on the ampersand create a visual resting place in the layout of the whole work.

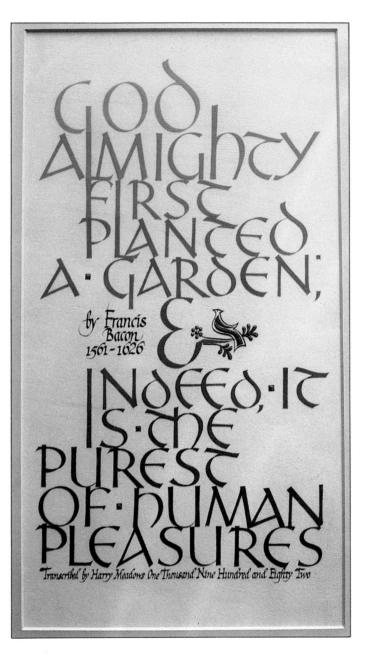

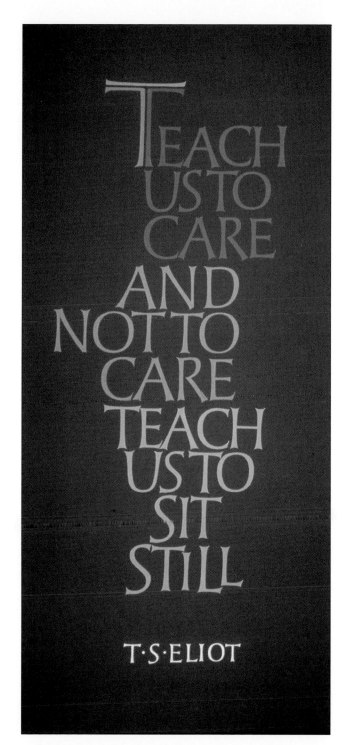

MICHAEL HARVEY
Presenting a quotation in a legible and pleasing arrangement on the page is not as easy as it may at first appear. For this work, Versal letters have been rendered in three different colours on a dark background, to eye-catching effect. The layout and use of colour need careful planning. Some quotations will more naturally dictate the line breaks. Three methods of alignment have been used in this work. The first three lines are ranged left, the next three lines ranged right. The final four lines are centred. This has created overall interest. The tri-coloured letter T adds a binding touch.

EMBELLISHED AND ILLUSTRATED QUOTES

Additional illustration and decoration, combined with original layout, captures the attention of the reader. These features can be considered in two main ways – as an adjunct to the calligraphy or as an integral part of the words. Working as an adjunct to accompany the words, illustrative material can add another dimension to the meaning of the piece. The placement is not unlike that found in illustrated books where a drawing accompanies the text. To create a good visual balance on the page, however, these two diverse components need to be considered together at the planning stage. The intention should be to attain a visual relationship even if there is no physical contact between the two elements on the page.

There are many ways this can be achieved. One is to pick up a theme from the writing and involve it in the ornamentation or illustration. This could mean creating an actual visual device or introducing a colour, or finding a method of executing the decoration that reflects the calligraphic hand. The alternative solution is more startling; that is, to devise an illustrative method that is a definite contrast to the calligraphy. This requires much careful thought and planning to make it work. It is a bold approach that can be very exciting. These are two very different design solutions that, if approached with care, will avoid a mediocre visual presentation.

To produce a piece of work in which the illustrative material is regarded as an integral part of the words can be a more difficult proposition. Comprehensive planning, working right through to a finished colour rough, is advisable. One direction for beginning the work is to break up the layout of the words from a regular patterning to a disjointed style. This creates obvious areas where decoration can be included, and it can then be worked on together with the calligraphy. The size of the letters could be altered to create a visual texture and you might even contemplate using more than one style of hand.

There are no written rules for this kind of work. The creative and inventive calligrapher has a wonderful opportunity to begin to push the art in a direction that is personally satisfying and can elicit an individual sense of achievement. Great pleasure can be acquired from delving into literature to discover obscure, challenging quotations and poems that, when beautifully presented, will evoke interest, intrigue and admiration.

HARRY MEADOWS
A differently described version of the Francis Bacon quotation shown on the previous spread uses minimal or no interlinear space. The capital letters sit on top of each other creating links between lines through the vertical strokes. Some of the spaces between letters are enclosed, resulting in interesting shapes. Some letters share strokes or overlap. Raised gold burnished to a brilliant sheen has been used extensively as a filling-in technique.

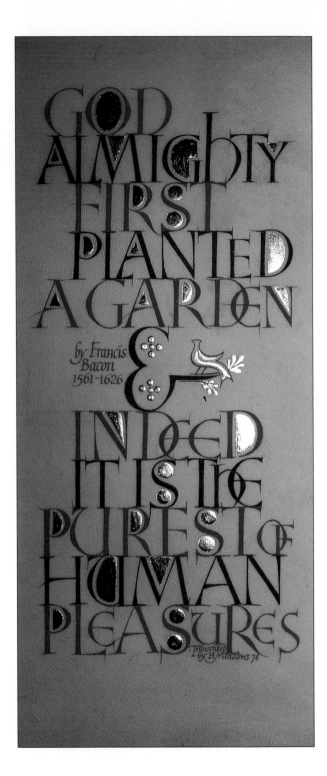

▼ KENNEDY SMITH
The illustration accompanying this quotation sits separately from the words. However, it is intrinsically linked to them by its nature, and the dominant effect it has on the work. Its organic form allows the quotation to be distributed around the image. Fortunately, the well-known words are most suitable for this device, but that may not always be the case. The amorphous structure has been decorated with delicate fossil-like markings.

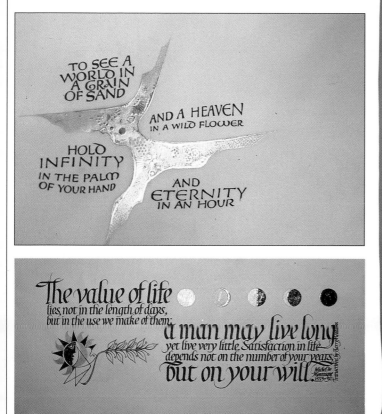

TO SEE A WORLD IN A GRAIN OF SAND

AND A HEAVEN IN A WILD FLOWER

HOLD INFINITY IN THE PALM OF YOUR HAND

AND ETERNITY IN AN HOUR

The value of life lies, not in the length of days, but in the use we make of them; a man may live long yet live very little. Satisfaction in life depends not on the number of your years, but on your will.

▲ HARRY MEADOWS·
Illustrative material for a quotation can be physically separate from the words, providing balance in the layout. Here, raised gold burnished to a high brilliance illustrates the passage of time, reflecting the theme of the text. Changing the size of the Italicized script adds to the textural quality, as do the fine hairline extensions on some of the strokes.

▲ DENIS BROWN
This quotation from Genesis provides the opportunity to introduce different techniques, in order that the importance of each succinct passage is given its own space. Many techniques are used in this work, including variations of letter size, colour, changes from upper to lower case letters, and making use of a painted background to highlight some passages. All create their own emphasis and texture, and work in harmony on this page.

127

MEIC MORGAN-FINCH
These splendid decorated Versals are reminiscent of woodcut letters, with their varying textural qualities. The texture is created by well-controlled pen strokes. Many of the patterns are made with simple marks carefully repeated to build up a decorative composition that fills the whole letter stroke. Except for colour, the components of basic design are all used: dot, line and shape. The nature of the resulting ornamental theme perfectly complements the letterforms. In the second row the spaces between letters, and the counter spaces, have been filled in with linear shapes that also evoke the texture of wood grain, further contributing the character of a woodcut in the whole work.

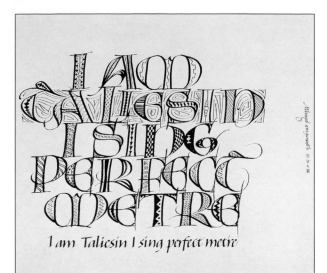

MEIC MORGAN-FINCH
This is an alternative layout of the previous image. The same sense of texture has been achieved by filling in the letter strokes with simple repeated marks. The decorated Versals have very fine line extensions to the serifs, adding a further component of pattern and texture.

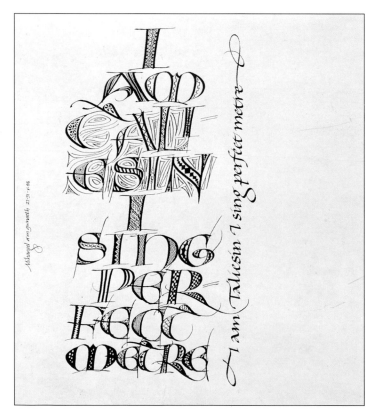

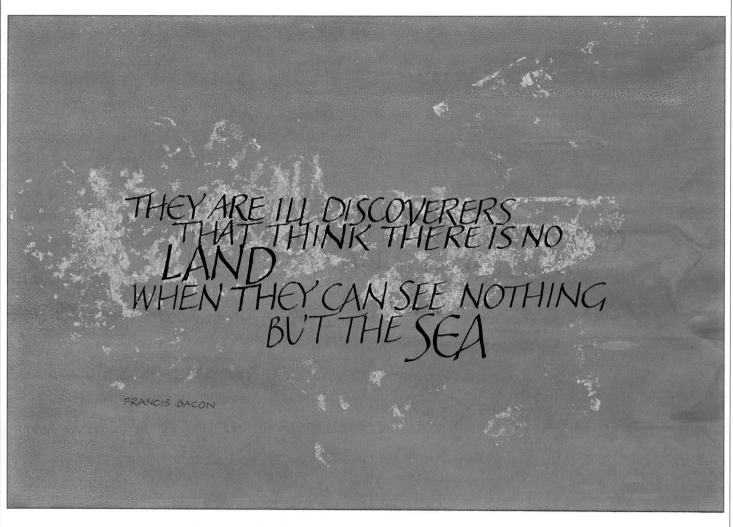

THEY ARE ILL DISCOVERERS THAT THINK THERE IS NO LAND WHEN THEY CAN SEE NOTHING, BUT THE SEA

FRANCIS BACON

ISABELLE SPENCER
A specific illustration representing the contents of the text is not the only way to enhance a rendering of a quotation calligraphically. Here, the calligrapher has created an interesting ground on which to write the words by applying transfer gold to an experimental screen print. The method of production, choice of colour, and addition of the gold give an illustrative result which does not dictate in a literal manner. Its apparent lack of definition in fact supports the text theme.

PAUL SHAW
The basic technique of decorating letters by filling in the counter shapes, in this case selectively, can give a decorative quality to the whole work. In this Ezra Pound quotation, it first appears that the counters to be filled have been chosen at random. Closer inspection reveals that specific shapes are filled in with a selected colour, and this is carried through the entire work.

▲ KENNEDY SMITH
Good planning shows in the tight layout of this work. The quotation from Shakespeare's *King Henry V* has been transcribed in letters based on a Rotunda hand, on Canson paper. The bees have bodies of gold leaf and wings of white gold, which was allowed to tarnish a little before being fixed with glair. The honeycomb is highlighted using powder gold.

◀ JOHN SMITH
The ocean is all-pervasive in this presentation of lines from "The Rhyme of The Ancient Mariner" by S.T. Coleridge. A watercolour wash has been put on the hand-made paper. The resulting tonal quality evokes the depths of the sea. A simple illustrative motif of ocean plant life introduces the lines of words written in designer's gouache.

HARRY MEADOWS
A medley of lines from poems written on the theme of the sea provides excellent subject matter for this calligraphic work. The opportunity to combine the naturally perceived rhythms of the restless ocean with the rhythmic quality of calligraphic patterns creates a tempting challenge for the calligrapher. Changes in letter size and style, punctuated by flourishing and illustrations of sailing ships, perfectly capture the intended spirit.

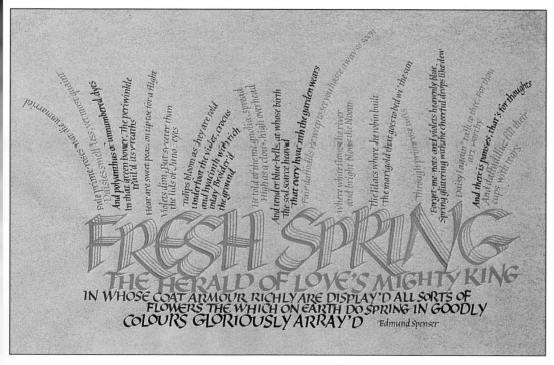

JOHN SMITH
The main title of this exuberant rendering of words by Edmund Spenser has been written using a "music" pen. This is a pen that, with controlled manipulation, reproduces five parallel lines simultaneously. The spirit of the subject is perfectly captured through the use of colour, lettering style and layout. The lines of descriptive images of spring burst forth from the main title. The title is firmly and solidly anchored at its base to four further lines of words. These lines have minimal interlinear spaces, and in their rich earthy colour and solidity of form support the total work.

131

DAVE WOOD
Ideally, text and illustrative material should complement each other in some way. They can be linked physically by line, shape or colour, or the words of the text may inspire visual images. Each part of this work moves in its own space, but the parts are still related through mood and colour. The freely written hand has an exaggerated s which breaks into the interlinear space and connects the lines vertically.

FRANCES BREEN
The texture of the Ingres paper is exploited to great effect in the illustration accompanying this detail of a rendering of a tenth-century Irish poem. The texture in the ink and pencil illustration is reflective of the beautifully written script, based on a seventeenth-century Irish hand. A Mitchell nib with designer's gouache was used for the script.

GEORGIA DEAVER
Beautiful flowing and enlarged red letters based on Rustic capitals introduce the story of a stonecutter. The text is rendered in an elegant version of the same hand, with its characteristics of fine vertical strokes and strong diagonals and horizontals.

ANNIE MORING
Tissue paper of various shades of blue has been mounted on smooth, heavy paper to provide an original background for the transcription of a poem by Lord Byron. Tissue paper is very difficult to write on, easily damaged by a pen, but a brush has been used here. The brush lettering includes several tones of carefully mixed blue and green designer's gouache. A splendid profusion of raised gold dots has been interspersed between the words of the first seven lines.

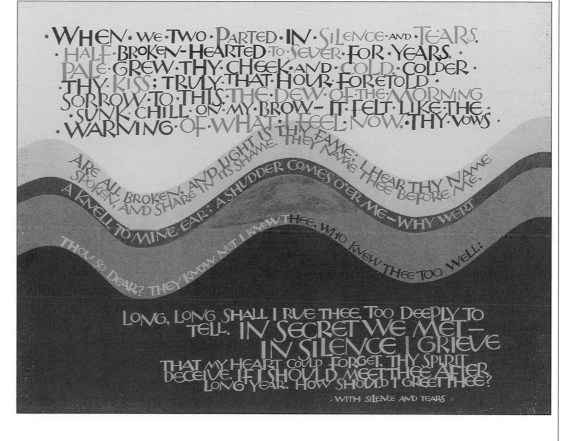

ANGLO-SAXON ⊕ RIDDLE SONG

Shunning silence,
my house is loud
while I am quiet:
we are movement bound
by the Shaper's will.
I am swifter,
sometimes stronger
he is longer lasting,
harder running.
sometimes I rest
while he rolls on.
He is the house
that holds me living—
alone I die.

THE SOLUTION IS:— A FISH AND RIVER

This Riddle is one of a collection
that Rest in a thousand year old vellum
manuscript known as the Exeter Book
which has resided in Exeter Cathedral
library ('skin songs in a Holy House'),
since its donation, c. 1000 a.d.
by Leofric, the 1st Bishop of Exeter.

TRANSLATION FROM OLD ENGLISH BY CRAIG WILLIAMSON

DENIS BROWN
The Half-Uncial inspired insular Anglo-Saxon script, with its characteristic wedge serifs, is the ideal if not the only choice for this rendering of an Anglo-Saxon riddle song. The work is portrait format, and the lines are centred. The limited space between the words assists in maintaining the rhythmic quality established by the lettering. Greater word spaces might destroy this excellent effect.

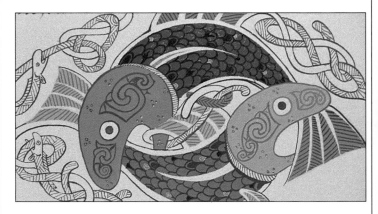

DENIS BROWN
The detail of the illustration, which contains the solution to the riddle, is based on and typical of the Celtic style of ornament. The fish and river evolve into each other.

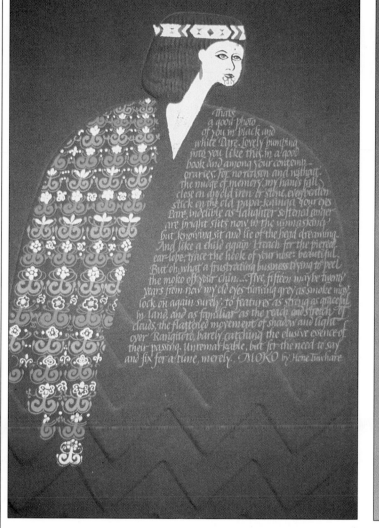

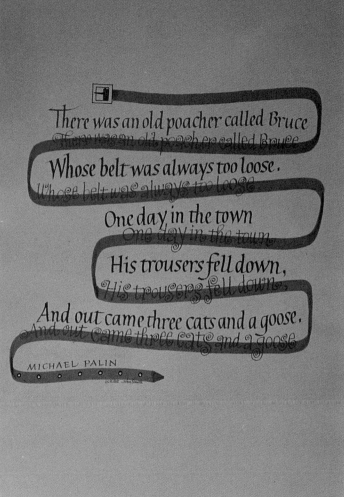

DAVE WOOD
This unusual picture shows a strong influence of the work of early twentieth-century artists, particularly those working in Vienna. One such artist was Gustav Klimt who painted women and couples draped in exotic and ornamental patterns, and attempted to obscure the definition between the figure and ground. The decorative element was very important, and is echoed here.

JOHN SMITH
Sometimes the words of a poem or quotation immediately dictate a visual image, and concept for a layout. This work is an amusing presentation of a text and illustration perfectly complementing each other. The words of a limerick by Michael Palin are written using designer's gouache and spaced within the "folds" of a belt as it winds its way down the page. The words are repeated in a free lettering style using Chinese stick ink.

MANUSCRIPT BOOK

The production of manuscript books was the basis of some of the finest calligraphy for many centuries. After the arrival of the printed page, perceptions and expectations began to alter. Changes evolved in the application of illumination, decoration, page layout and overall presentation. The great status afforded the manuscript book, as a special artform, was diminishing. Apprentices were no longer taught the centuries-old methods used in producing grand manuscripts. Even people who could afford the splendid manuscripts prepared by scribes and allied craftspeople abandoned them in favour of acquiring a product of the new technology.

Some interest was shown in forms of related decoration in subsequent art movements, particularly the Arts and Crafts and Art Nouveau periods of the nineteenth century. The contemporary calligrapher wishing to be involved in the production of manuscript books can learn much from studying fine examples in national collections. Encouraging contemporary interest in masterpieces of the past will perhaps help to recreate and restore all of the prestige once attached to this unique artform.

Manuscript books were the end result of the art and genius of early monks and scribes. The making of books is a craft involving interesting tools, materials, techniques, language, sounds, and even smells, which complements the skills of the calligrapher. The making of the simplest booklet can be a very rewarding experience and give a tremendous sense of achievement. Usually, this kind of accomplishment creates a desire to make more and explore further possibilities. By their historical coexistence, books and calligraphy can work well together.

The considerations for laying out a page in a book compared with a single sheet are a little different and the calligrapher must pay heed to this fact. For example, margins will have a different emphasis. Forethought needs to be given to the content and its presentation so that the essence of the book may be appreciated. Within the space of a single page of a manuscript book, however, much can occur; witness the amazing examples of the work of the scholastic Irish missionaries.

HARRY MEADOWS
To plan, design, lay out and transcribe calligraphy and illustrations for a manuscript book is a quite different process from working on a single sheet. On the cover of this book the title is neatly transcribed with conservative use of flourishing, resulting in a tight and compact presentation. On the spread (facing pages), the first letter of each paragraph is pulled into the margin and enlarged, to draw attention. The splendid illumination illustrates Icarus' fate as he flew too close to the sun. Gold, fine lines and words combine to make the picture.

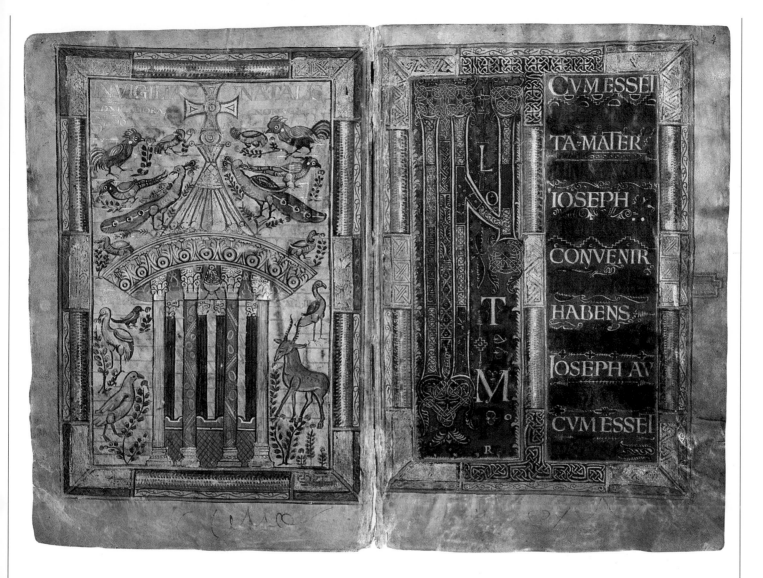

One of the richest periods in the development of the manuscript book came with the emergence and subsequent flourishing of Carolingian art, under the patronage of the Emperor Charlemagne. The Godescalc Codex is an excellent example of binding from that period.

Carolingian art evolved from a combination of primarily Insular and Byzantine cultures. As can be seen on this first page of text, the Insular tradition contributed abstract patterns made up of knotwork, interlacing and scrolls. These concepts were fused with the influences gleaned from

Mediterranean art. The left-hand side of this example perfectly depicts the inspirations gathered from this second source: figurative and illusionistic work. The same source suggested the use of the enlarged Roman capitals richly presented in gold on a purple-stained background.

JOHN BENTLY
This is a page from the Artist's Book illustrated opposite. The elements on the page were all drawn larger than the intended size for the final image. They were then reduced in stages allowing retouching and additions to be made. The heavily ornamented enlarged letter I is modelled on a letter in a fifteenth-century Italian manuscript. For this work it was drawn 300mm (12in) high. After the final reduction, the work was hand-coloured using watercolours.

JOHN BENTLY

The lettering on this page is styled on a Roman graffito hand, and was written with a fibre-tip pen. The work was initially transcribed twice as large as the final image. There is a great textural quality in evidence, which is enhanced by the range of letter heights, particularly the insertion of the larger letters breaking up the space. The image, drawn in ink, was also executed large and reduced in two stages. The border framing the page is in the style of a traditional decorative border. The whole work was prepared as artwork, and printed by offset lithography from a paper plate. The book is bound in a traditional Chinese style called Ts. The object is to produce beautiful books but, to make them accessible, the cost of materials is kept to a minimum. The lettering was executed with a Chinese pointed brush and fibre-tip pen.

► JOAN PILSBURY and WENDY WESTOVER
An elegant manuscript book, measuring 150mm (6in) by 450mm (18in) when opened as here, shows the opening pages of "Hatching Eggs" by Rose Macaulay. Great care and skill has gone into the presentation. Generous margin widths allow plenty of space for the text to be appreciated. The choice of yellow paper brings life to the page, where white may have proved too bland.

◄ ▼ DIANA HARDY WILSON
A small accordion-style book provides an ideal format for subjects with repeat patterns, be they verses of a poem or, as here, the months of the year. The Saunders paper has been sponged in the colours of the seasons corresponding to the months. This particular edition was made for the southern hemisphere. The boards are covered with a paper-backed cloth, more usually found covering mounts for framing. The ribbon tie is anchored under the end sheet of one board, with a loop exposed on one side. At the other side the ribbon emerges and is taken round the book and slotted through the loop.

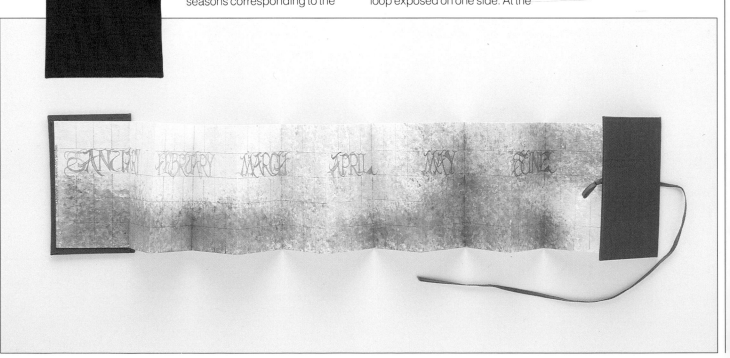

▶ DIANA HARDY WILSON
Letters freely drawn with a pencil and then filled in using a brush and gouache create the words for this title page. The letters and their extensions were painted with shades of green, appropriate to the subject. The multi-section book was made with Zerkall printmaking paper and the pages were left uncut, to exploit the deckle edge.

◀ ▼ ISABELLE SPENCER
An elaborate decoration has been ascribed to this accordion book. Raw silk is the fabric chosen for the covering, onto which a pattern has been created by embroidering with braid and threads of different shades. To close the book, gold braid is tied off on either side. Watercolour paper has been folded to make the pages of the book, upon which the words of a poem have been written using gouache. The first and last words have been decorated by filling in with coloured shapes in a random and interesting way.

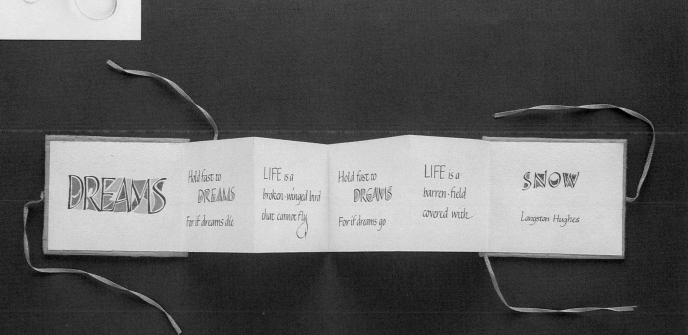

▲ There are many books with decorative covers commercially available. Most of these books are made with good quality paper and the pages are left blank. If writing in a book appeals, but the expense and expertise of bookbinding is elusive, these books provide a viable and excellent source for many calligraphers.

◀ ▲ KARLGEORG HOEFER Perhaps having drawn inspiration from the splendour of the cover of this book, letters in silver, grey and black dance their way from the front to the back. The result is not dissimilar to the composing of music – though the subject here, appropriately, is a Dancing Alphabet. Sometimes it is difficult to distinguish the letters as they seem to fall exhausted like a character in an animation film.

▲ KARLGEORG HOEFER
Using a traditional method, this book is secured by ties made from the same material – in this case, paper – as the cover. The alphabets within the book continue the traditional theme by being rendered in black and red. The alphabet shown is based on a Copperplate script.

◄ KARLGEORG HOEFER
The title page of this small manuscript book reflects its delicate and tactile nature. A fine lightweight paper has been chosen to make the text block. Through these pages preceding and succeeding alphabets can be glimpsed. The book contains a visual feast of personal calligraphic alphabets. An alphabet book such as this should grace every calligrapher's bookshelf – a personal exploration and rendering of elegant calligraphy displayed on well laid out pages, all in a beautifully handmade book.

PRINTED BOOKS

While preparation of an individually hand-crafted manuscript book is an exciting challenge to the modern calligrapher, an interest in books may also lead to preparing original artwork intended for printing in book form. The opportunities for this kind of work are relatively few, as handwritten text is obviously inappropriate to the majority of publications. However, there are occasional openings in the gift book market, for example, for small-format illustrated books including short texts that can be attractively laid out as calligraphy, initially prepared as individual pieces of artwork and reproduced on a page by page basis.

The covers of contemporary publications are the responsibility of art directors, employed by the publishing houses, and there are many titles which lend themselves to a calligraphic solution. The calligraphic approach is not often appreciated as a viable option to the relative soullessness of some modern typography, but the presentation of calligraphy on a book jacket, used alone or together with set type, can be eye-catching and original.

IEUAN REES
This splendid lettering creates great texture on the cover of a book. The space within and between the letters appears to be given equal importance to the strokes of the letters themselves. Eloquent hairlines make an occasional appearance among the letters, with their slightly Gothic feel. The wonderful line-filling device in the last line initially reads as another letter, and completes this beautifully balanced work.

MICHAEL HARVEY
Confident Versal-style letters announce the title of this book. Commandingly designed to go on a black background, their light colour immediately catches the eye. The illustration, created after the style of early scribes and illuminators, is embraced by the sub-title and author's name. Note the change in the size of lettering to match the importance of the information.

MICHAEL HARVEY
For this book cover, calligraphic lettering provides the illustrative material. The first image is the red Gothic T, which sits boldly on the black background. Superimposed over this is a green grid providing a framework for the proportioned Roman T, which in turn offsets the elegantly flourished letter. The grid has been turned on its axis, so that two corners disappear off the cover.

TIM O'NEILL
The Versals and the design of this book's cover illustrate the many considerations which play a part in calligraphy. The choice of lettering style complements the topic of the book. The size of the lettering, the space between the letters and words, and the change of colour all combine with the interlinear spacing to show how a design can work with careful planning.

TIM O'NEILL
Insular Half-Uncial inspired letters with their characteristic wedge serifs appropriately title this book, their counter shapes decoratively filled with colour. The flourishing is based on Celtic knotwork. The line illustration, evocative of the rich inheritance of fantastical birds and beasts in Celtic ornament, breaks the fine lines of the red border to great effect.

APPLIED CALLIGRAPHY

By its very nature and definition, calligraphy can be applied to an infinite range of visual works involving the written word. For centuries, handwriting was the main method of written communication, reproduction and documentation. Access to the exquisite fruits of the labours of the master scribes was largely confined to government and the wealthy classes. Many essential texts were reproduced by hand-copying, but without adornment. With the advent of movable type, exponents of the beautiful scripts and bookhands briefly thought they faced imminent redundancy. For a time the design and layout of their work changed to an imitation of the printed pages produced by the new technology. However, the art of the scribe survived for similar reasons to those of today: that is, for the purpose of supplying hand-crafted individual and small-quantity works.

Modern calligraphers and lettering artists have found new work in commercial contexts; for example, the development of advertising created opportunities for the craftspeople of fine writing. Many jobs involved the juxtaposition of a calligraphic word or phrase, perhaps as a heading, with mechanically set type, just as they have since the invention of the printing press.

The use of calligraphy and set type in the same work can have very interesting results. However, careful consideration is required before selecting this design solution. There are some occasions when a client would be better advised to use a typesetter rather than a calligrapher. The calligrapher is not a machine and the uniqueness of the work illustrates this fact. There are some formal situations where tradition has set standards that provide guidelines. For example, invitations, probably at one time all written out by hand, are often now printed in a typeface based on COPPERPLATE script. The calligrapher remains unsurpassed in having the ability to inscribe a different name on each invitation, whether there are twenty-five or two thousand names to write. A similar attitude is adopted for certificates.

In the application of calligraphy, serious consideration must be given to the nature of the work – the words and how to present them. Understanding the intention of the words is essential to provide ideas for the style of writing, and may even suggest suitable materials. The calligrapher needs to develop good intuition and then learn to trust it. This will help enormously during the important time spent working out rough ideas.

The range of visual design problems that can be solved solely by, or incorporating, calligraphy is vast. More often than not, it is the calligrapher who needs to be alert to this fact. Designers, art directors, or anyone who does not fully understand both the limitations and the possibilities of calligraphy cannot be expected to know all the answers. An additional task of the calligrapher is to inform others of the potential. A good method of doing this is by example. One course of positive and effective action the calligrapher can take is to present all personal stationery and mailings, including invoices, calligraphically. Employing calligraphy in this manner not only makes sense and freely advertises the availability of the skill, it is also good professional practice. The stationery and cards may be printed from original artwork but the direct and personal touch, which is one of the powerful features of calligraphy, will still be retained.

▶ DENA SHATAVSKY
Calligraphy has many applications in the commercial world and retains long-established uses where it still triumphs over the typeset and printed word. Preparing artwork for printing using calligraphy is not difficult. This wedding invitation uses a mixture of hand-crafting and printing technology side-by-side.

The design (by Barbara Biondo) evolved as a total concept. The invitation was presented as a complete package in a specially designed and made envelope. The envelope was made from Chromulux and lined with Japanese handmade paper. Ribbons, threaded through slots and tied, were used to seal it.

Contained within the envelope was the invitation, notification of the reception, notification of the recipient's acceptance and an individual pre-addressed return envelope. All these items were prepared as camera-ready artwork for printing. The floral design of the border was also prepared as artwork, but as an outline only. The lettering and outline border were then printed. The two shades of pink and dark green were then hand-painted into the border.

Mrs. Anton V. Smith requests the honour of your presence at the marriage of her daughter Jeannette Britten to Mr. Brian Michael Reilly Saturday, the twenty-fourth of September nineteen hundred and eighty-eight at three o'clock

Saint Peter of Alcantara Church 1327 Port Washington Boulevard Port Washington, New York

PRINTED MATTER

The practice of calligraphic design, or the inclusion of calligraphy in a design to be reproduced mechanically, requires special considerations. It is helpful if the calligrapher has some working knowledge of graphic design, its approach to layout and the possible restraints that may be encountered in print production.

To begin to solve any visual design problem a good working practice, a methodology, needs to be established. This may include the writing of an action list, and later a checklist, for a particular job. Learning to be energetic in the approach to working out design solutions in rough form is often a difficult step. It may be that scribbling lines and representative shapes to indicate the various components of a design is simply an unfamiliar practice, or a personal reticence may have developed over many years of working in a different way. Experimenting with different layouts and seeking the maximum potential of a design can best be achieved by working through as many ideas as possible. In time, possible solutions are quite quickly recognized and the focus of attention can be concentrated on those particular ideas suitable for development.

An understanding of reproduction methods is an invaluable addition to the knowledge of a calligrapher working for print. The photocopier can be a very useful item to use for enlarging, reducing or providing a single printed version of a work. The copy print can then be used with tracing paper to develop alternative solutions without having to rework the whole piece.

Unlike working in a one-off situation, working for reproduction has bonuses. One of these is that if a mistake is made, it is sometimes possible to save the work without having to begin again. Depending on the error, some careful touching out with opaque white paint and a fine paint brush, or patching with the same paper, may eliminate the marring. If an entire word is wrong, it can be rewritten and carefully pasted over the misspelt word. If the word is longer or shorter and cannot be written to fill the same-sized space, a more complicated cutting and sliding of the entire line may be required. Alternatively, the entire line could be rewritten and inserted with care so that there is no curtailment of ascenders and descenders from adjacent lines.

Crisp, white paper or line board is the best substrate to use. Artwork is prepared in black. For work of more than one colour, separations may need to be prepared; the printer can advise on this. Guidelines and marking-up for finished artwork should be done with a fine blue pencil. This will not reproduce on to the plate the printer will make to print from.

▼ DIANA HARDY WILSON
This Christmas card captures the spirit of people who find the long holiday a strain. The artwork was written with a fountain pen with split-nib attachment. The words were printed in a grey tint on Zanders Zeta Mattpost Hammer embossed board.

▲ JEAN LARCHER
The tools used to produce these numerals are one key to their energetic appearance. The 89 was written freely with a brush pen. The 90, with its linear texture, was written with a ruling pen. Both were printed in reverse.

TASMANIA·APRIL·MAY·1989:
AN·ISLAND·STATE·OF·GRANITE·ROCK·ORANGE·GREY·
GREEN·LICHEN·MOUNTAINS·&·ART·RIVERS·AND·
CRAFTSHOPS·ARCHITECTURE·WOODS·OF·MINOR·SPE·
CIES·&·HORIZONTAL·SCRUB·GREEN·&·INDEPENDENT·
GUM·TREES·BLUE·SKIES·SHEEP·SHEEP·SHEEP·DEVONSHIRE·TEAS·
&·FEDERATION·STYLE·MORE·GUM·TREES·CRUTCHED·SHEEP·
TOPIARY·OCEAN·BEACH·BLUE·HILLS·MOUNTAINS·&·BUSH·
CARNAGE·OF·ANIMALS·ON·THE·ROAD·WHITE·GRAVEL·EDGED·
ROADS·BRIDGES·MADE·FROM·PLANKS·DORSET·SHEEP·
&·HEREFORDS·RED·TIN·ROOVES·&·WHERE·FOR·THIS·O··
·TRAVELLER·THE·BUILDINGS·DON'T·LOOK·OLD·ANY·
MORE·SANDSTONE·IN·SUNLIGHT·BOOBYALLA·AND·
LEATHERWOOD·&·PETROL·STATIONS·WITH·FLAT·ROOF·
BEDECKED·WITH·PLASTIC·BUNTING·WHY?·VELVET·GREEN·
HILLS·WHERE·DRAWING·IS·AS·WE·FIRST·DREW·WITH·BLUE·
SKY·BLUES·GREEN·TREE·GREENS·GREEN·GRASS·GREENS·TA·
LL·STRINGY·BARKS·&·CATTLE·SIT·DOWN·&·LOOK·SAGELY·
BUSH·&·GRANITE·ROCKS·LIKE·OLD·FRIENDS·STILL·THE·SEA·
WITH·HINT·OF·GREEN·IGNORES·THIS·OLD·FRIEND·IN·ITS·
RUSH·TO·RUN·OUT·EUCALYPTUS·PLANTATIONS·GRAVEL·
ROADS·&·GREAT·CLOUDS·MIMOSA·VERTICAL·CURVES·
&·BLIND·CURVES·&·HILLS·HOP·FIELDS·MUTTON·BIRDS·&·
HORSE·MANURE·REDLINE·COACHES·&·THE·MAN·THE·
PLAN·JAPAN·&·INDEPENDENT·GREENS·&·FERNS·AND·
FRIENDS·OF·11·PATERNOSTER·ROW·BILL·ANDREWS·DICK·
BEST·OF·SALAMANCA·PLACE·GALLERY·RUTH·&·GODFREY·
BURRELL·OF·51·WIAMEA·AVENUE·JANE·&·LLOYD·CHURCH·
ILL·ROAD·&·GARRY·&·KATHY·FORWARD·AT·13·MAC·GOR·
STREET·UP·ON·MT·NELSON·MARY·&·ROSS·AT·14·PIN·ANAH·
ROAD·&·JOHN·&·PENNY·ST·AT·THE·502·MT·NELSON·RD·AND·
CHRISTINE·&·JACK·LOMAS·IN·THE·DERWENT·VALLEY·
COUNTRY·NEAR·LACHL ... JILL & ... IART·
&·ALEX·&·JOHN·SUTHE ... ZLAND·
SOUTH·IN·LESLIE·ROAD·& ... TOM
SCHLEGEL·IN·LUCH·AT·143·MC ... ILEST·
BOB·VINCENT·STILL·PLANNIN ... AND·OF·
COURSE·FORMERLY·OF·BONN' ... MTON·
SQUIRE·SW8·NIXON·ST·RES ... NT·PETE·
WILLMOTT·AND·AWAY·IN ... NORTH·
JANE·&·LILY·DEETH·FIND·THE ... 52·DRY·
STREET·OR·AT·THE·SIGN·OF·THE ... CK ... TOO·AND·
LURKING·ROUND·THE·CORNER· ... PREST·IS·ALAN·
LIVERMORE·AT·GALLERY·CIMITIER·&·AU·DWELLING·IN·THE·
WONDERFUL·ALBION·HOUSE·PATRICIA·&·ERIC·RATCLIFF·&·ALAN·
MCINTYRE·IN·BELHAVEN·ST·&·ALEC·HEADLAM·IN·BAIN·TERRACE·&·SO·
MANY·MORE·INCLUDING·BRIDPORT'S·CALLIGRAPHER·TERRY·MARITON·
KEEP·THE·ISLAND·GREEN·THANK·YOU·WITH·PEACE·&·LOVE·O·

◀ DIANA HARDY WILSON
A limited edition open letter says "thank you", and celebrates a visit to an island. The blank image area represents the island. The lettering is a random mixture of upper and lower case letters that draw on several styles for their inspiration. The artwork was prepared proportionally larger than the final work. The image was then reduced using a photocopier and printed onto recycled cartridge paper.

▲ MICHAEL HARVEY
The direct approach: the image tells its own story! A simple and very effective idea for a personal card from a calligrapher and lettering artist. The letterforms in the top picture have been drawn with some interesting features. The P and O are just touching, and the A has a crossbar that extends both sides of the diagonal strokes. The counter shapes and spaces between have different textural qualities achieved by the application of dots and lines.

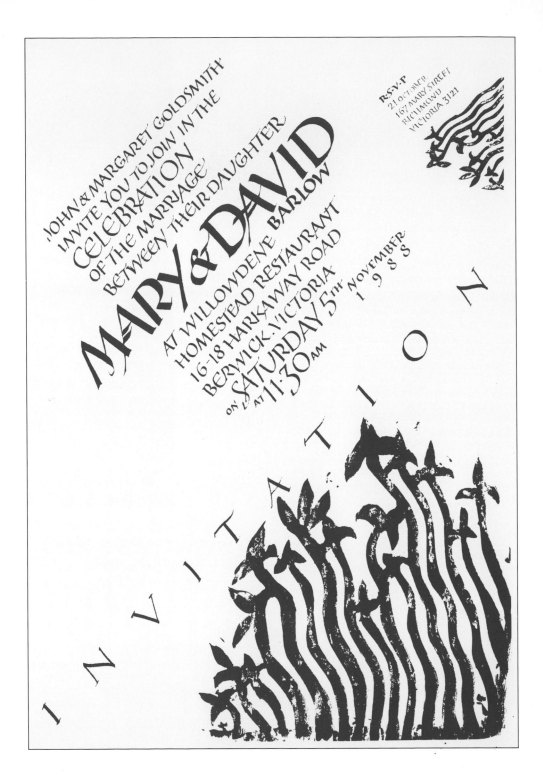

DAVE WOOD
An original concept for an invitation to celebrate a marriage. The angle of the information is an important feature of the overall design. The invitation folds to a triangle with the word "Invitation" spaced along its long top side. The illustration is then growing from the apex of the triangle, which is pointing downwards. The second fold forms a smaller triangle containing the RSVP and smaller illustrative material. The final fold is across the A5 sheet horizontally from a point where the two triangles meet. The style of the letters is very complementary to the occasion. The artwork was printed in red on grey paper.

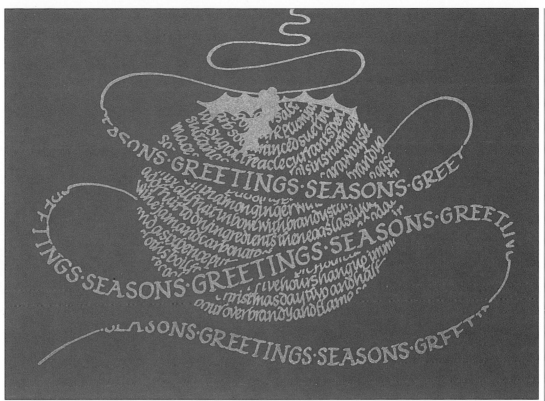

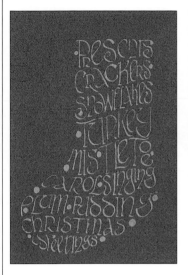

▲ DIANA HARDY WILSON
Calligraphers have a reputation for producing interesting cards. This is a very simple design in the style of a calligram. A shape of relevance to the occasion is filled with words related to the season.

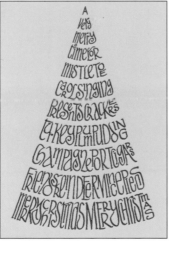

DIANA HARDY WILSON
The calligram is an excellent device to use as the basis or complete solution for conveying information for many occasions. Although it has great flexibility of design, it can be difficult fitting in all the data in a legible manner. However, the general appeal is strong as the images can stand on their own, and the reader can take delight in reading the words. The hot plum pudding with its steam rising upwards is composed of its ingredients and method of making. The tree, presented as a tightly contained shape, encloses ingredients too, of a celebratory nature appropriate to the time of year.

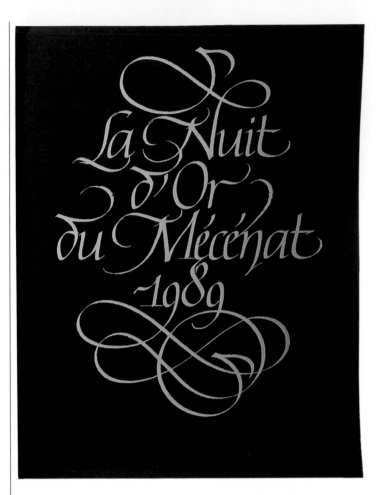

JEAN LARCHER

For an impressive promotional brochure cover printed in gold on black, the artwork was prepared in the same size as the final work. Using a speedball pen and black Indian ink the words have been written with exuberant flourishing.

JEAN LARCHER

For the calligrapher designing her or his own card, an opportunity arises to exploit all the wonderful ideas that a client was not brave enough to use. The artwork for this exquisite personal card was prepared using an automatic pen with watercolour and inks. The work was then printed in full colour by offset lithography.

ISABELLE SPENCER
Calligraphy with its many applications is an accessible option for use by local groups to advertise their activities. For this local arts group, a considerable amount of information had to be included on an A3 poster. The final solution is reminiscent of a design for sheet music. The artwork was prepared to size and photocopied onto shaded paper.

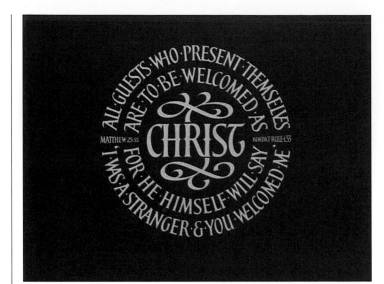

◀ IEUAN REES
The layout for a circular presentation needs to be worked out thoroughly in advance. Plan the work with lines radiating from the centre of the circle. Some letters may need slight adjustments to the strokes. In the outer rim of this piece there are some original ways of coping with the space problem. The letter pairs WH, WA, WE, ME, HE, VE each share a stroke, thus making the compensation in a creative way. Balance of the central word with the whole is achieved beautifully with a flourish filling the space above and below.

▶ GEORGIA DEAVER
The design of an invitation for a celebratory occasion offers a challenge. Using only letters, superbly evocative solutions can dance across the page.

▶ IEUAN REES
Designing for print or material on view to the public involves many considerations, not least its eye-catching appeal. These tightly packed letters written with minimal interlinear spacing immediately draw the attention of the viewer. The use of the tight arrangement to create new stroke relationships can be exciting. Here, the stroke of the upper bowl of the S is used to make the crossbar of the A of Cardiff. The diagonal of an R rests on an N.

▲ GEORGIA DEAVER
Great freedom exists for calligraphers in design and layout, compared to the rigidity of set type. This is exploited here with exaggerated letter shapes to accommodate the address line.

◀ GEORGIA DEAVER
There is a refreshing trend towards an informal approach to the design of invitations and calligraphers are in the vanguard of this movement. In this landscape-format invitation, the capital letters of the lower two lines act as a prop for the flowing top line.

COMMERCIAL WORK

Calligraphy has gained some ground and discovered new competition in the realms of advertising, magazine design and commercial presentation.

Unless a calligrapher, or a person with some knowledge of calligraphy, is working in the studio of a design group, the notion of employing calligraphic solutions to design problems is not likely to arise. It may be assumed in the current environment that solutions involving calligraphy are near the bottom of the list. However, the nineteenth and early twentieth centuries provided much work for lettering artists and, in time, for the re-emerging calligrapher. In those days the craft of lettering and good handwriting was highly regarded. The lettering artist was kept busy working on a wide range of jobs, many of which could still be done most elegantly by a calligrapher. The jobs included ticket writing, showcards, signs, posters, leaflets, invitations and a wide variety of ephemera. Economics, new methods of production, presentation and a presumed change in visual perceptions have obstructed this outlet.

In recent decades, with changing social trends and an accompanying desire for categorization, calligraphy and fine lettering have unwittingly suffered. A long period of identification of hand-lettering as quaint, home-made and traditional has surrounded much commercial use of calligraphy. The advertising world rarely uses calligraphy although it "borrows" from its history and expertise frequently. Examples are seen when a trend for nostalgia surfaces, or a seasonal message warrants a calligraphic style to create a mood or evoke a sentimental feeling. There are advertisements which employ the concept of the decorative letter, and there are instant-lettering sheets which supply them.

In the commercial world, unless an individual calligrapher takes the initiative, calligraphy will rarely be seen. The styles of instant lettering and typefaces now available to typesetters and designers, pay a passing homage to calligraphy. This may suggest a narrowing of the gap between the obviously mechanically reproduced letter and the calligraphic, but this still does not provide employment for the calligrapher.

All, however, is not gloom and doom. There are enlightened art directors who, in their need to produce a unique and excellent result, will employ a calligrapher to supply beautiful writing and calligraphic devices, as can be seen from the fine examples reproduced here.

DONALD JACKSON
The use of calligraphy for commercial applications is not only viable, but is also finding "new" avenues. The slight paradox occurs when a comparison is made with earlier this century when so much ephemera was still produced using expertly crafted hand-lettering. This distinctive image was created for a company who founded their reputation on healthy eating. The uncomplicated and refined nature of the design makes it very suitable for application in a whole range of situations, among them shop fascias, menus and packaging. The illustrations are by John Lawrence.

ROBERT BOYAJIAN
The range of applications of calligraphy for commercial work is as broad as the subject. This record cover is one of the more unusual. The words are centred on the cover. Loose Italic letters with slight extensions to the first and last letters are used for the name of the recording artist. The album title is rendered in upper case letters whose vertical and diagonal strokes begin and/or end at a quirky angle. The image and the words work well together, and are more closely related for the inclusion of the flourish on the letter A in Migration.

ROBERT BOYAJIAN
Unless a work is commissioned, it is sometimes difficult to decide on a topic for a piece. The twelve months of a year that constitute the Gregorian calendar provide a concise concept. This calendar with beautiful Gothic letters and attendant flourishes shows how suitable the subject is for calligraphy.

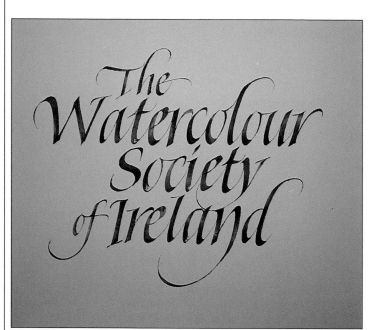

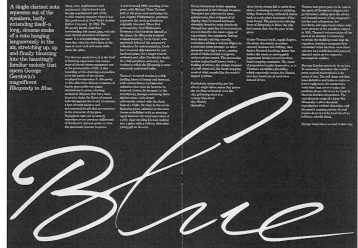

DENIS BROWN
Designing for a specific purpose, especially for an organization whose activities are very particular, can be very difficult. Preconceptions must be set aside and an original approach attempted. The daunting aspect of designing for another art discipline is not in evidence in this glorious sign. The perfectly formed Italic letters with truly elegant extended strokes are composed of the most subtle colours.

PAUL SHAW
Magazines and periodicals seldom use fine scripts produced by hand. Their more usual mode of production is the clean, sharp and hard finish of type, and an occasional decorative heading. It is therefore encouraging to see this spread showing a perfectly wonderful juxtaposition of very freestyle lettering and rigid columns of set type. The text has been wrapped around the enlarged loop of the l, making a link between the heading and the text. The position of the heading expertly shows that it is not necessary to run the title across the top of the page.

PAUL SHAW

This innovative idea for the cover of *Meetings and Conventions* involves intricate interplay of words and numerals. There is a lesson taught in typography that advises against the use of too many typefaces in one piece of work. In this calligraphic image this concept is dismissed to good effect, and the theme exploits the use of many different styles to convey its message. The profusion of words and figures is assembled to provide a background over which the large 1989 is superimposed.

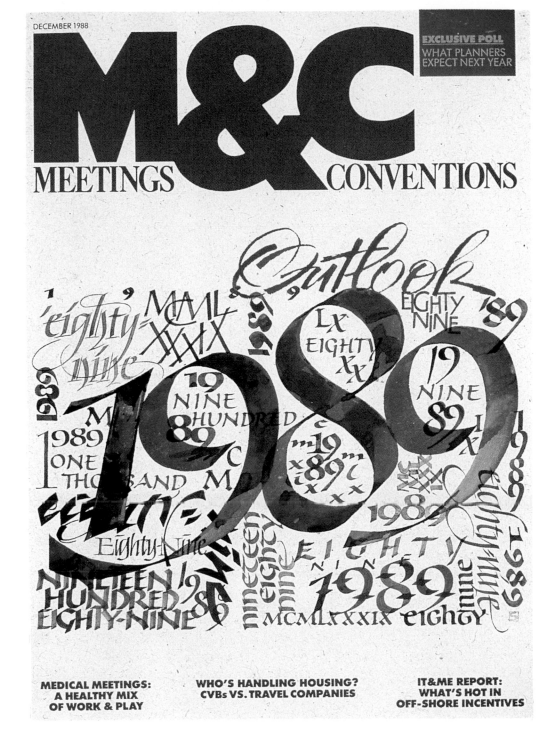

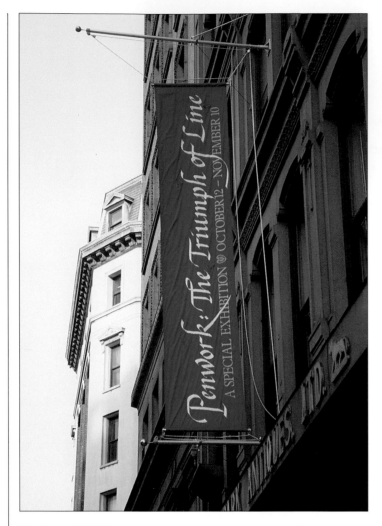

St. Catherine's Church
Netherhampton

EASTER

Good Friday 10 a.m. Service
of Meditation and Hymns

Easter Day 9-30 a.m. Holy
Communion with Hymns

BARBARA BIONDO

The planning and design of an exterior sign for a special event needs much creative thought. In a street in a commercial district there will already be a profusion of permanent signs, so finding a way to advertise a particular exhibition is not easy. The use of a banner – an item with a long and colourful history – is a brilliant solution. Hung perpendicular to the building, it expertly announces the exhibition and its location. The use of calligraphy is totally complementary to the event.

KENNEDY SMITH

The information to be included on a notice that will hang in a public place needs to be accorded levels of importance. Sometimes this is quite difficult, but a way must be found to attract the attention of the viewers and draw them closer to read the smaller written details. Colour, lettering size, an image or a dynamic layout are all possible solutions. This notice written in Rotunda script uses colour and an enlarged single word to catch the eye. It was executed in ink and gouache on coloured paper.

▼ MICHAEL HARVEY
In recent decades, hand-lettering and calligraphy have been little used for presentations, packaging and point-of-sale material. The trend for things new, glossy and "modern" pushed by advertisers and advertising has squeezed the use of calligraphy into areas with specific connotations. Earlier in this century, hand-lettering was accorded great status, and was a skill requiring a long apprenticeship. Preconceptions have since got in the way. The flexibility of calligraphy and hand-lettering affords a great ability to be evocative at will. The stencil-style lettering is an excellent example of this versatility.

▶ DENIS BROWN
What other way could an announcement for an exhibition of calligraphy and bookbinding be presented? The word "exhibition" is given classical proportions and delicately curved serifs with a slightly concave effect at the top and convex at the bottom. The layout of the notice allows plenty of space for all the information, so nothing is cramped.

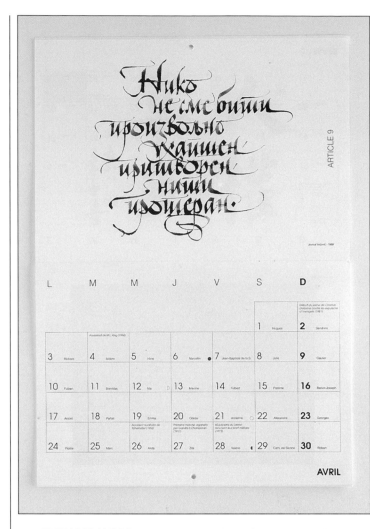

ARTICLE 9

L	M	M	J	V	S	D
					1 Hugues	2 Sandrine
3 Richard	4 Isidore	5 Irène	6 Marcellin	7 Jean-Baptiste de la S.	8 Julie	9 Gautier
10 Fulbert	11 Stanislas	12 Ida	13 Maxime	14 Fulbert	15 Paterne	16 Benoit-Joseph
17 Anicet	18 Parfait	19 Emma	20 Odette	21 Anselme	22 Alexandre	23 Georges
24 Fidèle	25 Marc	26 Alida	27 Zita	28 Valère	29 Cath. de Sienne	30 Robert

AVRIL

▲ JOVICA VELIJOVIC

Each month of this calendar based on the Universal Declaration of Human Rights is introduced by a calligraphic rendering of one of the Articles. Article 9 is written in upper and lower case letters which exude and exploit great textural quality. This is achieved through the angularity of the letters with their uninhibited swash extensions, and the irregularity of tone of the liquid medium that further activates the lettering.

▼ GEORGIA DEAVER

The design of promotional material necessitates supplying more information than just details about the product. The target market must be known. The range of cabinets being promoted here has the important feature of being available in bright, attractive colours to appeal to a young and dynamic clientele. The freely written multi-coloured script vivaciously reflects this. Set at a thrusting angle against a crisp white background, the letters are the dominant feature. They are afforded greater prominence than the picture of the product itself. This demonstrates the success of the script – that the range can be recognized solely by the dynamic logo.

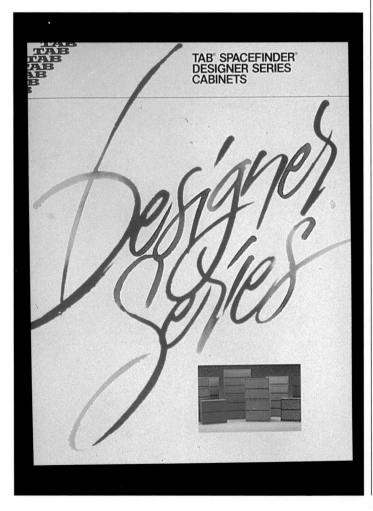

TAB® SPACEFINDER® DESIGNER SERIES CABINETS

▼ PAUL SHAW
It could be regarded as unusual to find calligraphy of any kind within the pages of a twentieth-century daily newspaper. In an age of great advances in printing technologies, when so much is produced electronically, it is encouraging to see freely written letters appearing in the columns of a prestigious newspaper such as *The New York Times*. The script introduces an article in the Travel section, on the delights of travelling in the Far East. The letters attempt to evoke the perceived sense of that part of the world, but without doing it in a stereotypical way.

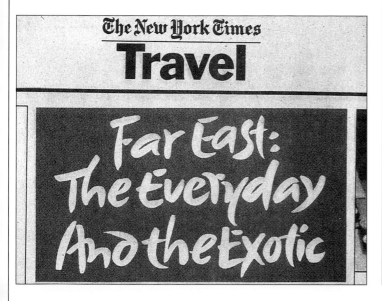

ARTICLE 26

JUIN

▲ HASSAN MASSOUDY
A beautiful rendering of Article 26 of the Universal Declaration of Human Rights. This truly magnificent calligraphy is perceived not only as a means of communication, but also as a great art form. The script used is based on an early Arabic script, Kufic. The bold vertical and horizontal strokes create a contrast to the triangular letters, and an interesting textural quality is developed. There is great life and movement in the dynamism of the strokes and attendant elegant flourishing of the top line, done in a more cursive script. The whole has enormous nobility.

165

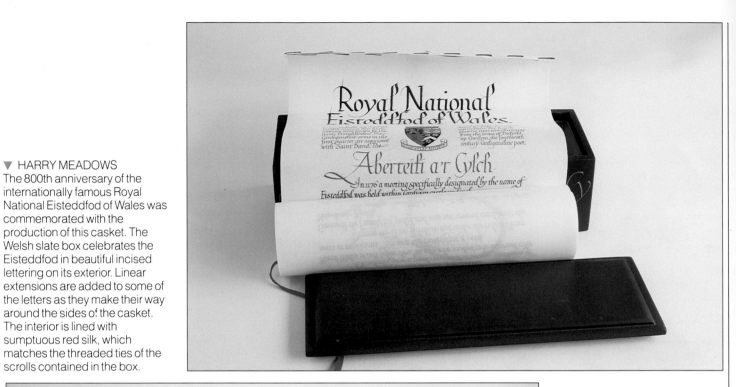

▼ HARRY MEADOWS
The 800th anniversary of the internationally famous Royal National Eisteddfod of Wales was commemorated with the production of this casket. The Welsh slate box celebrates the Eisteddfod in beautiful incised lettering on its exterior. Linear extensions are added to some of the letters as they make their way around the sides of the casket. The interior is lined with sumptuous red silk, which matches the threaded ties of the scrolls contained in the box.

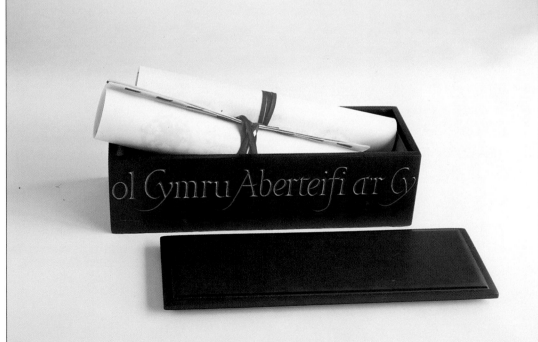

▲ HARRY MEADOWS
The two vellum scrolls — one in Welsh, one in English — outline the history of the Eisteddfod. They display beautiful calligraphy and heraldry written with Chinese stick ink, watercolour and shell gold. The red of the lining is echoed in the threaded lacing of the ties which secure the scrolls.

The World Trade Center. It's the only place to begin sampling all of New York's hundreds of sights & experiences.

Get an eyeful of the city and parts of neighboring states from our Observation Deck, 107 stories up on top of Tower Two. And you won't believe our elevator ride—1/4 mile in 58 seconds flat.

After you've seen New York's most spectacular view, stay for dinner (or have breakfast, lunch, or tea) at our 22 restaurants and eating spots. And do some shopping on our Concourse, where 60 establishments offer everything from best-sellers to wedding bands.

The Deck: 9:30–9:30 every day: $2.95 adults, $1.50 for kids & senior citizens. Call 212/466-7377 for Deck info, or 212/466-4170 for our brochure.

NEW YORK BEGINS AT THE DECK AT THE WORLD TRADE CENTER

THE PORT AUTHORITY

PAUL SHAW

A stunning calligraphic interpretation of the twin towers of the World Trade Center in New York. The purpose of the work is to encourage people to sample the delights of the city from the observation deck of Tower Two. The design solution for this presentation almost matches the reactions of most people who go to the top of Tower Two! Gradual tonal changes occur in the image as the towers rise 107 floors up into the air.

THE THIRD DIMENSION

There are many people who are great exponents of the art of fine writing but choose to work with tools and materials other than broad square-cut nibs, ink and paper. These people transfer their intimate knowledge of letter construction and calligraphic hands to working with the tools required to apply and incise lettering on, for example, stone, slate, glass and wood.

In some cases the transition is from two to three dimensions. There are a number of craftspeople who only produce their beautiful lettering on solid, hard materials. Embodied in the work are many of the finest traditions of calligraphy: swashed letters, flourishes, delicate thin strokes and bold thick strokes – and all with the same confidence and aplomb as that executed by a pen on paper.

The evolution of the incised letter, as recognized in the tradition of Western lettering, is best observed in the grand applications made by the Romans. The Roman square capital as an incised letter is called "capitalis". Many fine examples of these letters can still be seen today on the elegantly proportioned Etruscan and Roman architecture. The letters were used on triumphal arches, monuments, entablatures and sculptured panels.

The work of modern lettering artists working in three dimensions also encompasses memorial monuments and commemorative stone tablets or plaques, although the work is typically on a less grand scale than that of the Romans. In more domestic contexts, nameplates may consist of lettering incised on stone, wood, glass or metal, from large plaques displaying the name of a company building or private house, to the smaller scale of, for example, finely wrought decanter labels. A special delicacy is brought to everyday objects such as drinking glasses and glassware containers by hand-engraved designs, applied either for simple decoration or to personalize the object.

Engraving or incising letters on stone or glass is obviously a less fluid process than writing with a pen on paper. You may need to learn how to modify familiar lettering styles if you are making the transition from pen-written calligraphy to one of the three-dimensional media. An interesting challenge is working on a fully three-dimensional object; for example, adapting the lettering to the curved or faceted surface of a glass container rather than applying letterforms to a continuous flat surface.

Preparing the piece

In common with any area of design, working with these materials requires good planning and rough sketches to achieve the best layout. An accurate measure needs to be made of the amount of space an inscription will occupy and how the lines will fall. You need to establish whether all the lines will fit into the available space without appearing too cramped, or whether the lettering can be made smaller without becoming lost or illegible. Consideration should also be given to margins and room for the letters to "breathe". Some works will require more acute attention at the preliminary stage if there are tight strictures on the available space. Potentially, more of these works provide a predetermined space than those executed on paper – a goblet, a panel to be inscribed for incorporation in a specified location, or a memorial tablet are all examples of this. Thus, working in this area can on occasions provide less opportunity for flexibility in the design.

However, the craftspeople working with these materials seem uninhibited by such obstacles. They show great skill and dexterity in manipulation of the equipment and tools used with a wide variety of unrelenting materials.

IEUAN REES
Looking at this wonderful work, one is forgiven for forgetting that the material is hard. The letters spring forth like water and cascade down the rock. Working with tools suitable for incising letters in stone and achieving a result comparable to a pen gliding across paper is a very laudable achievement.

▶ IEUAN REES
An elegantly presented name-plate with some subtle and interesting features. The crossbar of the H extends to the left to become a motif. The same motif is echoed at the end of the line, so it appears to stretch behind the word. The central flourish above the b anchors the piece.

▲ HARRY MEADOWS
The overlapping and resulting linking of the upper case letters forms a pattern of its own. The tension created between their serifs as they almost touch is exceptional. The lower case letters are quite beautifully made.

▲ HARRY MEADOWS
The incised lettering gently rolls like the ocean across this Welsh slate plaque. Small semicircular lines indicate both the hull of the ship and the waves, the latter especially so, as the lines are juxtaposed with the flourished extension to the letter b. The letter shapes are beautifully proportioned, and the ascenders have very distinctive curling tops.

▶ MARTIN WENHAM
Beautiful wood grain traverses this bread platter. It is made from cherry wood and measures 300mm (12in) in diameter. The incised condensed letters were V-cut, and have neatly flaring serifs.

▲ MICHAEL HARVEY
The vast range of species of wood offering tactile qualities, colour, and the visual texture of the grain serves as a very receptive medium for incised and carved letters. The Roman upper case letters display fine proportions, and have subtly curved serifs with a concave effect at the top and a convex effect at the base.

▲ MARTIN WENHAM
This unique design entitled Toccata 26 is made from the exceptionally beautiful wood of the yew. The work stands a magnificent 540mm (25½in) high. The wood is renowned for its fine grain, and the incised letters of this work complement the grain of this piece.

▲ IEUAN REES
This memorial tablet has wonderfully deceptive qualities. Its overall appearance evokes bold outline pencil lettering on paper. In fact the tablet is created in bronze and the letters are etched. The letter strokes are subtly flared towards their ends. There are some interesting combinations: ME, and the unusual OR in memory; likewise the AR, and HB in Archbishop. The tight layout is a dominant feature but the letters do not look cramped; instead an intriguing negative and positive textural quality pervades the whole work.

◀ IEUAN REES
The detail of the memorial tablet shows more clearly how the seemingly plain letters achieve elegance of form through understatement, excellent proportions and precise execution.

▼ TIM O'NEILL
This is an original application and most suitable for calligraphy and hand-lettering. Unlike other hand-printing methods, artwork for silkscreen can be prepared as a positive image. The exciting graphic properties are of a thick, stencilled film of ink with brightness and opaque colour. This solidity of colour is wonderfully exploited on this T-shirt. The lines of letters are linked in a most delightfully flowing manner that demonstrates the excellent capacity of silkscreen to be used for strong and freely drawn imagery.

▲ MARGARET LAYSON
The materials used by calligraphers cover a broad spectrum. This presentation is made on laminated leather. The leather was vegetable-tanned and coloured with leather dye, and the Roman letters were carved with a scalpel. Finally, the letters were painted with pearlescent ink.

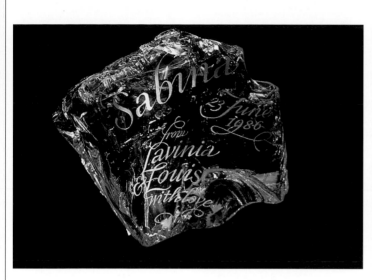

▲ AUDREY LECKIE
Commissioned as a gift, this is an extraordinary execution of engraving on cullet. The achievement of getting script letters onto the contours of this glass must be applauded.

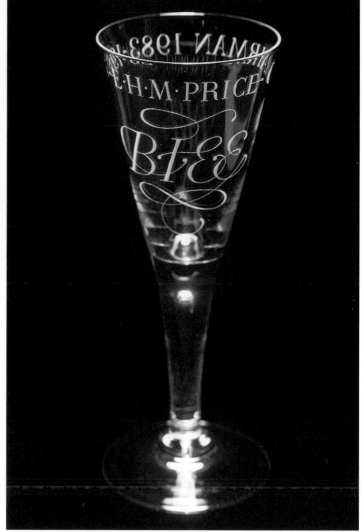

▲ AUDREY LECKIE
An elegant goblet displays equally elegant lettering. Working in three dimensions and in transparent form offers great challenges. These are not only the techniques involved and the care required in their execution, but also the opportunity to exploit the third dimension. Working with glass, the form can be followed or opposed, both to good result. The glass held at certain angles and in certain lighting conditions could seem to disappear and only the lettering remain.

▶ Incised lettering on a fascia in Dingle, Ireland, a representation using Celtic forms. The act of incising these letters into the stone is very final and determined and denotes permanency. It makes a sharp contrast to the fly-by-night signs of every high street, that have succumbed to plastic and neon.

▲ A letterbox displaying two contrasting calligraphies is an unusual but pleasing sight in the English-speaking world. The letterforms are clean, sharp and well presented.

▶ IEUAN REES
In this unusual design for an open sign, the Roman letters carefully follow the clean lines of the stand. The juxtaposition of the two rows of letters creates its own textural pattern on the stand, which itself casts interesting shadows. How light falls on and is interrupted by an object can be important considerations in working in three dimensions.

▲ A children's library in Dublin, Ireland, where by chance the image of the skyline is reflected in the window. This provides an interesting reference for the lettering. The letterforms have a distinctive textural quality, mainly highlighted by the irregularity of the counter shapes.

◄ AUDREY LECKIE
Suspending a sign perpendicular to a building makes it more visible than one fixed flat. This is important for clientele visiting the area, so they can locate the site. This sign has lettering most appropriate for its purpose. Splendid flourished extensions to the L of Lion are well balanced with similar extensions on the n and q of Antiques.

► Part of a monument in Dublin to celebrate the "Spirit of Ireland" displays fine incised letterforms. Note the arch of the n rising above the vertical stroke. The layout and position of the words on the stone have been well considered. If they had been placed one block higher, the balance would have been destroyed and the words would have seemed cramped.

▲ IEUAN REES
A delightful sign for a gallery, with beautiful lettering with flourished extensions and an array of very interesting quirks to individual letters – for example, the split in the first stroke of the M, before the extension is made. Note the parallel quality of the flourishing with hairline extensions. The layout is balanced by the positioning of the flourishing. Note, too, how the unusual r and y in "gallery" can be read two ways.

► GEORGE THOMSON
These beautiful incised letters are based on classical Roman forms. The medium is Hopton Wood stone.

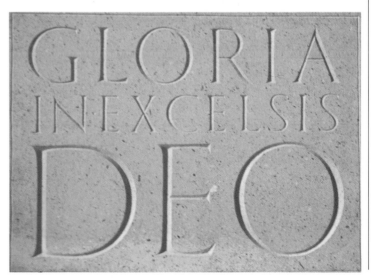

EXPERIMENTAL CALLIGRAPHY

One of the greatest delights of working with calligraphy is to explore its apparently limitless potential. The breadth of applications perhaps reflects the fact that it was for a long time the major source of written communication. Most of the uses of calligraphy developed since Roman times are available in an identical state or a contemporary equivalent to be included in a modern calligrapher's repertoire. Economics may remain an obstacle, as it did centuries ago, when the scribes depended on availability of materials and patronage of the wealthy classes to enable them to produce such highly illuminated manuscripts.

For the calligrapher the cost of some of the materials and, for the potential purchaser, the true cost of such labour-intensive work can often be prohibitive factors in the creation of great works today. It may be possible that the inventive calligrapher can begin to create a conducive environment which can include appreciation for fine calligraphic works.

Calligraphy can embody the spirit of a calligrapher. It can be representative of personal beliefs and ideals; it can be an adventure, eliciting great excitement on a personal level with each new discovery. The production of the very first piece can arouse a great sense of achievement. The nature of calligraphy is such that there is constant discovery and development and much pleasure can be derived each time a work is completed. There are so many aspects of this art to explore, from perfecting an elegant italic hand to conquering the intricacy of illumination.

Some people, having developed a range of basic calligraphic skills, choose to seek original and unusual applications. This may involve using different materials or applying these skills to other fields of the visual arts. Calligraphy works well in combination with techniques and materials from many sources. It is not solely confined to use with any specific set of materials; there need not be any limits – limits are imposed by the individual. To develop and expand personal horizons the calligraphic artist needs to learn to trust intuitions and instincts and nurture these traits. It is paramount to perceive what is possible and have a belief in one's own ability to achieve it.

Words and images

The calligraphers represented in this section have attempted to push back the boundaries and explore beyond the realms of a safe solution. If there were rules to be broken, they would be broken in an attempt to achieve a challenging and splendid piece of work.

The calligrapher exploring the possibilities of the less obvious visual solutions can discover that this kind of work generates its own growth pattern. Even after careful planning, preparation of a finished colour rough, and beginning the final version of the work, thoughts of minor adjustments, slight variations and hints of other solutions may arise. Invariably, there occurs the feeling that there is still scope for improvement. It is this, coupled with the enthusiasm derived from acquiring a great sense of achievement on completing an important piece of work, that encourages a continuation – the calligrapher, as artist, in a relentless search for the masterpiece.

On some levels, working experimentally is the calligrapher's playtime, a time for having fun with letters, shapes, colours and a variety of visual contrivances. The possibility of discovering something new always exists. Some recognition of individual strengths and weaknesses may occur, and methods that allow these to flourish or be overcome, can be found when working in this more relaxed style.

The use of words to create an image and still tell a story requires great imagination and creativity. There are calligraphers who are great exponents of sharing how they see things and what they see. Their individual experiences unfold in their work, where they have combined calligraphy with other areas of expertise to produce a harmonious work of art.

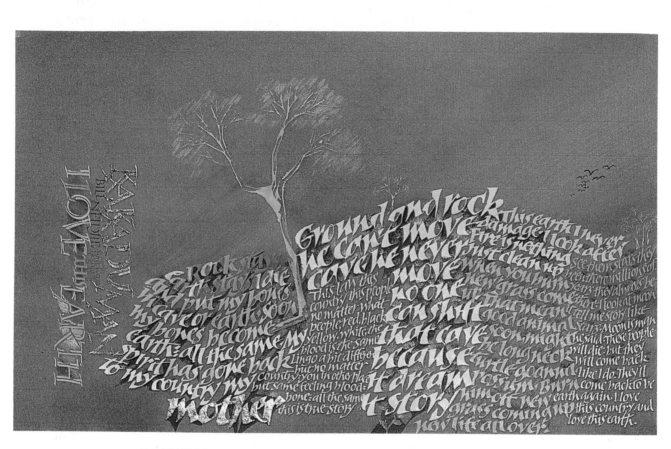

DAVE WOOD
The wilderness and beauty of Australian landscape are evoked in this rendering of Bill Neidjie's words. They are recreated by the use of exaggerated and angular letterforms, by the choice of colours, and by the spacing of the letters, words and lines. The aridity, the ruggedness, the jagged rocks and the harsh, burnt land are captured and celebrated.

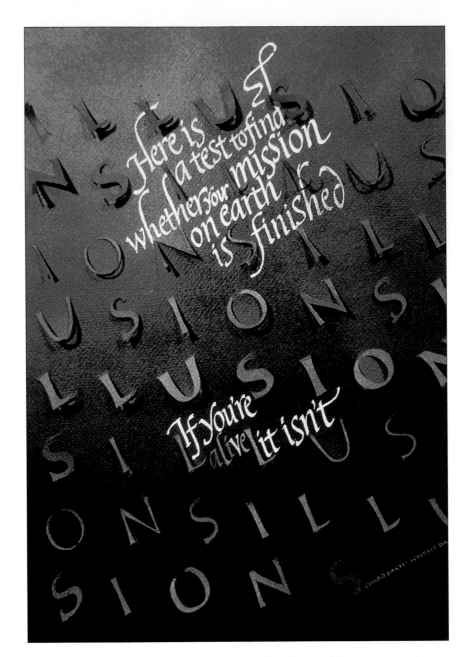

DAVE WOOD

In this original work, cut-out letters range across the page and establish a deception which befits the word they spell. These letters add a quirkiness to the work even before the words have been read. Space for the text is found in between the cut-out letters, which occasionally obscure an ascender or letter stroke.

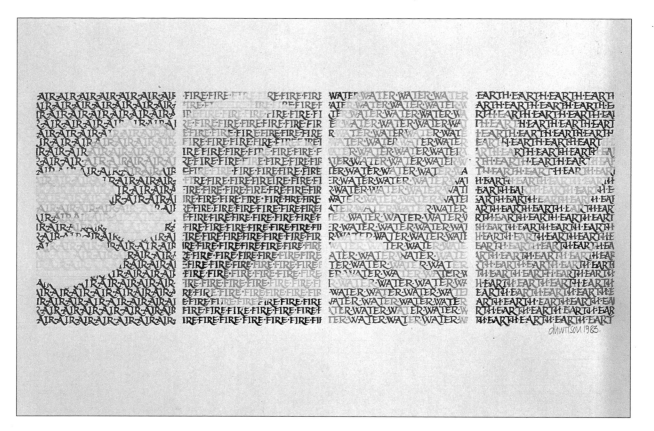

DIANA HARDY WILSON
Here, four substances considered to constitute the universe are placed side by side, and words are used as a non-illustrative device. A sense of rhythm and texture is created by repeating the words, and the position of their letters changes on adjacent lines. This results in diagonal lines of letter shapes running through the image.

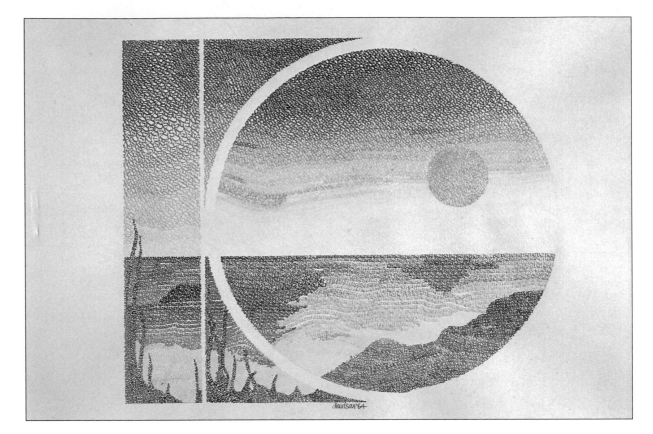

DIANA HARDY WILSON
The tranquil seascape seen here is wholly made up of the words of the components it is depicting. Careful tonal gradation of the colours, combined with placing the letters in close proximity and at angles to one another, establish a specific style of texture and rhythm.

DIANA HARDY WILSON

In this image of a summer screen, the entire work is made from words and bands of colour. Using gouache and working with tonal gradation, the word "summer" is repeated over and over again. The letters are tightly written and word spacing ignored to create a textural quality where the word itself becomes the pattern. The letter s is the most rounded and open letter in the word, and it makes its own linear pattern throughout the work as the words on adjacent lines are moved along by one letter per line. The clouds which drift across the screen are made by using less and less colour.

MICHAEL HARVEY

This is a stunning and innovative work, echoing the sounds of the nearby Cotton Club, where Duke Ellington, honoured at the bottom of the piece, could be heard. The picture sings as the words descend down the air shaft. Innumerable techniques have been employed in the creation of the final image. There is no fear in exploiting, mixing or contrasting different methods. There is evocation peering out of dark corners of the tower block air shaft, and there are spaces of light. The styles of lettering draw on a wide range of references and reflect what can be seen in Harlem or any inner city — the stencil lettering of warehouses, graffiti from the walls of lifts and subways.

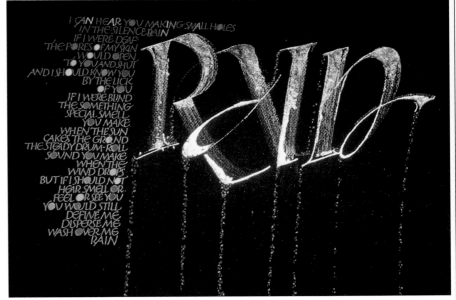

DAVE WOOD

When no particular idea presents itself for a calligraphic work, how and where is a solution to be found? Selecting and deciding on suitable subject matter can be taxing at times. Searching purposefully through literature is a very pleasant experience, but does not always proffer quite the right inspirational thought. Perhaps the looking is too concentrated. It is often the simplest and most obvious (after it is identified) subject matter, staring us in the face, that can be used to design a brilliant visual work. These notions can be moulded and manipulated either with an outrageously elaborate combination of techniques, or by designing with simple elegance and understatement.

"Rain" has been written large, and in a manner which exploits the texture of the substrate. The uneven visual surface of the letters surprisingly gives a solidity to the forms. The tiny coloured letters spelling "rain" fall down the page like drops on a window.

KENNEDY SMITH

Exploring and devising new ideas does not necessarily mean abandoning traditional layout design. This portrait format uses the power of an image produced with gold leaf on gum ammoniac to immediately capture attention. The dense blue of Canson paper brings solidity to the work written in varying sizes of Uncial script with two lines of majuscules, which create a visual texture and pattern to the writing.

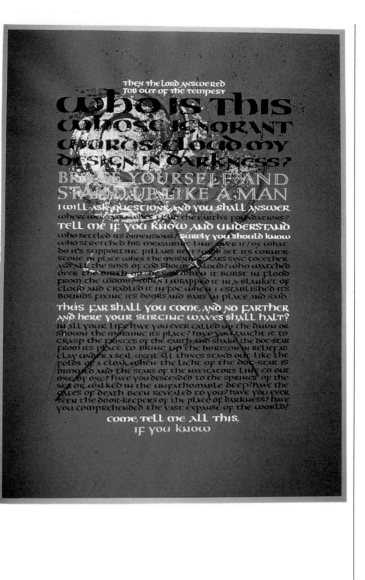

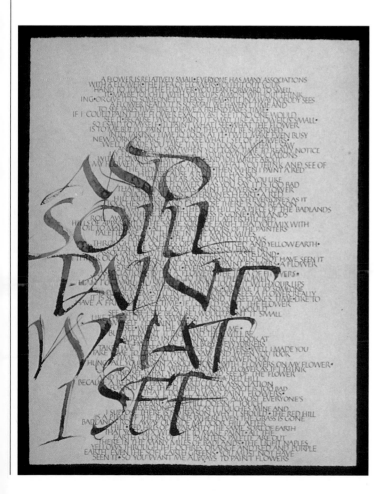

GEORGIA DEAVER

The text is written in upper case letters with dots placed at mid-letter height to separate each line of thought. The words are tightly spaced, the thoughts they represent culminating in a defiant crescendo in the form of the large freely flowing letters. These are placed over the now forgotten and unneeded thoughts, the problem is solved, "so I'll paint what I see". Or maybe not, as some of the text can still be seen through the irregularity of colour in the large letters.

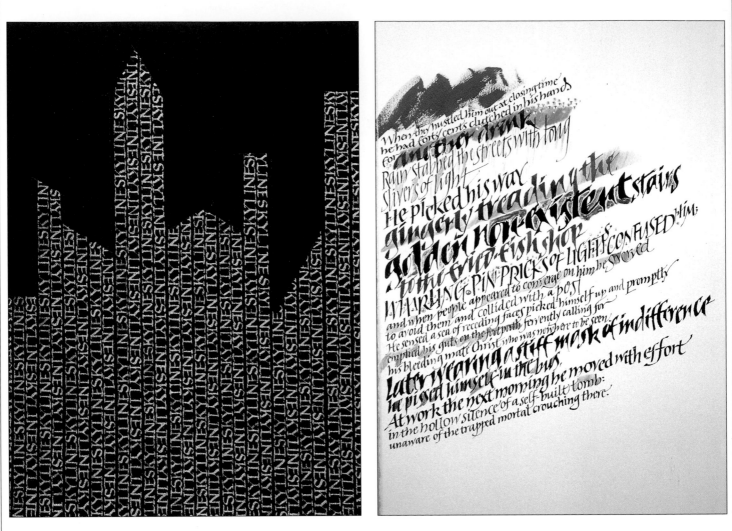

DIANA HARDY WILSON
Random shapes from a view seen daily are identified and their complexities condensed to an absolute basic outline that frames this image. Vertically linear rows of letters painted in silver gouache face alternate directions, creating texture. Writing the rows in this manner also avoids the repeating patterns that occur otherwise. The letters climb to the height of the now imaginary cityscape and stop where they meet the black Canson paper sky.

DAVE WOOD
Combining different styles of lettering within one page does not always work as well as it does here. This piece is composed line by line, creating a visual interpretation of the words. Paralleling this development is the application of many techniques to support the writing styles and the words – a calligraphic set design. When the text refers to "rain" and "slivers of light", the writing is long and spiky, and smudges of grey fill in spaces and run down from the lines. The text refers to "golden non-existent stairs": here is the gold and parts of some of the letters are non-existent. "Pin-pricks of light" is stabbed by dots of gold. The result is a visual pot-pourri.

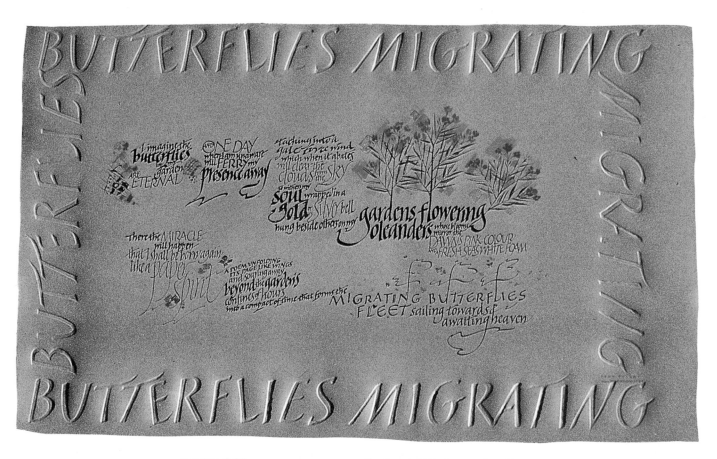

DAVE WOOD

This is another visual pot-pourri of lettering styles and decorative techniques. The lettering and supporting embellishments evoke and reflect the implied meaning of the words. The spirit of the letters runs wild, and grows like the plants in the garden. The uninhibited layout moves from thought to thought like a butterfly from flower to flower. The work is framed by magnificent embossed letters, casting both shadows and light.

TOOLS AND EQUIPMENT

1 T-square
2 Fabriano handmade paper
3 Fabriano handmade paper
4 Plaka: bold and durable water soluble paint
5 Ruling pen
6 Protractor: useful for marking pen angles
7 Scissors
8 Chinese stick ink
9 Grinding palette for Chinese stick ink
10 Plaka
11 Pointed Chinese brush
12 Pointed Chinese brush
13 Pointed sable brush
14 Square-cut brush
15 Short-haired fine-pointed sable brush
16 Plastic transparent ruler
17 Fine pointed technical pen
18 Fine pointed technical pen
19 Segmented mixing palette for paints or inks
20 Vellum
21 Fountain pen with bold sized nib
22 Long-haired fine-pointed sable brush
23 Calligraphic fibre tip pen
24 Slip-on reservoirs for metal nibs
25 Selection of metal nibs, including oblique cut nibs for left-handed calligraphers
26 Pen holder and William Mitchell roundhand nib
27 Pair of dividers
28 Paint mixing palette
29 Tubes of designer's gouache: water soluble paint
30 Selection of chisel-cut fibre tip pens for calligraphy (graded in millimetres)
31 Adjustable set square
32 Scalpel and 10A blade
33 Plastic eraser
34 Designer's gouache

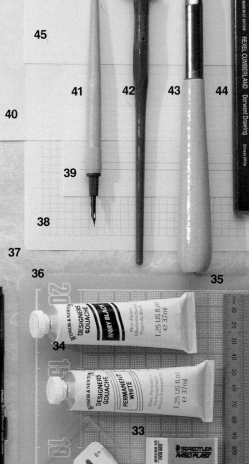

35 Metal ruler: always cut against a metal rule on a cutting mat or strong cardboard, and cut away from the image area

36 Cutting mat

37 Eraser in holder: good for erasing in specific places; refillable

38 Squared paper

39 Calligraphy practice paper with pre-ruled guidelines

40 Layout paper

41 Mapping pen and very fine metal nib: good for fine line work

42 Poster pen with extra broad nib

43 Burnisher

44 Carpenter's pencil

45 Cartridge paper

46 Imitation parchment

47 Colour pencils: aquarelle or watercolour pencils that are water soluble

48 Drawing ink: use with nibs or brushes; have a transparent quality but mix well together

49 Calligraphy ink: especially formulated inks with a good dense colour

50 Watercolour dyes: dense and brilliant colours; experiment before use

51 Two pencils bound together to make double points

52 Automatic pens

53 Mixing palette: this size good for mixing a quantity of one colour for sponging or washes.

54 Quill pen

55 Masking tape

56 Compass

57 Automatic pens

58 Speedball pen and nib

Page numbers in *Italic* refer to the illustrations and captions

A
accordion-style books, *140*, *141*
action lists, 148
advertising, 15, 156, *163*
agate burnishers, 74, *75*
alignment, 56, *57*
alphabets, 102, *102-7*
 Carolingian, *20*
 Copperplate, *26*
 Foundational hand, *34*
 Gothic Blackletter, *38*
 Gothic cursive, *39*
 Humanistic Italic, *44*
 Italic, *50*
 Lombardic, *59*
 Modern Uncial, *89*
 Roman capitals, 78, *79*
 Rotunda, *40*
 Rustica, *82*
 Uncial, *87*
 Versals, *91*
 Welsh, *105*
Anglo-Saxon scripts, 88, *96*, *134*
animals:
 illuminated manuscripts, 27
 ornament, 68
applied calligraphy, 146, *147-67*
 commercial work, 156, *156-67*
 printed matter, 148, *148-55*
Arabic numerals, 67, *67*
Arabic scripts, *165*
arch of Septimius Severus, *79*
Arches paper, *103*
Art Nouveau, 136
Arts and Crafts movement, 136
automatic pens, *95*, *106*
Avery, Dorothy, *117*, *123*

B
Bacon, Francis, *124*, *126*
Baker, Arthur, *107*
bamboo brushes, 15, *17*
banding, ornament, *70*
banners, *162*
Barrie, Stuart, *102*
Bently, John, *138-9*
Bible, *53*
'Bible Historiale', *71*
bindings, manuscript books, 62

Biondo, Barbara, *147*, *162*
black and white borders, *14*
Blackletter, 37-8, *37*, 40
blades, ruling pens, 80
'bleeding off', 53-4, *53*, *56*
Book of Durrow, 108
Book of Kells, 88, *97*, *101*, 108
books:
 manuscript, 60-2, *60-3*, 136, *136-43*
 printed, 144, *144-5*
Books of Hours, *47*
borders, 12, *12-14*, 48, 96
 around alphabets, 102
 basic strokes, *13*
 black and white, *14*
 with brushes, *12-13*, *14*
 corners, 12, *12*
 with fibre-tip pens, *13*
 with letter shapes, *14*
 ornament, *71*
 rules, 80
 texture, 86
Boyajian, Robert, *158-9*
Breen, Frances, *73*, *117*, *132*
Breese, Kenneth, *103*
brochures, *152*
Brown, Denis, *102*, *121*, *127*, *134*, *160*, *163*
brushes:
 bamboo, 15, *17*
 drawing borders with, *12-13*, *14*
 flourishes, *31-2*
 lettering with, 15, *15-17*, *123*, *133*, *139*
 ruling with, *80*
 working with colour, *21*
burnishing:
 gilding, *35*, 36
 raised gold, 74, *75*
business cards, *105*
Byron, Lord, *133*
Byzantium, 68, *137*

C
cable patterns, *69*
'calamus', 76
calendars, *158*, *164*
calligrams, 18, *18*, *151*
calligraphy ink, 22
cane, reed pens, 76

Canning, Eileen, *142*
Canson paper, *130*, *183*, *184*
capital letters:
 decorated, 27-8, *27-8*
 dropped capitals, 30, *30*
 Gothic, 37
 Half-Uncial, 88
 Humanistic, *45*
 Lombardic, 58
 Roman, 44, 72, 78, *78-9*, 94
 Rustica, 81, *81-2*
 Uncials, *87*, 88
 Versals, 90, *90-1*
capitalis, 78
cards, 148, *151*, *152*
Carolingian, 19, *19-20*, 44, 94
Carolingian art, *137*
Cartae Antiquae, *96*
cartouches, 12
Celtic ornament, 68, 70, *97*, *145*
Celtic scripts, 88
centring text, *55*, 56
ceremonial documents, 28, 108-9, *109*
certificates, 28, 53, 108, 109, 146
chain patterns, *69*
Charlemagne, Emperor, 19, *137*
charters, 28, 109
check lists, 148
chequering, ornament, *70*
chevron zigzag, *69*
Chinese brushes, 15, *17*
Chinese stick ink, *117*, *123*
Christianity, 68
Christmas cards, 18, *148*, *151*
Chromulux, *147*
circular presentation, *154*
citations, 108, 109
civic documents, 28
coats of arms, 109, 111, *113*, *115*
codex, 27
Codex, Aureus, *36*
Coleridge, Samuel Taylor, *130*
collage, 86
colour, 21-3, *21-3*
 alphabets, 102
 applying, 22-3
 borders, 12
 brush lettering, 15
 coloured grounds, *23*
 decorated letters, 96
 dropped capitals, 30

illumination, 46, *46-8*
inks, 22
Lombardic lettering, 58
paints, 22, *22*
printed work, 148
rules, 80
sponging, 64, *64-5*
Versals, 90
washes, *23*, *104*, *130*
wet into wet, 64
coloured pencils, *99*
commemorative stones, 168
commercial work, 156, *156-67*
compasses, ruling pens, 80, *80*
composition, 24, *24*
Copperplate, 25, *25-6*
copybooks, 118
Corkery, Daniel, 73
corners, borders, 12, *12*
Cotton Club, *182*
covers:
 manuscript books, 60, 62, *142*
 printed books, 144, *144-5*
crayons, *95*, *107*
 double point, 29
crow quills, 72
crystal parchment, *75*
cursiva Humanistica, 44
cursive, Gothic, *39*
cut-out letters, *178*
cutting, quill pens, 72, *72-3*

D
Deaver, Georgia, *133*, *154-5*, *164*, *183*
decorated letters, 27-8, *27-8*, 46, *46-8*, 96-7, *96-101*
depth scales, 56, *57*
Derby, *111*
designer's colours
 see gouache
diapering, ornament, *70*
Dingle, Ireland, *174*
diplomas, 109
distemper, *119*
dog-tooth agate burnishers, *75*
dots, 96, *107*
double point, 29, *29*
 flourishes, 32
drafting pens, 80
drawing ink, 22
'drawn' letters, *58*

Drogo Sacramentary, *94*
dropped capitals, 30, *30*
Dublin, *174*, *175*
duck quills, 72
dummies, manuscript books, 62
dyes, 22
Dynevor family, *113*

E
eastern calligraphy, 15
educational diplomas, 109
Egerton manuscript, *48*
egg-white, glair, *74*
Egypt, 35, 76
Eisteddfod, *166*
Ellington, Duke, *182*
embattled pattern, *69*
embellished and illustrated
 quotes, 126, *126-35*
embellishments, and
 composition, 24
endpapers, manuscript books,
 62
engraving, 25, 168
envelopes, *147*
equipment *see* tools
Etruscans, 68, 168
exhibitions, *162-3*
experimental calligraphy, 176,
 177-85
extensions:
 hairline, 25, 40, 41, *51*, 80
 swash letters, 85, *85*

F
fabrics, 68
fans, paper, *123*
faxes, *95*
feathers, quill pens, 72
felt markers, *102*
fibre-tip pens, *13*, 95, *95*, *139*
filling-in letters, 58, *58*
flat plans, manuscript books, 60,
 62
flourishes, 31, *31-2*, 85
 Copperplate, 25
 Italic, 49
 Lombardic, 58
fly leafs, 60
format, 53
 composition, 24, *24*
 landscape, 24, *24*, 53

portrait, 24, *24*, 53, *115*
 square, 24, *24*, 53
formal calligraphy, 108-9, *109-17*
found objects, making marks on
 paper, 64, *65*
Foundational hand, 33, *33-4*
France, *47*
Francis of Assisi, St, *122*
fret patterns, 70, *71*
Fuhrmann, Renate, *41*, *119*

G
Gaelic, *73*
'gammadion' device, 68
garden cane, reed pens, 76
Genesis, Book of, *127*
geometric designs, ornament,
 69, *71*
gesso, raised gold, 74, *74-5*
gift books, 144
gilding *see* gold
glair, *74*
glass, incised lettering, 168, *173*
goblets, incised lettering, *173*
Godescalc Codex, *137*
Gokal, Farah, *18*
gold:
 on ceremonial documents, 109
 gilding, 35-6, *35-6*, 90
 gold leaf, *35*, 36, 74, *74-5*, *183*
 gold powder, 36
 raised gold, 74, *74-5*, 109, *127*
 shell, *117*
goose quills, 72
Gothic, 37-41, *37-41*, 44
 Blackletter, 37-8, *37*, 40
 cursive, *39*
 Rotunda, *37*, 40-1, *40*
 Textura, 37, 38, 40, 41, *41*
gouache, 21, 22, *117*, *121*, *135*,
 141, *181*
 gilding, *35*, 36
 metallic, 36, *184*
Greece, 35, 68
Gregorian calendar, *158*
grounds:
 coloured, *23*
 gesso, 74, *74-5*
Guest, Suzanne, *17*, *99*
guidelines, *57*, 148
gum ammoniac, *35*, 36, *183*
gum arabic, 22-3, 36

Gutenberg, Johannes, *53*

H
haematite burnishers, 74, *75*
hairline extensions, *25*, 40, 41,
 51, 80
hairline serifs, 78, 80, 87, 90
Half-Gothic, 40
Half-Uncials, *87-8*, 88
handmade paper, *122*, *147*
Hardy Wilson, Diana, *86*, *140-1*,
 148-9, *151*, *179-81*, *184*
Harvey, Michael, *98*, *104*, *125*,
 144-5, *149*, *163*, *171*, *182*
headings, 42, *42-3*
 layout, 53
 subheadings, 42
heraldry, 28, 109, *110*
Hickey, Angela, *121*
Hoefer, Karlgeorg, *143*
Hughes, Charles, *99*
Humanistic, 44, *44-5*, *47*, 94

I
illuminated manuscripts, 21, 27,
 46, *46-8*, 68, 97, 108
illustrated quotes, 126, *126-35*
incised lettering, 168, *169-75*
India ink, *106*
Ingres paper, *132*
initial letters, 27-8, *27-8*, 90, 96
inks:
 brush lettering, 15
 Chinese stick, *117*, *123*
 coloured, 21, 22
 India, *106*
 ruling pens, 80
instant-lettering sheets, 156
Insular scripts, 96, *137*
interlacing, ornament, *69*, 70, *71*
interlinear spacing, 55
invitations, 146, *147*, *150*, *154-5*,
 156
Ireland, 68, *96*, 136, *174*
Islam, 68
Italian Gothic, 40
Italic, 44, 49, *49-52*
 Humanistic Italic, *44*
Italy, 40, 44, 49, 58, 94

J
Jackson, Donald, *156*

Japanese paper, *147*
Johnston, Edward, 33, 108
justification, 56, *57*

K
key pattern, *71*
Klimt, Gustav, *135*
Kufic script, *165*

L
landscape format, 24, *24*, 53
Larcher, Jean, *32*, *148*, *152*
Lawrence, John, *156*
layout, 53-6, *53-7*
 alphabets, 102
 ceremonial documents, 108-9
 manuscript books, 136
 marking up, 56
 ornament, *70*
 and texture, 86
Layson, Margaret, *172*
leaflets, 156
leather, incised lettering, *172*
Leckie, Audrey, *116*, *173*, *175*
legal documents, 109
lettera antica, 44
letterboxes, *174*
lettering:
 alphabets, 102, *102-7*
 brush, 15, *15-17*, *123*, *133*, *139*
 Carolingian, 19, *19-20*, 44, 94
 choosing styles, 55
 combining with ornament, *70*
 composition, 24
 Copperplate, 25, *25-6*
 decorated, 27-8, *27-8*, 46, *46-8*,
 96-7, *96-101*
 dropped capitals, 30, *30*
 filling-in, 58
 flourishing, 31, *31-2*
 Foundational hand, 33, *33-4*
 Gothic, 37-41, *37-41*, 44
 Half-Uncials, *87-8*, 88
 Humanistic, 44, *44-5*, *47*, 94
 illuminated, 46, *46-8*
 incised, 168, *169-75*
 Italic, 44, 49, *49-52*
 letterforms, 94-5, *94-5*
 Lombardic, 58, *58-9*
 making borders with, *14*
 Roman capitals, 44, 72, 78,
 78-9, 94

Rustica, 76, 81, *81-2*
spacing, 55, *55*
swash letters, 85, *85*
texture, 86
Uncials, 58, 87-8, *87-9*
Versals, 21, 58, 88, 90, *90-1*
Lindisfarne Gospels, *28, 96, 101,* 108
line filling:
 Italic, 49
 Textura, 41
linen, 76
lines:
 alignment, 56, *57*
 justification, 56, *57*
 length, 55
Lombardic, *48,* 58, *58-9*
Lombardy, 58
lower case letters:
 Carolingian, 19, *19-20*
 Gothic, 37
 Half-Uncials, 88
 Humanistic, 44
 Italic, *50*
 Rotunda, *40*

M

Macaulay, Rose, *140*
magazines, 156, *160-1*
majuscules:
 decorated, 27-8, *27-8*
 dropped capitals, 30, *30*
 Gothic, 37
 Half-Uncial, 88
 Humanistic, *45*
 Lombardic, 58
 Roman, 44, 72, 78, *78-9,* 94
 Rustica, 81, *81-2*
 Uncials, *87,* 88
 Versals, 90, *90-1*
manuscripts:
 illuminated, 21, 27, 46, *46-8,*
 68, *97,* 108
 manuscript books, 60-2, *60-3,*
 136, *136-43*
marbling, 62, 86
margins, 53-4, *53,* 136
marker pens, *102*
marking up, layout, 56
marks on paper, 64, *64-6*
masking fluid, 64, *66*
masking tape, 64, *66*

masking techniques, 64, *66*
Massoudy, Hassan, *165*
Meadows, Harry, *18, 110, 112,*
 114, 122, 124, 126-7, 131, 136,
 166, 170
meander patterns, *69*
Meetings and Conventions, 161
memorial literature, 28
memorial monuments, 168, *172*
metal pens, *121*
metallic leafs, 74
metallic paints and inks, 36
Middle East, 76
minuscules:
 Carolingian, 19, *19-20*
 Gothic, 37
 Half-Uncials, 88
 Humanistic, 44
 Italic, *50*
 Rotunda, *40*
Mitchell nibs, *117*
mock-ups, manuscript books, 62
Modern Uncial, *89*
montage, *99*
Morgan-Finch, Meik, *105, 128*
Moring, Annie, *133*
motifs, ornament, 68, 69
mould-made paper, *121*
Murphy, Richard, *121*
museums, 108
music pens, *131*

N

nameplates, 168, *170*
Neidjie, Bill, *177*
The New York Times, 165
newspapers, *165*
nibs:
 Copperplate writing, 25
 flourishes, 31
 Mitchell nibs, *117*
 planning layouts, 56
 quill pens, 72, *73*
 reed pens, 76, *76-7*
 split, 83, *83-4,* 99
 using paint with, *22,* 23
numbering pages, manuscript
 books, 62
numerals, 67, *67*

O

O'Neill, Tim, *145, 172*

ornament, 68-71, *68-71, 97,* 109
ox gall, 22-3

P

page plans, manuscript books,
 60, 62
paints, 21, 22, *22*
Palin, Michael, *135*
palladium leaf, 74
panelling, ornament, *70*
paper:
 Arches, *103*
 Canson, *130, 183, 184*
 for colour, 21, 22
 coloured grounds, *23*
 handmade, *122, 147*
 Ingres, *132*
 Japanese, *147*
 manuscript books, 62
 marks on, 64, *64-6*
 mould-made, *121*
 Saunders, *140*
 tissue, *133*
 Tre Koner, *106*
 watercolour, *141*
 Zerkall, *141*
papyrus, 72, 76
parchment, *75,* 76
pencils:
 coloured, *99*
 double point, 29, *29*
pens:
 automatic, *95, 106*
 fibre-tip, *95, 139*
 marker, *102*
 metal, *121*
 music, *131*
 quill, *58,* 72, *72-3,* 78
 reed, 76, *76-7,* 78, 81
 ruling, 80, *80,* 148
 speedball, *152*
 split nib, 83, *83-4*
photocopies, *95,* 148
Pilsbury, Joan, *52, 109, 111, 140*
planning layouts, 56
plant forms:
 illuminated manuscripts, 27
 ornament, 68, *96*
poems, 120, *120-5*
Pompeii, 81
portrait format, 24, *24,* 53, *115*
posters, *153,* 156

Pound, Ezra, *130*
powder gold, 36
powdering, ornament, *70*
printed books, 144, *144-5*
printed matter, applied
 calligraphy, 148, *148-55*
printing, 118
promotional brochures, *152, 164*
PVA (polyvinyl acetate), *35,* 36

Q

quadrata, 78
quill pens, *58,* 72, *72-3,* 78
 preparation and cutting, 72,
 72-3
quotes and poems, 120, *120-5*
 embellished and illustrated,
 126, *126-35*

R

ragged edges, 56, *57*
raised gold, 74, *74-5,* 109, *127*
Raw, Stephen, *95*
record covers, *158*
reed pens, 76, *76-7,* 78, 81
Rees, Ieuan, *32, 86, 90, 112-13,*
 115, 144, 154, 169, 170, 172,
 174-5
references:
 borders, 12
 decorated letters, 27-8
 layouts, 53-4
religious works, 108
Renaissance, 40, 44, 47, 49, 68, 94
reversing out, *56, 95, 95*
rhythm, texture, 86
Rochester, Custumal Book, *109*
Roman Empire, 35, 44, 68, 76
Roman lettering:
 capitals, 44, 72, 78, *78-9,* 94
 incised, 168
 numerals, 67
Rome, arch of Septimius
 Severus, *79*
Rotunda, 37, 40-1, *40*
rough layouts, 54
round Gothic, 40
royal documents, 28
Royal National Eisteddfod of
 Wales, *166*
rubrica, 21
rules, 80, *80*

ruling pens, 80, *80*, *148*
rustic lettering *see* Rustica
Rustica, 76, 81, *81-2*

S
Saunders paper, *140*
scale, ornament, 70
scallop patterns, *69*
scrolls, *111*, *166*
separations, colour, 148
Septimius Severus, arch of, *79*
serifs:
 Carolingian, 19
 foundational hand, 33, *33-4*
 Gothic, 37
 hairline, 78, 80, 87, 90
 Humanistic, 44
 Italic, 49, *50*
 Lombardic, 58
 Roman capitals, 78, *78*
 Rotunda, 40-1
 Uncials, 87
 Versals, 90
Shakespeare, William, *18*, *123*, *130*
Shatavsky, Dena, *147*
Shaw, Paul, *43*, *103*, *105*, *130*, *160-1*, *165*, *167*
shell gold, *117*
Shelley, Percy Bysshe, *23*
shields, heraldic, *110*
showcards, 156
signs, 156, *162*, *174-5*
silk:
 bindings, *141*
 fabric designs, 68
silkscreening, *105*, *172*
silver leaf, 74
size:
 gilding, *35*, 36
 ornament, 70
sketches, 108
slate, incised lettering, 168, *170*
Smith, John, 23, *85*, *123*, *130-1*, *135*
Smith, Kennedy, *18*, *127*, *130*, *162*, *183*
spacing:
 interlinear, 55
 letters, 55
 and texture, 86
 Uncials, 87-8

words, 55, *55*
speedball pens, *152*
Spencer, Isabelle, *99*, *106-7*, *129*, *141*, *153*
Spenser, Edmund, *123*, *131*
spiral patterns, *69*
split nibs, 83, *83-4*, *99*
sponging, 64, *64-5*, 86, *140*
spotting, ornament, *70*
square format, 24, *24*, 53
stone, incised lettering, 168, *169*, *172*, *174-5*
striping, ornament, *70*
style, choosing, 54, 55
subheadings, 42, 53
swan quills, 72
swash letters, 85, *85*
swashes, *51*
symbols, *97*

T
tape, masking, 64, *66*
technical drafting pens, 80, *95*
text:
 centring, 56, *56*
 composition, 24, *24*
 headings, 42
 layout, 53-6, *53-7*
 manuscript books, 60, 62
Textura, 37, 38, 40, 41, *41*
texture, 64, 86, *86*
textus precissus, 41
textus quadratus, 41
Thomson, George, *101*, *111*, *175*
three dimensional calligraphy, 168, *168-75*
tickets, 156
tissue paper, *133*
title pages, manuscript books, 60, 62
titles, 42
tools, 186-7
 automatic pens, *95*, *106*
 for borders, 12
 fibre-tip pens, *95*, *139*
 making marks on paper, 64
 for manuscript books, 62
 marker pens, *102*
 metal pens, *121*
 music pens, *131*
 quill pens, *58*, 72, *72-3*, 78
 reed pens, 76, *76-7*, 78, 81

ruling pens, 80, *80*, *148*
speedball pens, *152*
split nibs, 83, *83-4*
Tre Koner paper, *106*
Ts binding, *139*
turkey quills, 72

U
Uncials, *48*, 58, 87-8, *87-9*
Universal Declaration of Human Rights, *164-5*
unjustified lines, 57
upper case letters:
 decorated, 27-8, *27-8*
 dropped capitals, 30, *30*
 Gothic, 37
 Half-Uncial, 88
 Humanistic, 45
 Lombardic, 58
 Roman, 44, 72, 78, *78-9*, 94
 Rustica, 81, *81-2*
 Uncials, 87, 88
 Versals, 90, *90-1*
United States of America, 15

V
vegetation:
 illuminated manuscripts, 27
 ornament, 68, *96*
Velijovic, Jovica, *164*
vellum, 35, 46, 60, 72, *74*, 111
Versals, 21, 58, 88, 90, *90-1*
Vienna, *135*

W
Wales, *110*, *166*
washes, colour, *23*, *104*, *130*
watercolour paper, *141*
watercolours, 22, *23*, *118*, *121*, *130*
wave patterns, *69*
wax crayons, *95*
Welsh alphabet, *105*
Wenham, Martin, *101*, *118*, *171*
Westover, Wendy, *140*
wet into wet, *21*, 64
Wood, Dave, *52*, *54*, *65*, *99*, *100*, *116-17*, *132*, *135*, *150*, *177*, *178*, *182*, *184-5*
wood, incised lettering, 168, *171*
wood-tar, *119*

woodcuts, *128*
words, 118, *118-19*
 applied calligraphy, 146
 calligrams, 18, *18*, *151*
 embellished and illustrated quotes, 126, *126-35*
 layout, 53-6, *53-7*
 manuscript books, 136, *136-43*
 printed books, 144, *144-5*
 quotes and poems, 120, *120-5*
 spacing, 55, *55*
 texture, 86
World Trade Center, New York, *167*

Z
Zanders Zeta Mattpost Hammer embossed board, *148*
Zerkall printmaking paper, *141*
zigzag patterns, *69*

CREDITS

The author would like to thank all the calligraphers who generously contributed their work; and warmly acknowledges the patience and valuable help of many friends. Every effort has been made to obtain copyright clearance, and we do apologize if any omissions have been made.

Chloë Alexander 174, 175 (photos)
Dorothy Avery 117, 123
Arthur Baker 107
Stuart Barrie 102
John Bently 138, 139
Barbara Biondo 162
Robert Boyajian 158, 159
Frances Breen 73, 116, 132
Kenneth Breese 103
Denis Brown 102, 120, 127, 134, 160, 163
Bridgeman Art Library 28, 36, 47, 48, 71, 94, 96, 97, 137
Georgia Deaver 133, 155, 164, 183
Renate Fuhrman 41, 119
Farah Gokal 18
Suzanne Guest 17, 99
Michael Harvey 98, 104, 125, 144, 145, 149, 163, 171, 182
Angela Hickey 121
Karlgeorg Hoefer 142, 143
Charles Hughes 99
Donald Jackson (© Cranks Ltd, London) 156, 157
Jean Larcher 32, 148, 152
Margaret Layson 172
Audrie Leckie 116, 173, 174
Hassan Massoudy 165
Harry Meadows 18, 110, 112, 114, 122, 124, 126, 127, 131, 136, 166, 170
Meic Morgan-Finch 105, 128
Annie Moring 133
Tim O'Neill 145, 172
Joan Pilsbury 52, 109, 111; with Wendy Westover, 140
Stephen Raw 95
Ieuan Rees 2, 32, 86, 90, 112, 113, 115, 144, 154, 169, 172, 174, 175, back cover
Dena Shavatsky 147 (designed by Barbara Biondo)
Paul Shaw 43, 103, 105, 130, 160, 161, 165, 167
John Smith 23, 85, 123, 127, 130, 131, 135
Kennedy Smith 18, 127, 130, 162, 183
Isabelle Spencer 99, 106, 107, 129, 141, 153
George Thomson 101, 111, 175
Jovica Velijovic 164
Martin Wenham 101, 118, 171
Diana Hardy Wilson 86, 140, 141, 148, 149, 151, 179, 180, 181, 184
Dave Wood 52, 54, 65, 99, 100, 116, 117, 132, 135, 150, 177, 178, 182, 185

DIANA HARDY WILSON has been involved with hand lettering and calligraphy since her school days, when she received her first commissions. She graduated from the Tasmanian School of Art, and is now based in London, where she has participated in several group exhibitions. Her first major solo exhibition was in 1985, and titled, "Colour Speaks Words/Words Speak Colour".

The exhibits included her highly individual works of a juxtaposition of painting and calligraphy on paper, and her decorative handmade books. She is an exhibiting member of the Free Painters and Sculptors, and has taught at the London College of Printing, Westminster Adult Education Institute and Croydon College.